THE MAHARAJAS

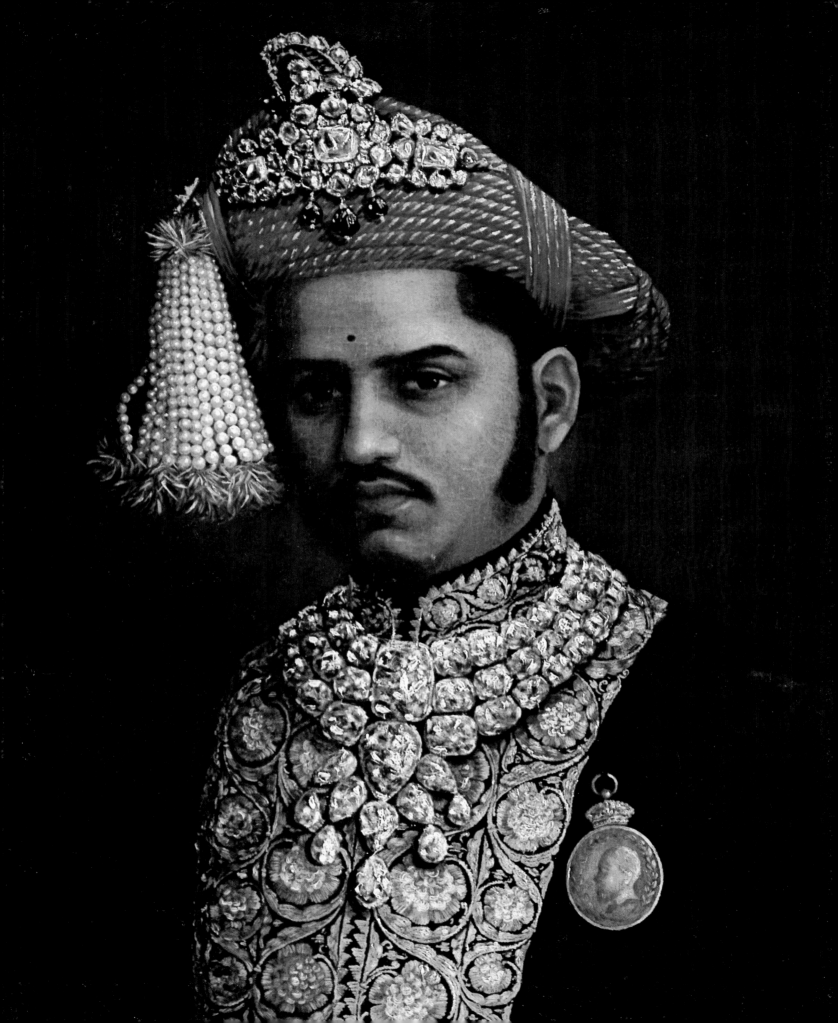

TREASURES OF THE WORLD

THE MAHARAJAS

by
Geoffrey C. Ward
Photographs by Seth Joel

Select
BOOKS

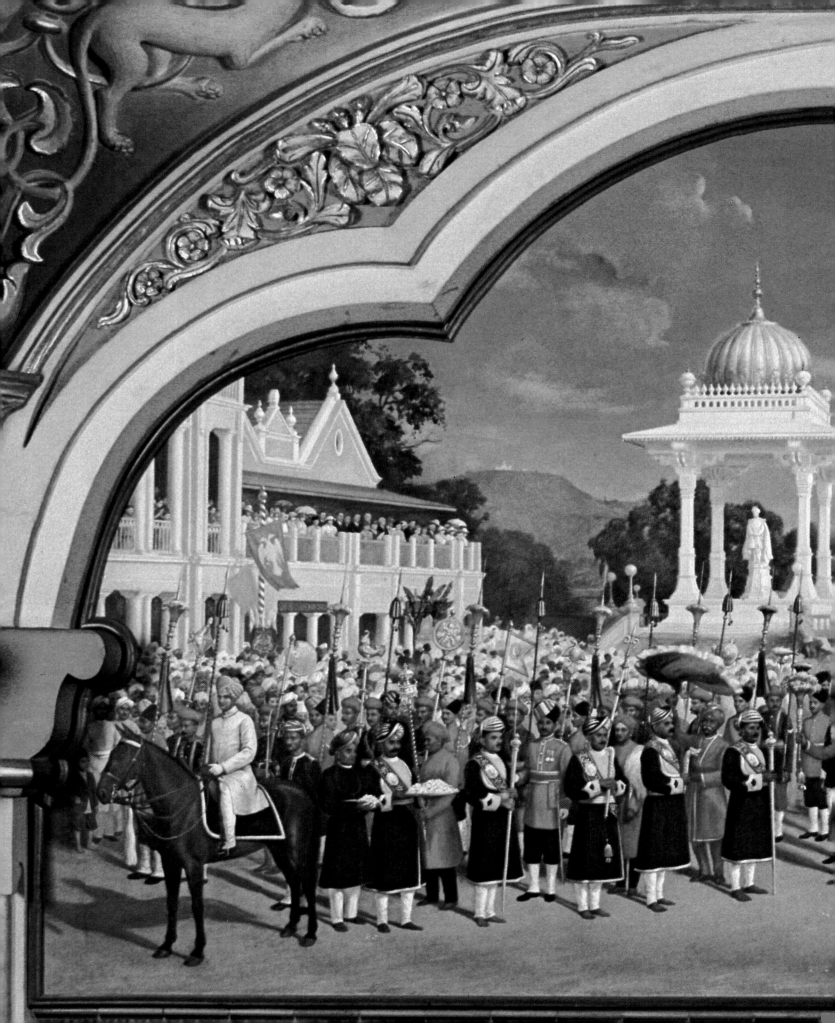

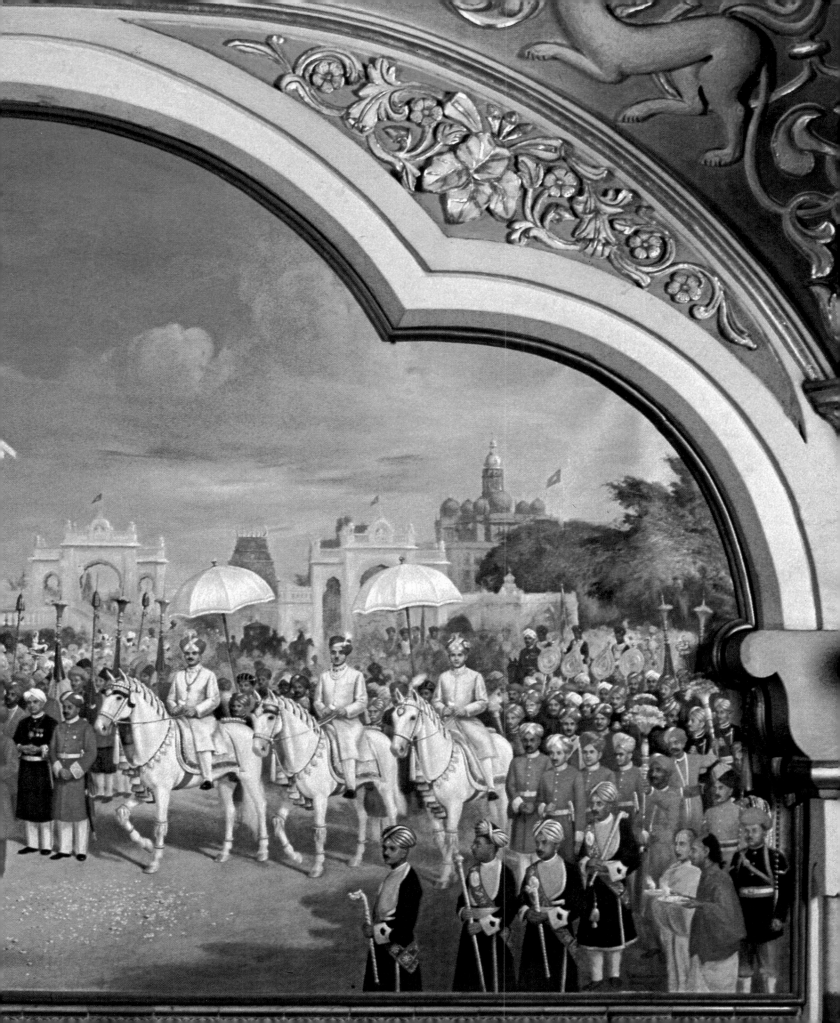

Treasures of the World was created by
Tree Communications, Inc.
and published by Stonehenge Press Inc.

TREE COMMUNICATIONS, INC.

PRESIDENT
Rodney Friedman

PUBLISHER
Bruce Michel

VICE PRESIDENTS
Ronald Gross
Paul Levin

EDITOR
Charles L. Mee, Jr.

EXECUTIVE EDITOR
Shirley Tomkievicz

ASSISTANT EXECUTIVE EDITOR
Henry Wiencek

ART DIRECTOR
Sara Burris

PICTURE EDITOR
Mary Zuazua Jenkins

TEXT EDITOR
Thomas Dickey

ASSOCIATE EDITORS
Vance Muse Artelia Court

ASSISTANT ART DIRECTOR
Carole Muller

ASSISTANT PICTURE EDITORS
Deborah Bull Charlie Holland
Linda Silvestri Sykes

MANAGING EDITOR
Fredrica A. Harvey

ASSISTANT COPY EDITOR
Cynthia Villani

PRODUCTION MANAGER
Peter Sparber

EDITORIAL ASSISTANTS
Carol Epstein Martha Tippin
Holly McLennan Wheelwright

FOREIGN RESEARCHERS
Rosemary Burgis (London) Bianca Spantigati Gabbrielli (Rome)
Patricia Hanna (Madrid) Alice Jugie (Paris)
Traudl Lessing (Vienna) Dee Pattee (Munich)
Brigitte Rückriegel (Bonn) Simonetta Toraldo (Rome)

CONSULTING EDITOR
Joseph J. Thorndike, Jr.

SELECT BOOKS
Treasures of the World was created and produced by Tree
Communications, Inc., New York, N.Y.
First published in Great Britain 1984

THE AUTHOR: Geoffrey C. Ward, former editor of *Audience* and *American Heritage*
magazines, spent much of his boyhood in India.

CONSULTANTS FOR THIS BOOK: Mulk Raj Anand, writer and publisher, is a leading
authority on the culture and art of India. Shehbaz Safrani, acting curator of the
Tibetan Museum in New York, was born and raised in India. Ellen S. Smart is
curator of Asian Art at The Walters Art Gallery in Baltimore.

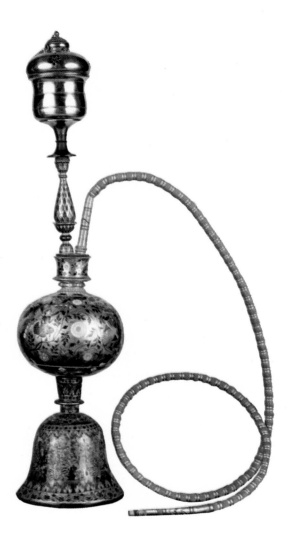

COVER: *The elephant-headed Hindu god Ganesha,
represented in this silver image with a prominent
belly and four hands, sits on a lotus plant. Ganesha
has one broken tusk, which he sacrificed in a battle
while defending the god Shiva.*

TITLE PAGE: *In this detail from a full-length portrait
painted in 1881 (see page 121), the maharaja of Ba-
roda Sayaji Rao wears an elaborate diamond neck-
lace and a turban with an exquisite tassel of pearls.*

OVERLEAF: *On the leftmost white horse, Maharaja
Krishnaraja IV of Mysore leads the annual proces-
sion celebrating his birthday. He reigned from 1895–
1940. His brother and nephew ride with him, past a
canopied statue (at center) of Krishnaraja's father.*

ABOVE: *This hookah—a water pipe for smoking
tobacco—has a painted glass base, on which rests a
silver globe covered with brightly painted enamel.*

CONTENTS

AFGHANISTAN

CHINA

KASHMIR

KHYBER PASS

PUNJAB

PAKISTAN

Indus River

HIMALAYAS

Brahmaputra River

RAMPUR
Rampur

BHUTAN

BIKANER
Bikaner

Delhi

Mathura

COOCH BEHAR

RAJPUTANA
Jodhpur
JAIPUR
Amber
Jaipur
Fatehpur
Sikri
Agra
Yamuna River
Gwalior

OUDH
Benares
Sarnath

Ganges River

BANGLADESH

JODHPUR

TONK

GWALIOR

BENARES

BENGAL

Chitor
Udaipur
MEWAR

MALWA

REWA

Calcutta

GUJARAT

Ujjain
Indore
Indore River
INDORE

Baroda
Narmada
BARODA
Surat

ARAVALLI HILLS

Godovari River

HYDERABAD
Golcanda
Hyderabad
Krishna River

Bombay

ARABIAN SEA

BAY OF BENGAL

MYSORE
Bangalore
Seringapatam
Mysore

Madras

Ootacamund
NILGIRI HILLS

TRAVANCORE

SRI LANKA (CEYLON)

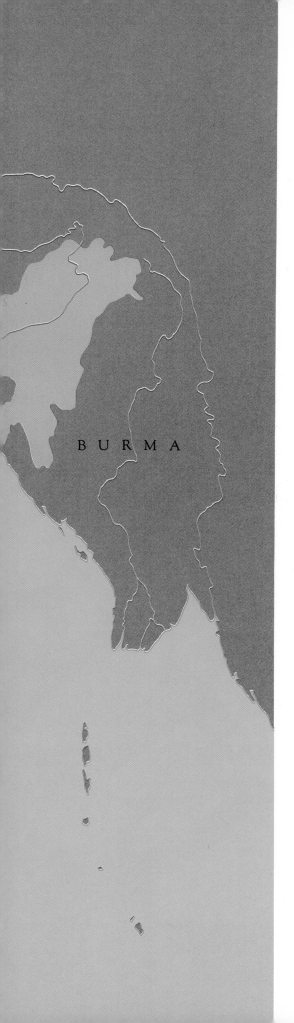

INDIA

Within the boundaries of the present-day nation of India, the map here shows some of the princely states that dominated the subcontinent during its history. Until the twentieth century, India was not a single political entity, but a conglomeration of almost seven hundred states ruled by princes with such titles as maharaja, or "great ruler", maharana, or "great prince"; and nizam, or "governor."

Beginning in the sixteenth century, Muslim overlords known as the Moguls, who had invaded the subcontinent from central Asia, ruled much of India. During the next three centuries, as Mogul power waxed and waned, Great Britain gradually made itself the paramount power in India by energetic colonizing, diplomacy, and in some cases by outright conquest. Hundreds of Indian princes signed treaties that placed their realms under the protection—and the domination—of Great Britain. Not until 1947 did Great Britain grant India its independence.

The five states that figure prominently in this book are outlined, in a brick-red color, to indicate their mid-nineteenth-century borders. The symbols in the key below designate some important cities, royal palaces, and ruins. The countries surrounding India bear their modern names.

BURMA

● Cities ♣ Ruins

♟ Principal Residence of the Maharaja

0 250 500 Mi

0 250 500 Km

I

LION OF VICTORY

JAI SINGH THE RAJPUT

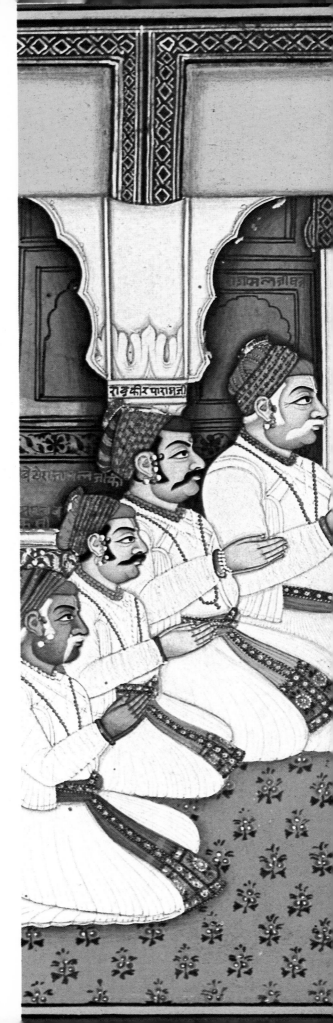

On a hilltop seven miles from the city of Jaipur stands an ancient fortress, its thick-walled watchtower forever looking out onto the north Indian plain. Just once during his reign, each maharaja, or "great ruler," of Jaipur wound his way up the gaunt hillside to this citadel. There, guards blindfolded him, and a torchbearer led him inside, through a labyrinth of passages to a windowless chamber where he removed his blindfold. After his eyes adjusted to the flickering torchlight, he saw laid bare before him the glittering heart of his family's royal treasure—an unimaginably rich heap of jeweled objects, said to have been stolen from a foolhardy prince who had dared venture too far south. There were curved swords with emerald hilts, gold wine cups jagged with rubies, twisted ropes of pearls, chokers covered with diamonds, children's pull toys weighted down with gold and precious stones. From this splendid hoard, the maharaja was permitted to pluck for himself a single gleaming bauble: to be greedier than that, family legend held, would prove him to be unworthy of his throne.

Seated on a pile of flowered cushions at right, the moustachioed Jai Singh II, maharaja of Jaipur in the early 1700s, confers with his equally hirsute courtiers.

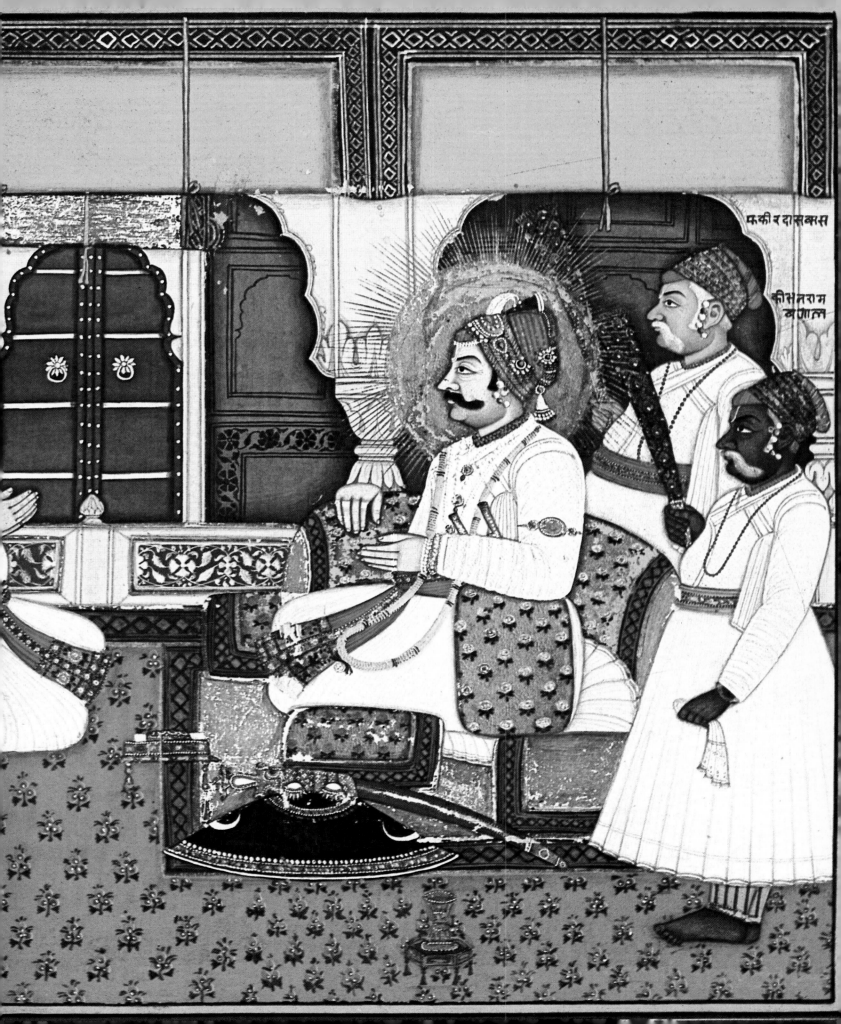

In a glittering, miniature painting, Akbar—emperor of the northern region of India from 1556 to 1605— sits in a portico, at left above, and receives homage from a group of powerful native princes, among whom may well have been a ruler of Jaipur. The charismatic Akbar was a Muslim and an emperor of the Mogul dynasty—central Asians who seized power in India in the sixteenth century.

Jaipur's resplendent throne was just one of hundreds held by local princes all across the vast Indian subcontinent. Some rulers were cruel despots; others were gentle champions of reform. But all wielded absolute power within their borders. Their domains ranged in size from Hyderabad, nearly the size of Great Britain, to Avachar, which covered precisely one square mile.

As large as western Europe, India is walled on the north by the Himalayas, bounded on three sides by the sea, and watered by three great river systems: the Indus, the Ganges, and the Brahmaputra. India is so immense, and its peoples so diverse, that no one ruler has ever held sway over it all.

Though divided politically, the people of India shared some common ground—their Hindu faith, which evolved over many centuries from a foreign religion that absorbed a myriad of local Indian cults and beliefs. Beginning about 1500 B.C., light-skinned pastoral tribesmen from the region of present-day Iran, who called themselves Aryans, or "nobles," began filing down through mountain passes onto the Indian plains, pushing the darker-skinned indigenous people before them. The sacred lore the invaders brought with them, filled with poetic hymns of praise for their gods of nature—the sun, the moon, the heavens—merged with the diverse cults and local divinities of peoples they displaced. The result was Hinduism, with its crowded pantheon of gods.

More a way of life than a method of worship, Hinduism makes sacred ritual of every detail of daily living: there is a correct way to do everything from bearing a child to drawing the last breath. Underlying it all is the conviction that all living things are perpetually evolving. Each soul has lived an infinite number of lives in the past and is destined to live an infinite number in the future. This chain of being has no beginning and no end: one may be reborn in the next life as an ant or a sage, a frog or a king, depending on one's conduct in this life. Only by living properly through many incarnations may a person be released from worldly existence. Those who succeed achieve union with Brahman, the supreme being who contains within himself a Hindu trinity—Brahma the creator, Vishnu the

preserver, and Shiva the destroyer. Vishnu and Shiva are so diverse in their powers and attributes that the followers of Hinduism worship them in some thirty-three million so-called aspects, or incarnations. Each aspect has his or her own name and is a completely distinct deity, yet also a part of the greater god.

Hindu society traditionally has been divided into four main castes, or classes—priests (Brahmans); warriors (Kshatriyas); merchants, farmers, and artisans (Vaishyas); and menials (Shudras). Each of these in turn has been divided into countless subcastes. Caste laws dictated a person's livelihood, dress, food, method of worship, and choice of spouse. Hindus accepted these strictures without complaint for the most part, since a person's caste was determined by the quality of past lives.

The special genius of Indian civilization has been its ability to adapt. Hindu India outlasted wave upon wave of invaders from the northwest, among them Bactrians, Scythians, and Persians. All came as conquerors, only to find themselves eventually enfolded into the ancient Indian fabric.

The rulers of Jaipur were Rajputs, which means "sons of kings"— Hindu warriors who were the indirect descendants of the Scythian invaders. Like their ancient forebears, they were a martial people who venerated the horse, the sword, and most of all the sun, from which they believed themselves to be descended.

Beginning in the seventh century A.D., new and more formidable interlopers began raiding India. They were Muslims, followers of the faith founded by Mohammed about A.D. 600. The first Muslims to invade India were Arabs; they were followed by tribesmen from the central Asian plains. It took the Muslims nearly nine hundred years to do it, but they came close to conquering the entire subcontinent. Simple greed impelled the invaders, but religious zeal provided them with a convenient pretext. "The whole country of India is full of gold and jewels..." explained one Muslim general, "and the whole aspect of the country is pleasant and delightful.... Since the inhabitants are chiefly infidels and idolaters, by the order of God and his prophet it is right for us to conquer them."

TEXT CONTINUED ON PAGE 20

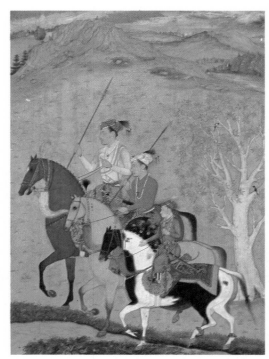

The three young Mogul princes who ride companionably in this 1653 painting became, some five years later, fierce rivals for the imperial throne of India. Aurangzeb—the middle brother above— won, but as emperor he had few trusted allies: among them was his general, Maharaja Jai Singh II.

13

A STAR-STRUCK PRINCE

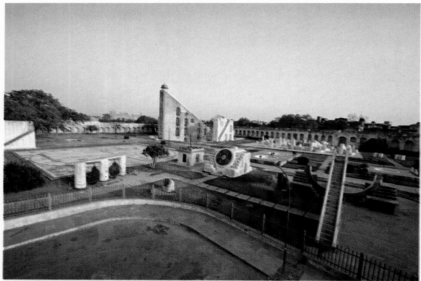

From afar, the twenty-nine giant astronomical instruments of Jai Singh's observatory resemble a small fantasy city in the center of his namesake city, Jaipur.

When he was a boy, Jai Singh II loved astronomy—an apt fascination for the child of a clan that claimed descent, via assorted gods and ancestors, from the sun itself. By the time he was maharaja of Jaipur and a grown man, Jai Singh's reputation as a scientist matched his fame as a military leader and politician.

When the Mogul emperor Mohammed Shah asked him to scientifically revise India's calendar, Jai Singh withdrew temporarily from public life and gave himself to his intellectual passion. Besides the calendar work, he undertook—in 1734—the building of the colossal astronomical instruments sculpted of masonry and metal on these pages.

Turning a palace courtyard into an open-air observatory, the prince paid tribute not only to the intricacy of the skies, but also to his own brilliance. Jai Singh had absorbed the teachings of both ancient and contemporary stargazers and concluded that he was wiser than they. Ptolemy—the classical Greek astronomer—according to Jai Singh, was "a bat who could never arrive at the sun of truth." He thought that his giant instruments would offer greater precision than the smaller instruments others had used. For example, massive sun dials could record smaller degrees of solar movement and time— seconds, as well as minutes and hours—than conventional dials. The instruments proved to be marvels of accuracy, but Jai Singh tempered his pride in the achievement with humility, saying that he was only "an admiring spectator" before the splendors of divine creation.

Low light gilds several instruments, at right, from a group of twelve that measures the sun's latitude and longitude as it moves across the sky, occupying—one by one—the twelve zones of the zodiac.

14

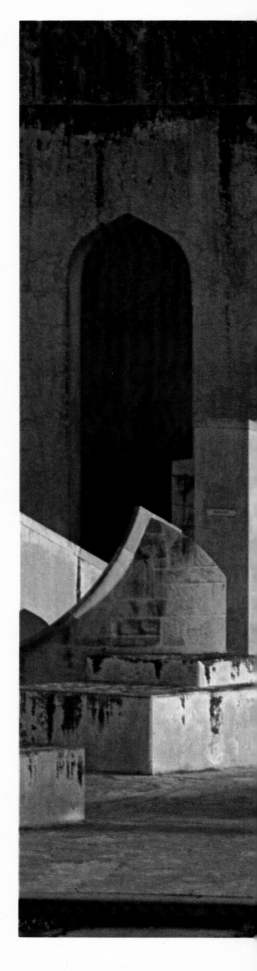

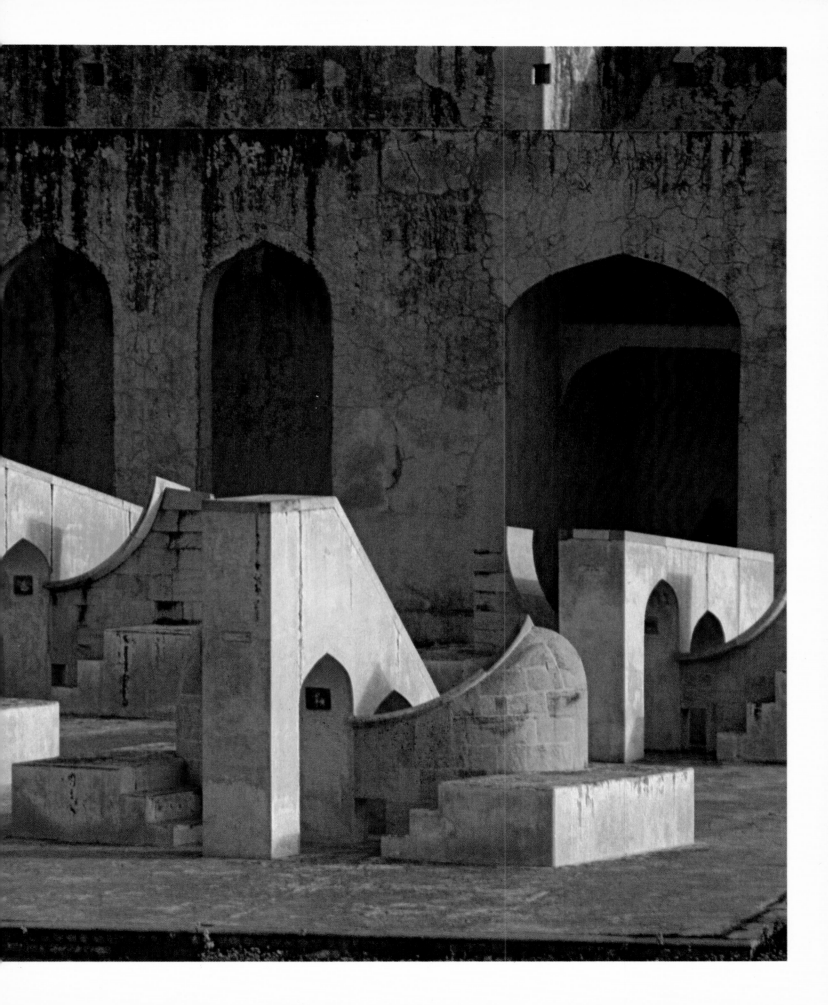

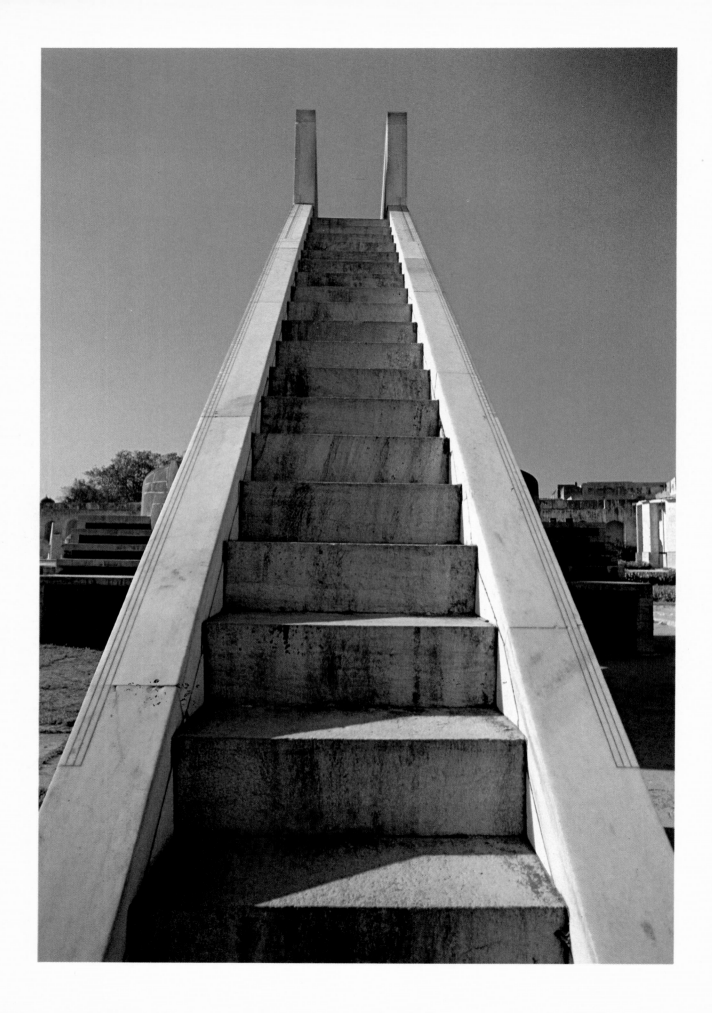

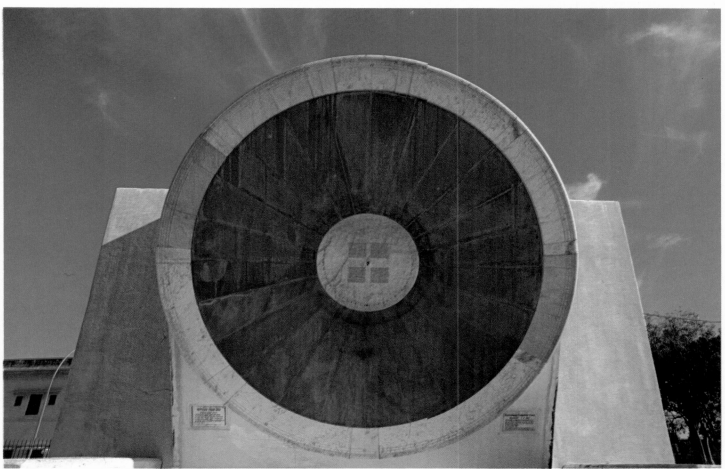

A dark iron disk caps one end of a stone cylinder that rests horizontally in a great masonry bracket, each element typifying the heavy materials and construction that made Jai Singh's instruments almost impervious to local earthquakes. This cylinder lies with one end pointing to the north and the other to the south. In Jai Singh's time a slender rod protruded from each end of the cylinder casting a shadow on the iron disk that told the position of the sun when it was in—alternately—the northern hemisphere or the southern hemisphere.

When the maharaja and his royal astronomer climbed to the top of the stone staircase opposite, they looked down over its marble rail at two quadrants, or calibrated marble arcs, curving upward on either side. The shadow of the sharply triangular stair falling on one or the other quadrant told them the time in Jaipur, with a margin of error of only twenty seconds. The observatory contained many such staircases, which in the day cast informative shadows and at night served as observation platforms for scanning the stars with the naked eye, as Jai Singh did. Eighteenth-century Indians seldom used that seventeenth-century European invention: the telescope.

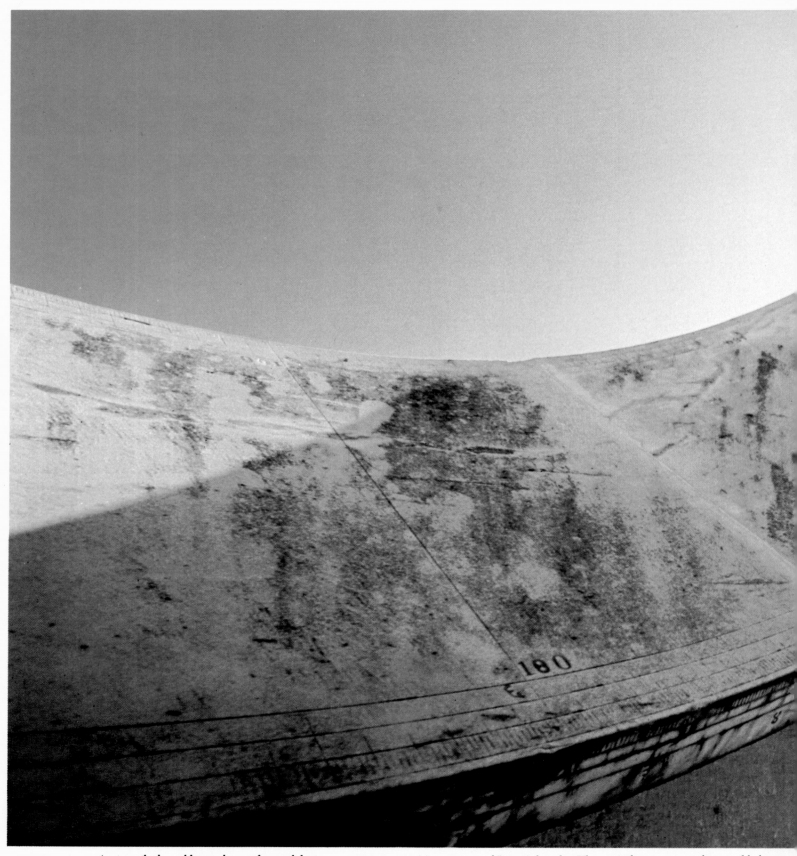

An inscribed marble quadrant of one of the instruments on page 14 soars toward Jaipur's hot sky. The city's desert surroundings yielded a

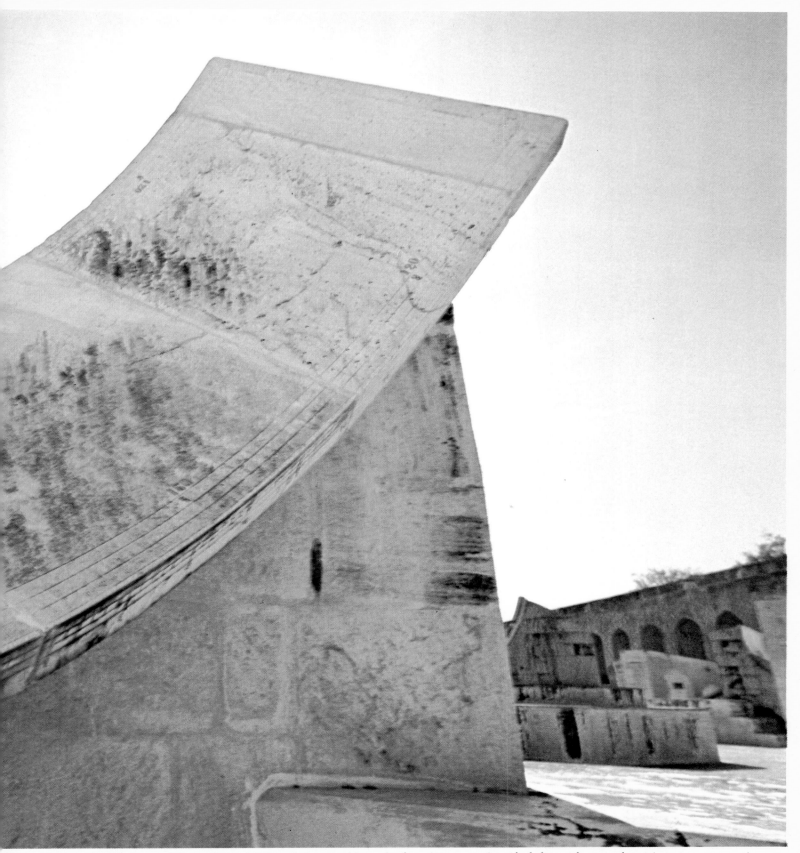

rich variety of building materials—including black and white marbles and red sandstone—and an ideal climate for its maharaja's project.

Jai Singh II's gifted grandson Pratap Singh, above, was a poet, a musician, and a patron of many painters, one of whom portrayed him here draped with pearls and holding prayer beads in his right hand and a flower in his left.

TEXT CONTINUED FROM PAGE 13

India had no more fierce defenders than the Rajputs during these Muslim invasions. One Rajput prince is said to have lost an arm and to have suffered some eighty wounds in the struggle, yet he dragged himself onto the battlefield one more time in 1527 to face the last and greatest of the would-be conquerors from the north, Baber. An indirect descendant of the Mongol warlord Genghis Khan, Baber invaded India from the central Asian region Turkistan with twenty-five thousand men (many of them armed with matchlocks) and swept all before him. He established a dynasty of Muslim emperors, the Mogul empire, at the city of Agra.

From their kingdoms in the forbidding Aravalli Hills, the Rajputs sallied forth from time to time to harass the Moguls. But in 1562 the Rajput ruler of Amber realized that resistance was futile and offered his daughter in marriage to the Mogul emperor, Akbar, as a sign of surrender. From then on the rulers of Amber became hired swords for the Mogul emperors. Playing a shrewd double game, they commanded thousands of Rajput horsemen against the emperor's enemies, while making sure that he did not too greatly curtail their own power at home.

Jai Singh II, the greatest of the rulers of Amber, came to power in 1699. He was a fine soldier (his name means "lion of victory"), a loyal supporter of the Mogul emperor Aurangzeb, and a ruthless defender of his own throne. When he learned that his brother was planning a coup, he made a supposedly conciliatory visit to his rival's home with an entourage that included their mother's closed carriage. When his brother, unarmed, stepped up to the carriage to greet his mother, Jai Singh's soldiers sprang from behind the curtains, seized the usurper, and hurried him off to prison.

Accustomed to living by his wits in a world of incessant warfare and palace intrigue, Jai Singh, perhaps understandably, became obsessed with order. He first sought it in the heavens. He decreed that the works of ancient Greek and Persian astronomers be translated into Sanskrit, the language of Indian scholars and priests. He amassed a great library, with books in many different languages. When traditional brass astronomical instruments failed to please

him—they were too small, he said, and wind threw off their calculations—he resolved to build his own giant and immovable instruments out of masonry. Five enormous observatories eventually were built for him, with instruments ninety feet tall, at Delhi, Benares, Ujjain, Mathura, and within his own palace in the center of his brilliant new city of Jaipur.

Having detected harmony in the skies, he now tried to create it single-handedly on earth. He resolved in 1720 to abandon his clan's dark fortress at Amber and build a gleaming white capital of his own on the plain below, laid out along the strictest possible geometrical lines. He ordered six villages on the site to be evacuated and began work on a twenty-foot wall with fortified towers and eight great gateways to surround the city, which was to be made up of nine square precincts, equal in size and arranged in rows of three. In the central square Jai Singh built his vast palace and his observatory (see pages 14–19). Broad avenues ran the length and breadth of the city, thirty-seven yards wide, with every corner a right angle. Jai Singh made just one concession to the untidy past: out of respect for his subjects' religious sensibilities, he ordered that no village shrine be torn down; so here and there the brisk efficiency of traffic flow was interrupted by an ancient temple in the middle of the roadway. The maharaja often toured the site to urge his workers on. Four elephants pulled his two-story chariot, itself a miniature palace with fret-worked windows, carved balconies, and cupolas roofed with gold.

The fruit of Jai Singh's intricate plans was astonishing: a city of wide streets, sweeping vistas, and architectural unity unlike any other in the East. Within Jai Singh's huge palace were fountains and formal gardens, shady courtyards, and pavilions with pierced screen walls that let through what few breezes the desert sun allowed. Around his palace Jai Singh arranged his court's numerous workshops, studios, and stables. There was one stable for camels, another for horses, still another for elephants, and as many more for their accouterments. He built an armory in which to display his royal weapons as an object lesson for visitors. Collecting fine weapons became a passion for Jai Singh's successors, who filled the Jaipur

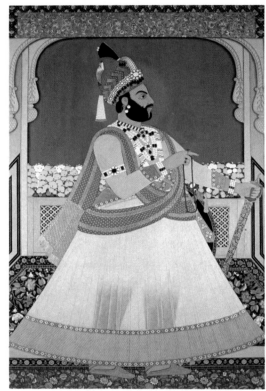

In 1803 the portly Jagat Singh, above, succeeded Pratap Singh, opposite, as maharaja and—like him—wore Mogul-style clothing: a sheer, full-skirted dress and loose trousers. The bifurcated beard and the sword are emblems of his status as both an aristocrat and a warrior.

armory with a variety of beautifully made guns, daggers, swords, and maces (see pages 27–49).

The palace had separate workshops for stitching clothes and for dyeing them. And in still another workshop employees did nothing but look after those royal costumes that were embroidered with jewels. Jai Singh also built quarters for poets, scholars, and painters, as well as shops for the perfumers who compounded fragrances to please the women of the palace and mixed vats of rose water with which the entire court was delicately sprayed from time to time.

The women of the Rajput courts (like those who lived with most maharajas) were kept from the gaze of other men because of a Muslim custom known as purdah, which requires women to be concealed from public observation. The women—and there were hundreds of them: wives, concubines, serving girls, nurses, children—occupied a large and richly appointed complex of apartments called the zenana, within the palace. The lives they led there were opulent, if uneventful, consisting of a langorous daily round of devotions, perfumed baths, elaborate toilettes and massages, and games of dice with their handmaidens. Their heads, ears, throats, hands, and feet glittered with gold and jewels because, the Rajputs believed, "women should be constantly supplied with ornaments, for if the wife be not elegantly attired, she will not exhilarate her husband." All this exhilaration was reserved for the maharaja's eyes alone, and when on rare occasions the women were allowed to leave their quarters, they slipped unseen from chamber to chamber through hidden passages, and they saw the world outside only through carved screens or between the swaying curtains of the palanquins in which they were carried from place to place.

Jai Singh reveled in the beauty and order of his city. He rose each day at dawn to the eerie wail of a flute, made his way in simple robes to the temple of Kali—the goddess of death to whom all the Rajput princes paid special allegiance—then returned to the palace to array himself for the sometimes tedious business of ruling. He worked a fourteen-hour day, much of it spent in his audience hall, where he sat enthroned and surrounded by his nobles to hear petitions, resolve

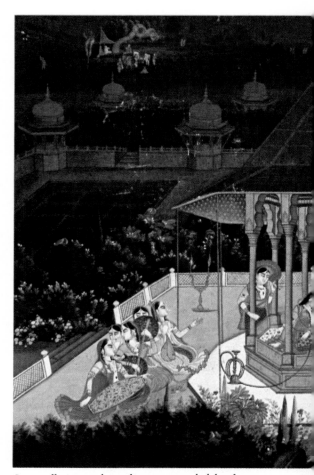

In an illuminated pavilion surrounded by fragrant gardens and by night, Jagat Singh embraces his favorite concubine, Ras Kapur, while attendants lounge about and musicians play. Preoccupied with his lover, this nineteenth-century maharaja neglected the affairs of Jaipur and squandered its wealth on her.

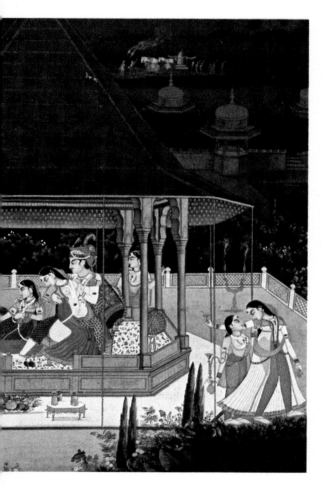

disputes, and receive gifts from his vassals and delegations from his fellow princes. Intellectual pursuits offered relief. He loved to pore over manuscripts in his library, he spent hours working out mathematical formulas (he loved the science of mathematics almost as much as he did astronomy), he charted the movements of the heavens from his outdoor observatory, and he eagerly debated fine points of religion and philosophy with his Hindu priests. He sat in his cool, spacious gardens in the evening, pleasantly muddled by the mead and rice wine that were his only recorded vices, and listened, content, as a court poet sang his lavish praises.

Jai Singh's magnificent city was still taking shape around him when he died in 1743. His heirs were a mixed lot. His son Madho Singh I inherited only his father's love of the sybaritic side of princely life: he grew immensely fat and delighted in having portraits of himself painted in different costumes and surrounded by an ever-changing cast of concubines. Pratap Singh, Jai Singh's grandson, was a generous patron of the arts: he employed fifty painters who specialized in miniatures and liked to have himself painted dressed as Krishna, the amorous blue incarnation of Vishnu. He built one of the most curious monuments in Jaipur, the Hawa Mahal, or the "Palace of Winds." This lofty facade, which rises five stories above Jai Singh's palace, is less than a foot thick and pierced with hundreds of filligreed windows. Behind these windows the women of his court sat to watch state processions, unobserved by the crowds below: they reached their perches through a tunnel.

By the turn of the nineteenth century, however, Jaipur had fallen on evil days: a succession of inept emperors had fatally weakened the Mogul allies; Hindu and Muslim interlopers theatened Jaipur's borders and exacted tribute. Pratap Singh was no soldier—in desperation he turned for help to a new and untried ally. In 1803 Pratap signed a treaty that brought Jaipur under the protection of the British, following a pattern already set by scores of other princes.

English traders had first arrived in India two centuries before, in 1609—relative latecomers to the European scramble for control of the lucrative commerce in Indian spices, cotton goods, sandalwood,

opium, jewels, and richly embroidered silk. Dutch, French, and Portuguese traders were already present in force along India's coast. The British East India Company, chartered in 1600 by Queen Elizabeth I to exploit India's wealth, at first sought only to establish coastal trading settlements, called factories, to guard their stores. But as the once mighty Mogul empire began to collapse, the British saw a chance to rule as well as to trade and started to shove their way inland. By 1803, when Jaipur sought their protection, the British were well on their way to almost total domination. By that time their European rivals had been either forced out or shut up in inconsequential enclaves.

In the early nineteenth century, the British directly ruled about two thirds of India and gained effective control over the other third through treaties with various maharajas who found it expedient to bow to these dynamic entrepreneurs. By bribery, cajolery, and intimidation, the British drew the maharajas one by one into their net, until the bright red map of British India was checkerboarded in green with nearly seven hundred so-called Native States. The arrangement benefited both sides: the British protected the princes of the Native States from attack or uprising; in return the princes respected Britain's monopoly on trade.

The princes also promised stability; and in India stability was rare and precious. Subjugating most of the subcontinent was one thing—governing it was quite another, as the British quickly found. Most Indians were Hindus, but alongside them lived millions of Muslims (a result of the long Mogul domination) and members of many other sects. The subcontinent was also a babel of languages: at least 850 different languages and dialects were spoken in India. Amid this welter of tongues and beliefs and clashing cultures, the princes represented permanence.

Until 1857, maharajas who proved too troublesome risked actual annexation by the British. In that year, however, Indian troops rose up against the British and tried to restore the Mogul empire in a bloody conflict that is known as the Indian Mutiny. Aided by loyal Indian forces, the British put down the mutiny; but thereafter they

A PRINCE'S SILVER SOLUTION

The day Madho Singh II received his invitation to the 1902 coronation of Edward VII in London, he was faced with a great dilemma. The maharaja of Jaipur was loathe to refuse the honor. A century-old treaty bound Jaipur to Great Britain; and his forebears and the British had survived their coexistence by showing mutual respect. If Madho Singh missed the coronation, he might offend. But a voyage to London and a stay there threatened direr consequences. He would become ritually unclean if he defied the Hindu proscriptions against ocean travel and—once abroad—eating food that had not been prepared according to strict Hindu culinary rules. So Madho Singh thought long and devised an ingenious solution.

While Hindu priests consecrated part of his ship as a temple, Madho Singh ordered a supply of proper food from his cooks, and from his silversmiths two huge silver urns to hold the Ganges River water that Hindus used for their holy ablutions. Loading food and urns on board and throwing gifts into the harbor to placate his gods, Madho Singh sailed off, well protected, to see his new sovereign crowned.

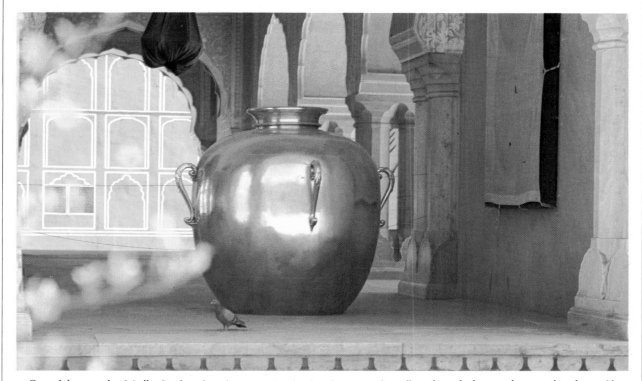

One of the urns that Madho Singh took on his trip to London stands over six feet tall, perhaps the largest silver vessel in the world.

took care not to interfere too greatly in the affairs of the princes.

Britain's Queen Victoria herself pledged always to "respect the rights and dignity and honour of the native princes as our own." All of the trappings and some of the substance of power remained in the princes' hands. They could levy taxes, save or squander their treasures at whim, maintain their armies, and administer justice. Yet behind the glitter, British power made itself felt. A British official, whose title was resident, kept a close watch on the actions of the princes in each Native State. British agents haunted the palace corridors. British tutors often taught the crown princes.

The mid-nineteenth-century maharaja of Jaipur, Ram Singh, was an enthusiastic admirer of everything English; he mastered ballroom dancing and hired an English colonel, Swinton Jacob, as his state engineer. Swinton did his best to bring Jai Singh's eighteenth-century city up to date: he placed a gaslight on every street corner, constructed waterworks, and supervised the building of a sprawling Scottish-style castle for his patron on a cliff overlooking the town.

Ram Singh apparently grew weary of the sameness of his great ancestor's blinding white city and experimented for a time with painting the buildings that lined each street a different bright color. He finally settled upon a deep rose and ordered the entire city to be painted in this hue. Back and forth against this vibrant backdrop moved the people of Jaipur—the men brilliant in their great loose turbans of blue and crimson and saffron, the women in bold red and orange and black.

All of Jai Singh's successors, weak or strong, wise or foolish, have presided once a year at the so-called white durbar, a ceremony notable among Indian princely events for its relative austerity and simplicity. The maharaja appeared on the rooftop of Jai Singh's palace, beneath a full moon and clad in white brocade, diamonds, and cascades of pearls. He took his seat upon a silver chair, gripping a sword sheathed in white velvet and emblematic of his family's power. Around him sat his nobles and courtiers, also in white and holding swords, the whole court gleaming colorless and silent in the moonlight above a city more colorful perhaps than any other on earth.

JAIPUR'S
SPLENDID ARMS

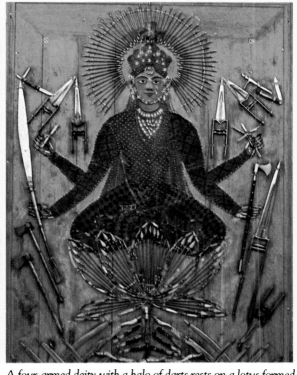

A four-armed deity with a halo of darts rests on a lotus formed of arrows. He is the centerpiece of a montage of formidable weapons that hangs in the royal armory at Jaipur.

Like many of India's numerous princes, the maharajas of Jaipur were members of the military caste—the Kshatriyas. Tradition exempted them from the pious public offices of other high-caste Indians and from manual labor, for the warrior-maharaja's essential work was to protect his land from invasion and his more peaceable subjects from harm. This hereditary obligation, though heavy, was a source of consuming pride to the Jaipur rulers. Chivalrous, high spirited, and often intoxicated by a pre-battle drink of opium-laced rose water, they exulted in a good fight. When no foe presented himself, they sought their pleasure in hunting—their other great avocation. In a lifetime of battling beasts and men, fine weapons were the tools of the warrior-prince's trade and the emblems of his honor.

To show that his family honor had been well served and his wealth honorably won, Maharaja Madho Singh II displayed his weapons—including the lacquered shield, the exquisite daggers and powder horns, and other splendid pieces on these pages—in the palace armory. Founded by Jai Singh II in the 1720s to house inherited arms as well as his own, the armory held an especially impressive collection—and with good reason. For much of the 1500s and 1600s, local princes had been the military right arm of the Mogul emperors, who were also zealots of war and of the chase. Through association the princes had ac-

quired imperial tastes and through fealty the means to afford them. They hunted with the falcons introduced by Mogul trainers, pitched Mogul-style red tents in their camps, and often carried weapons imbued with the Mogul sense of magic perfection.

The Moguls followed the essentially Persian belief that weapons had magical ability to strike and kill in proportion to the perfection of their manufacture, and they patronized armorers who worked in the masterly Persian tradition. Jaipur's maharajas eagerly bought the swords and daggers of these virtuoso craftsmen and later, as Mogul power waned, recruited them to their own court. With such artisans at their command and—in the 1700s—with expanding territory and new tax wealth, the rulers of Jaipur could indulge not just taste but whim. In addition to weapons designed for lethal efficacy, by the 1800s the princes were commissioning bejeweled showpieces and, in response to a European fad, novelty combinations of guns, knives, and other forms. Most of this multifarious weaponry found its way to the palace armory.

At Madho Singh's death in 1922, the armory collection ranged from an eleven-pound sword owned by one of Jai Singh's heroic forebears to gorgeous baubles like the gem-paved elephant goad on pages 48–49. Each age had left proof of its bloodlust and love of beauty—entitlements of the family caste.

Painted in lacquers, the leather shield opposite, with its four shining bosses, glows with scenes of the hunt. Clockwise from the bottom, a prince on horseback spears a lion who is savaging a princely retainer; women at a well offer water to a mounted huntsman; another lion attacks another prince; and an archer stalks a herd of deer by torchlight.

OVERLEAF: *In this detail from the shield opposite, a turbaned horseman turns to fend off the lion that attacks his horse's rump, while a friend behind a nearby bush prepares to shoot the lion if necessary. The cavalier's raised sword appears to have an Indian-style hilt that is joined to a blade of the type that the Moguls popularized in the 1500s.*

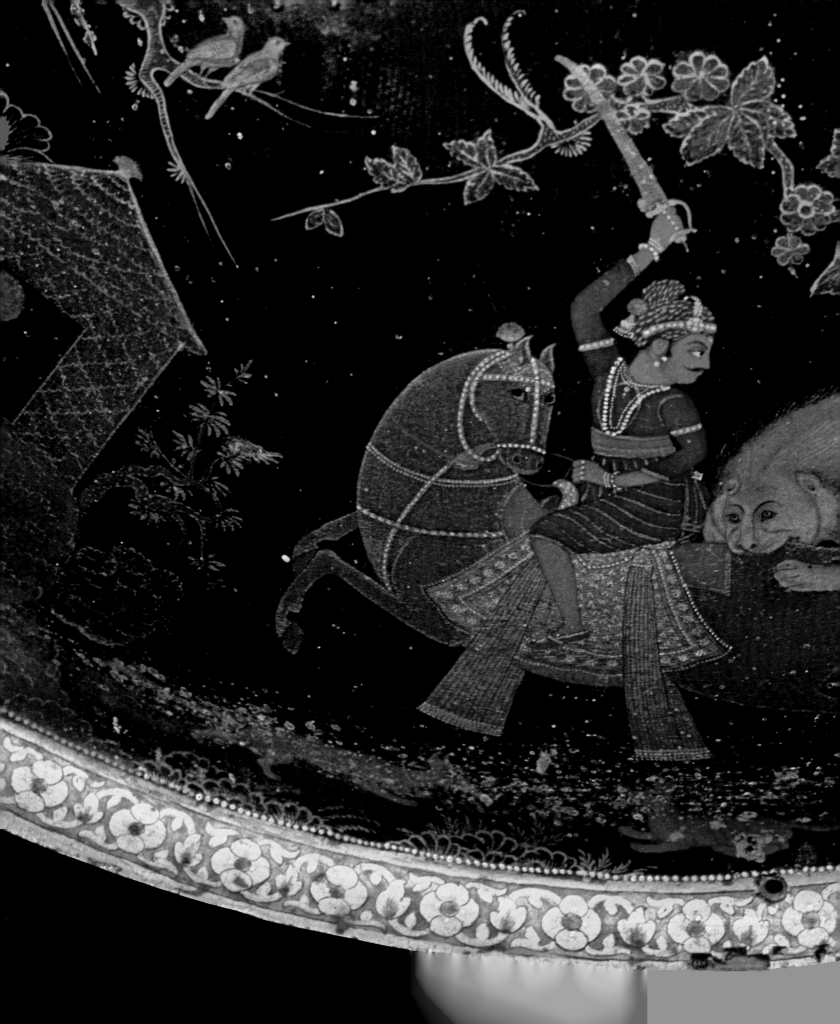

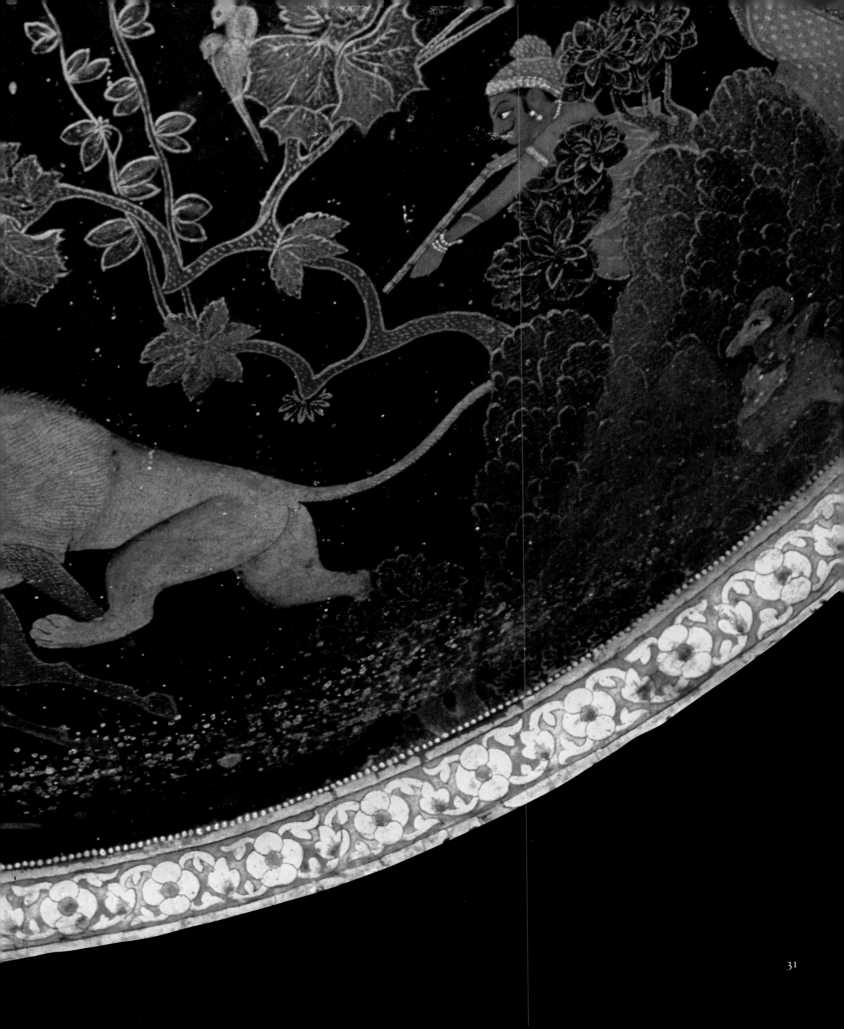

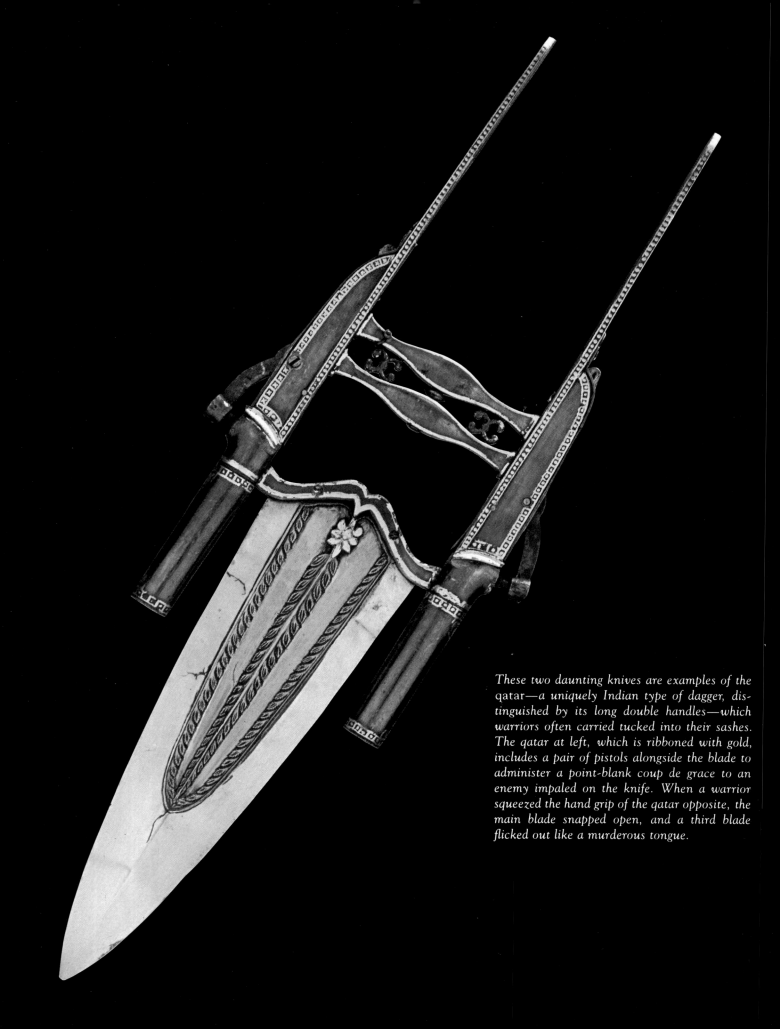

These two daunting knives are examples of the qatar—a uniquely Indian type of dagger, distinguished by its long double handles—which warriors often carried tucked into their sashes. The qatar at left, which is ribboned with gold, includes a pair of pistols alongside the blade to administer a point-blank coup de grace to an enemy impaled on the knife. When a warrior squeezed the hand grip of the qatar opposite, the main blade snapped open, and a third blade flicked out like a murderous tongue.

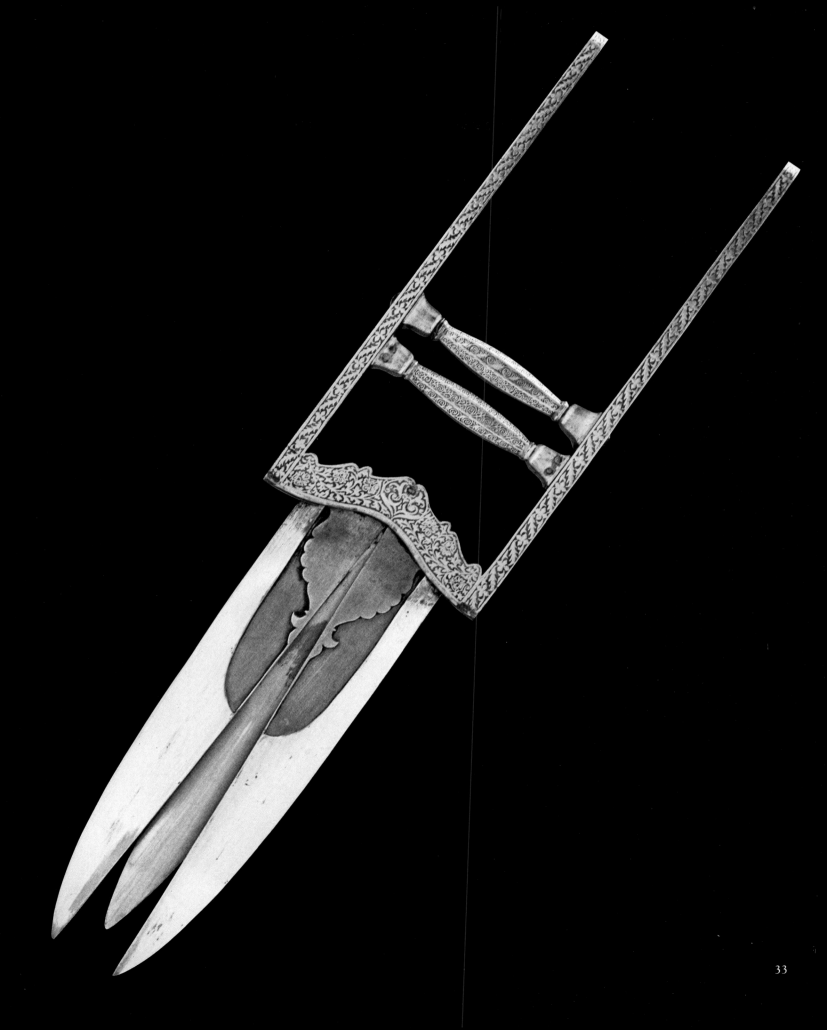

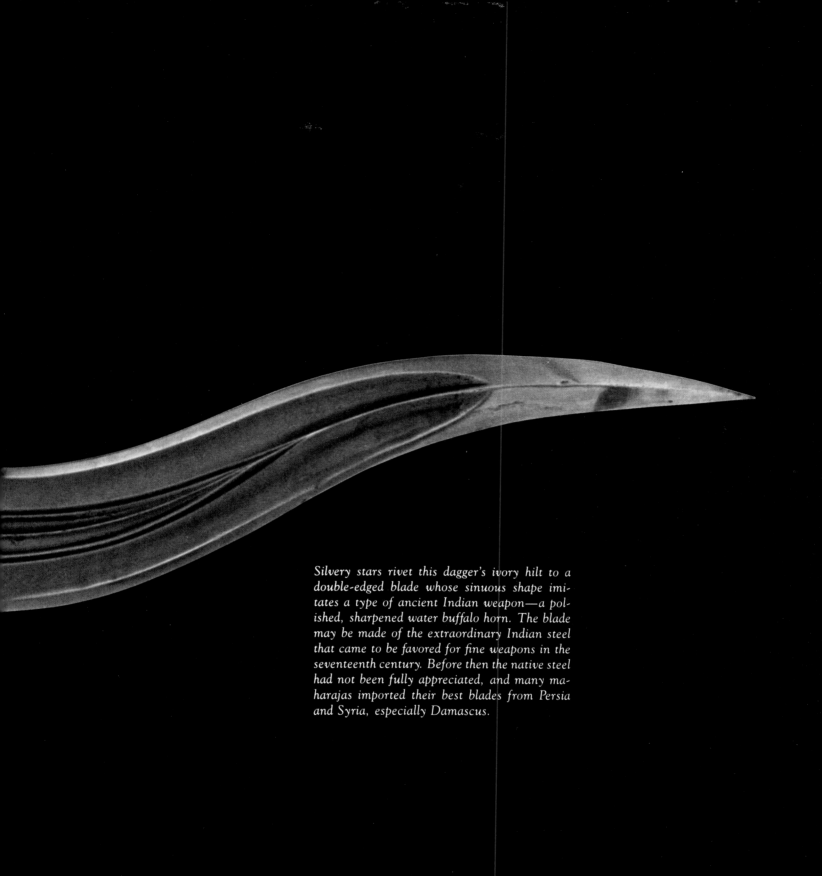

Silvery stars rivet this dagger's ivory hilt to a double-edged blade whose sinuous shape imitates a type of ancient Indian weapon—a polished, sharpened water buffalo horn. The blade may be made of the extraordinary Indian steel that came to be favored for fine weapons in the seventeenth century. Before then the native steel had not been fully appreciated, and many maharajas imported their best blades from Persia and Syria, especially Damascus.

35

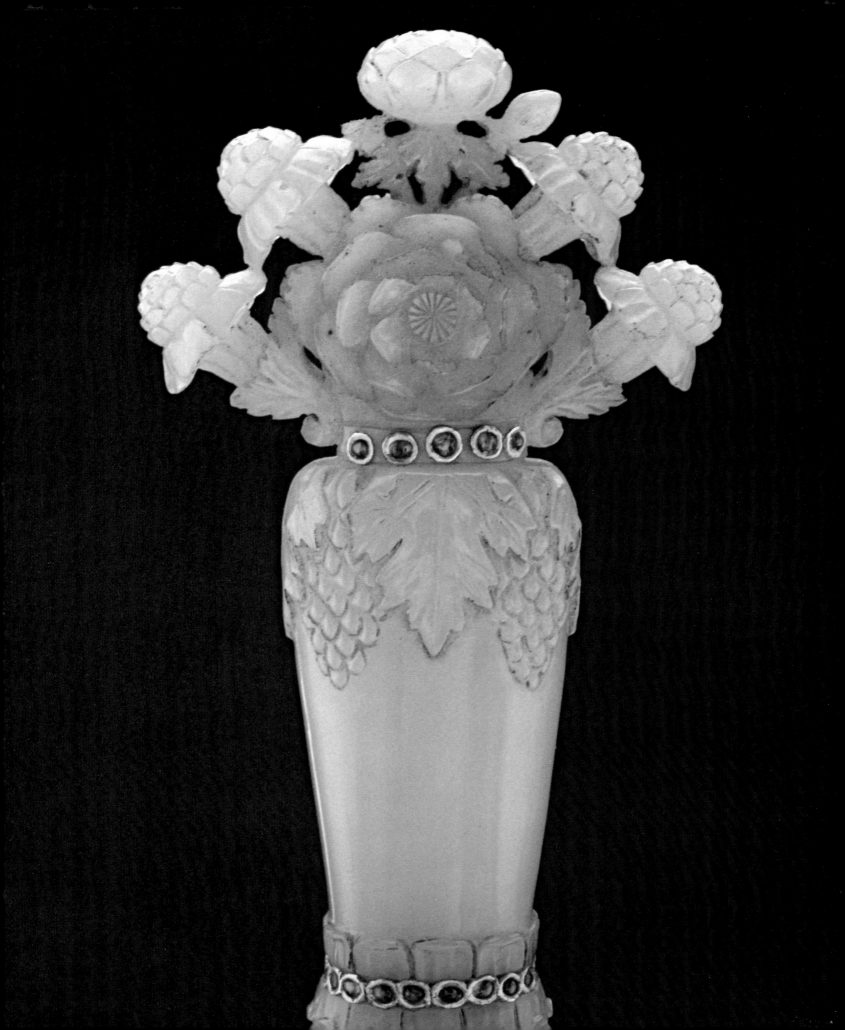

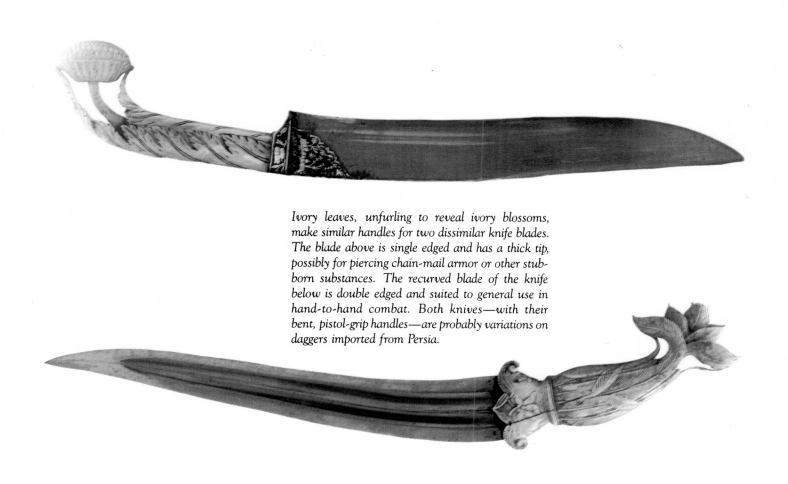

Ivory leaves, unfurling to reveal ivory blossoms, make similar handles for two dissimilar knife blades. The blade above is single edged and has a thick tip, possibly for piercing chain-mail armor or other stubborn substances. The recurved blade of the knife below is double edged and suited to general use in hand-to-hand combat. Both knives—with their bent, pistol-grip handles—are probably variations on daggers imported from Persia.

Flowers of white jade spring from a jade column—rimmed with grapes and grape leaves—that forms the elegant dagger hilt opposite. The hilt is set with rubies, a gem the Moguls loved. In the 1600s an ambassador to the Mogul emperor's court noted that the emperor wore rubies the size of walnuts. The ruler also exchanged gifts of jeweled daggers—many probably jade—with his supporters, and perhaps this hilt was such a gift to a prince of Jaipur.

OVERLEAF: A creamy lotus opens its petals on the handle of the knife immediately above. Since antiquity the lotus, or water lily, has been the flower most portrayed in Indian art. Indian artists, however, seemed to use little ivory until the Moguls arrived and encouraged local ivory carvers.

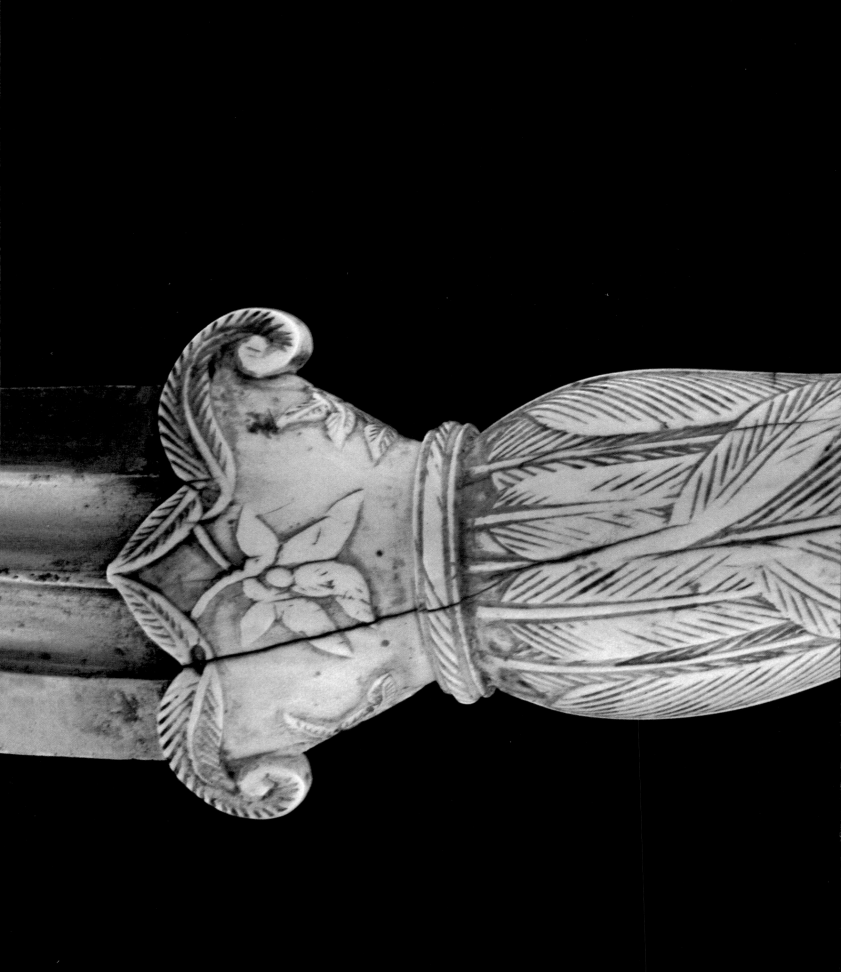

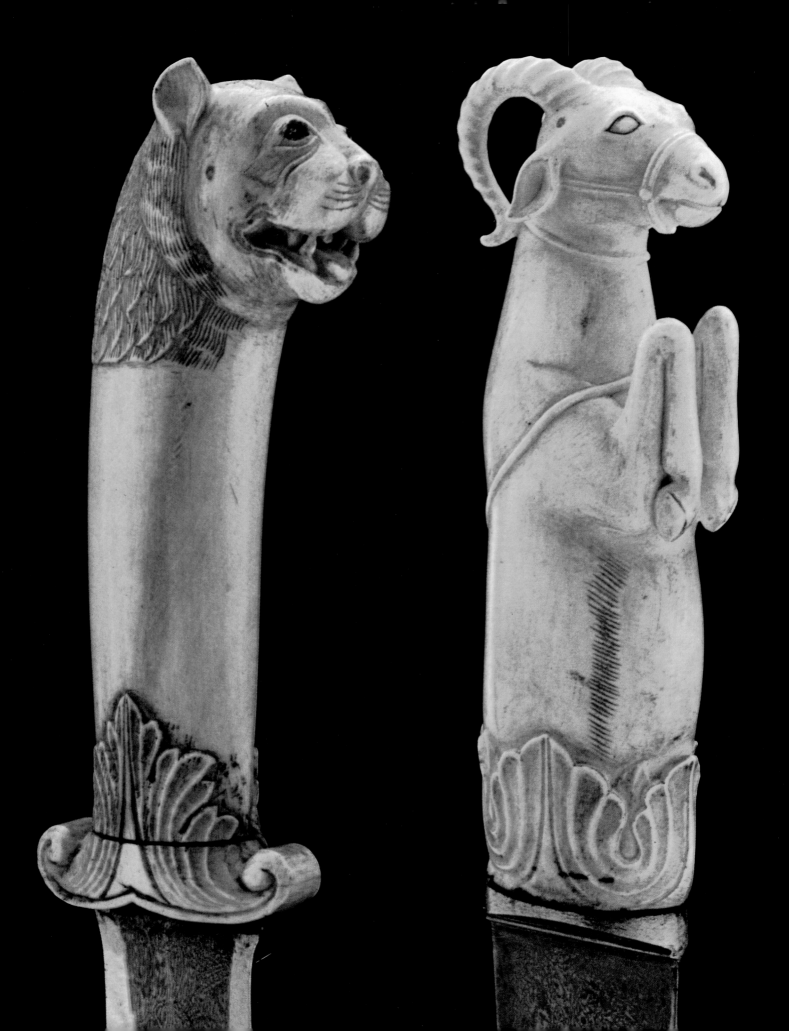

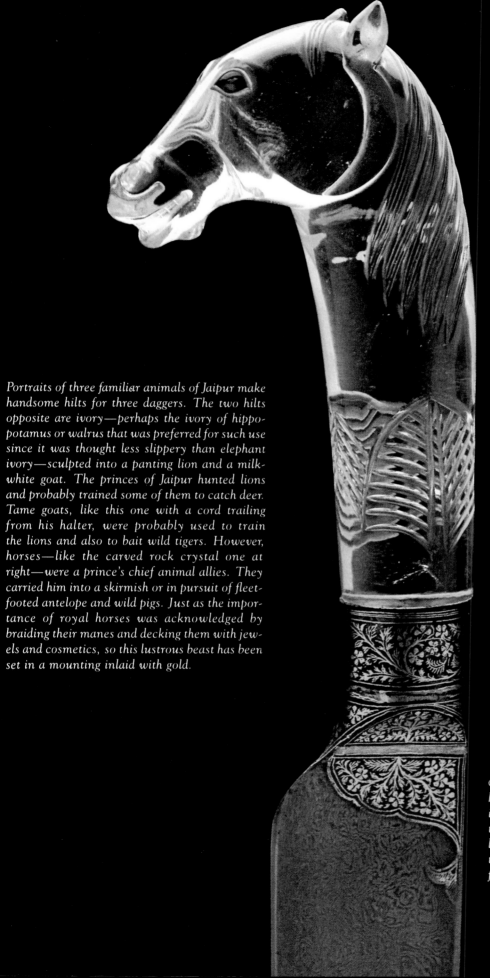

Portraits of three familiar animals of Jaipur make handsome hilts for three daggers. The two hilts opposite are ivory—perhaps the ivory of hippopotamus or walrus that was preferred for such use since it was thought less slippery than elephant ivory—sculpted into a panting lion and a milk-white goat. The princes of Jaipur hunted lions and probably trained some of them to catch deer. Tame goats, like this one with a cord trailing from his halter, were probably used to train the lions and also to bait wild tigers. However, horses—like the carved rock crystal one at right—were a prince's chief animal allies. They carried him into a skirmish or in pursuit of fleet-footed antelope and wild pigs. Just as the importance of royal horses was acknowledged by braiding their manes and decking them with jewels and cosmetics, so this lustrous beast has been set in a mounting inlaid with gold.

OVERLEAF: Sixteen inches long, this hollow horn—fitted with delicately carved and painted ivory—made a generous vessel for the powder that marksmen used in their matchlock guns. A long-lashed elephant covers the powder horn's tip, and two smaller animals perch in its curve, forming eyelets for a cord.

41

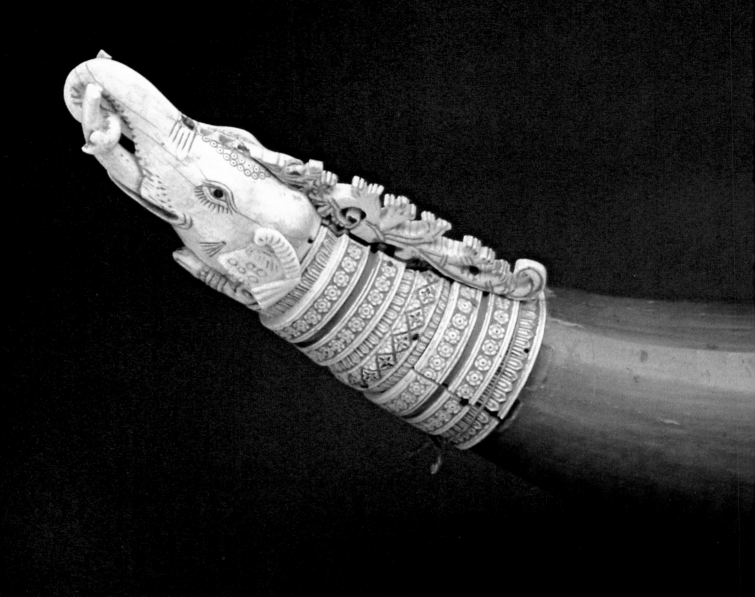

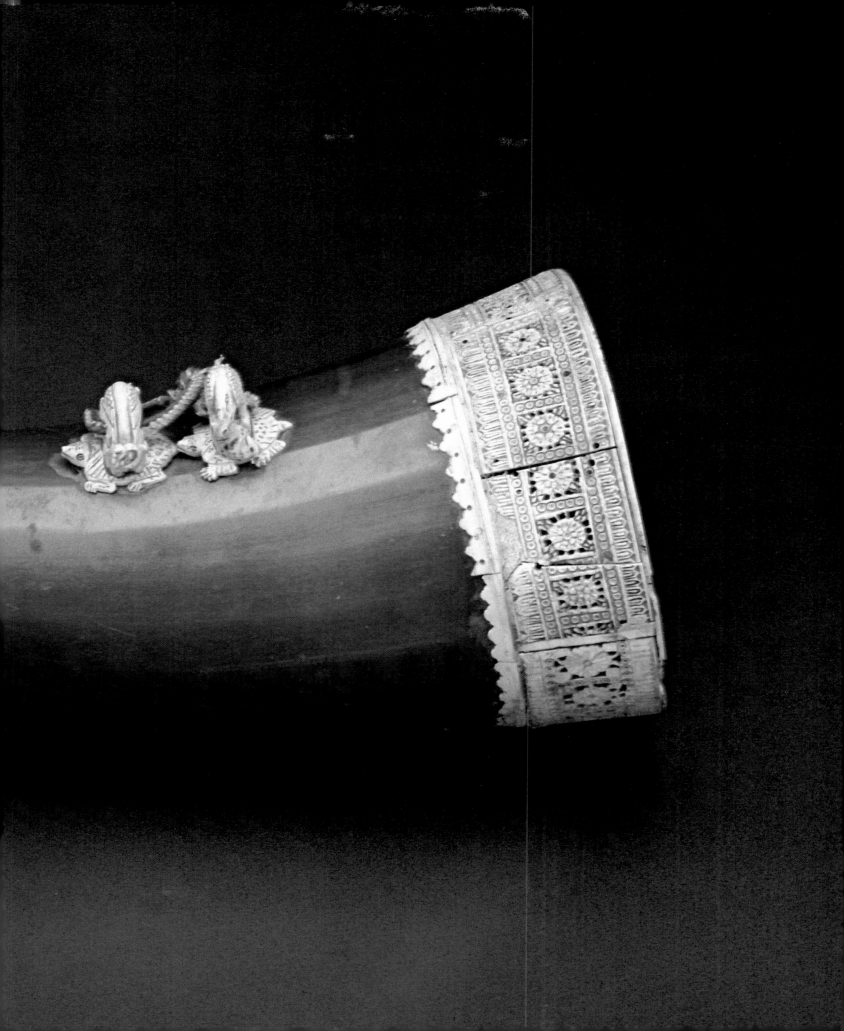

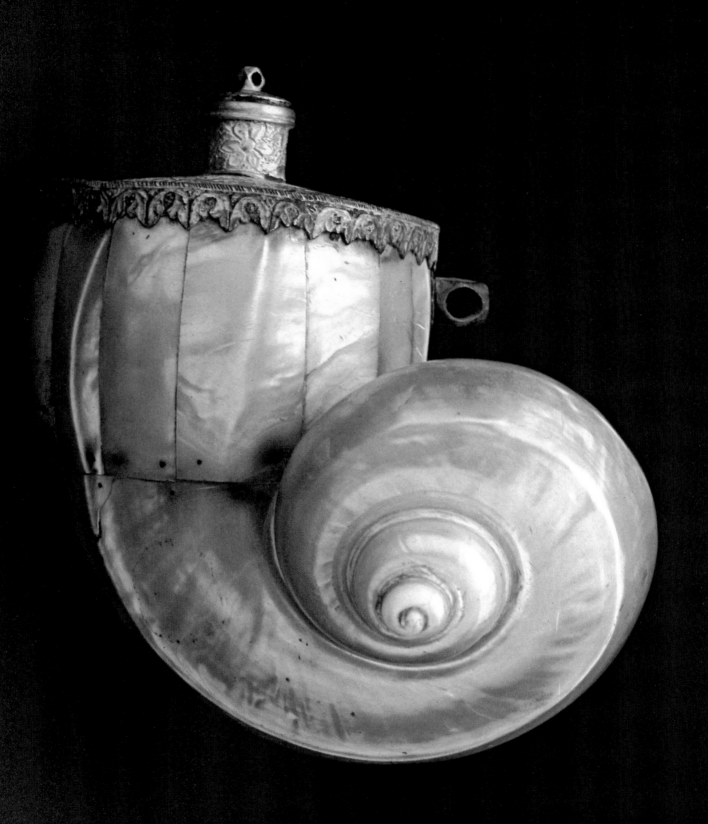

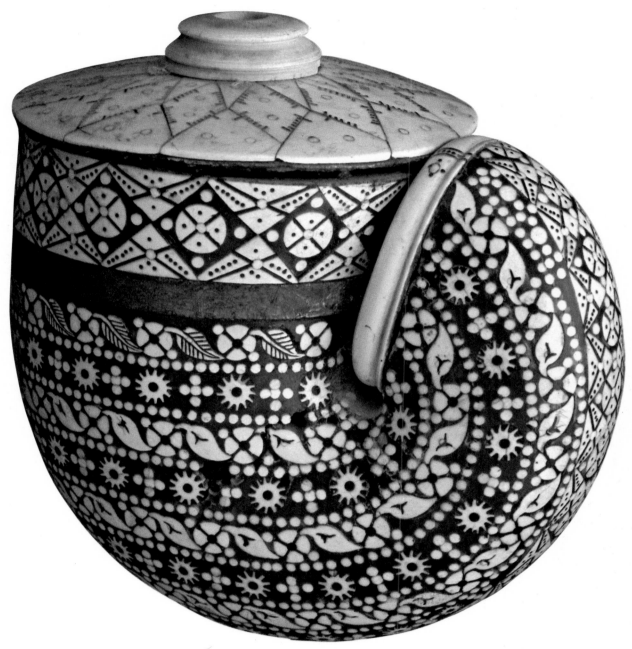

Ivory inlay, in rows of geometrics and stylized vegetation, swirls around this powder flask of horn, probably made in the nineteenth century. Its pieced ivory lid is scored with cryptic lines and circles.

A nautilus shell polished to iridescent pearliness makes the body of the gunpowder flask opposite. Its golden lid has a small spout for judicious pouring of the powder. The maharajas' favorite matchlock guns took two grades of powder—a fine one for priming and a coarser one for firing—and powder flasks were made in a great variety of forms.

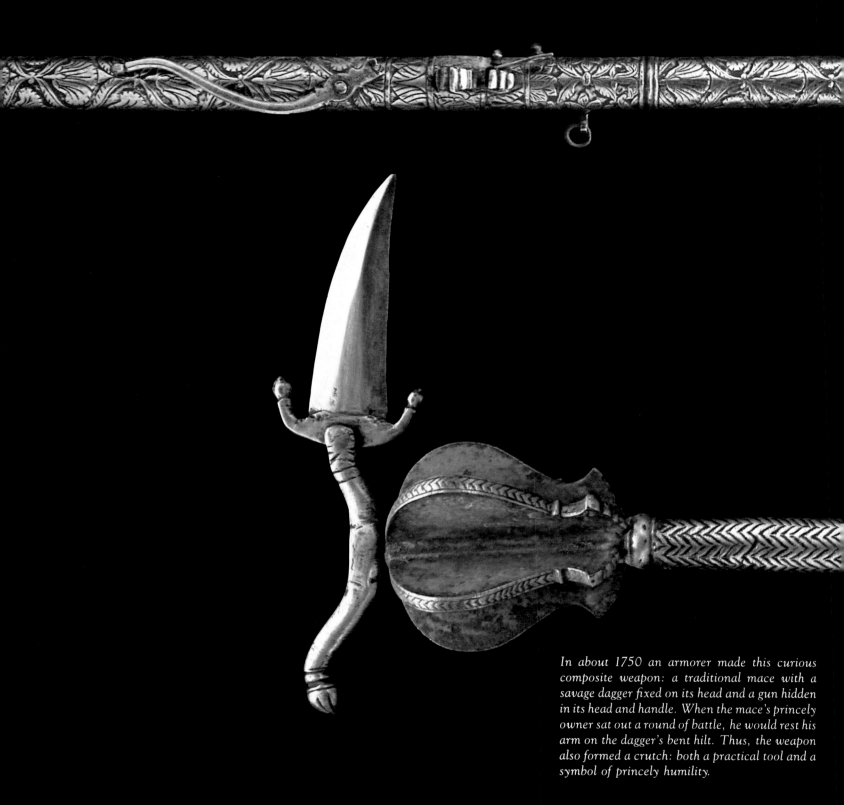

In about 1750 an armorer made this curious composite weapon: a traditional mace with a savage dagger fixed on its head and a gun hidden in its head and handle. When the mace's princely owner sat out a round of battle, he would rest his arm on the dagger's bent hilt. Thus, the weapon also formed a crutch: both a practical tool and a symbol of princely humility.

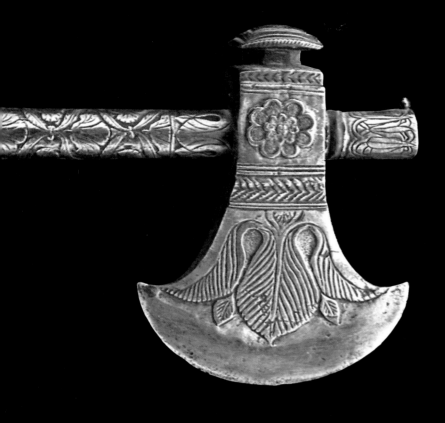

This steel battle-ax decorated with a rich, leafy pattern conceals a matchlock gun within: the ax head is the gun's stock, and the handle forms its barrel. The handle's S-shaped lever held a burning match to ignite the gunpowder—a standard matchlock firing mechanism.

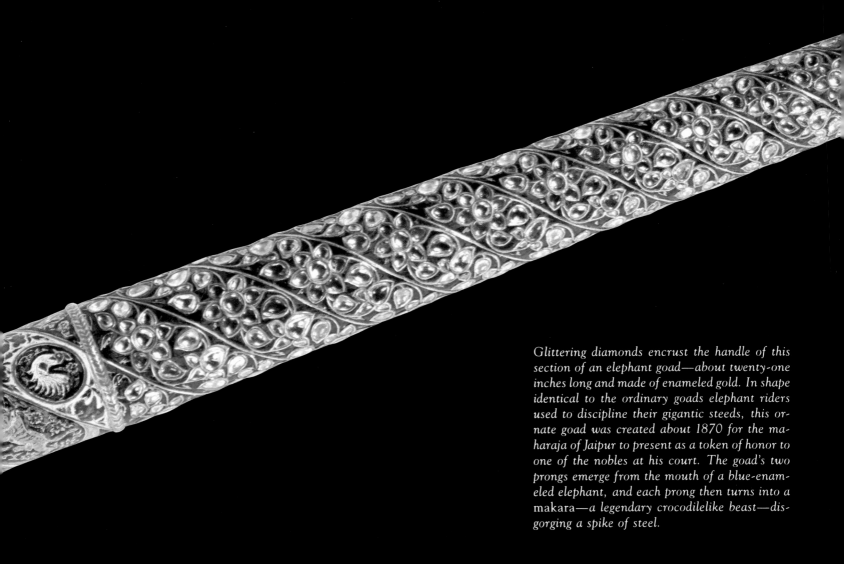

Glittering diamonds encrust the handle of this section of an elephant goad—about twenty-one inches long and made of enameled gold. In shape identical to the ordinary goads elephant riders used to discipline their gigantic steeds, this ornate goad was created about 1870 for the maharaja of Jaipur to present as a token of honor to one of the nobles at his court. The goad's two prongs emerge from the mouth of a blue-enameled elephant, and each prong then turns into a makara—a legendary crocodilelike beast—disgorging a spike of steel.

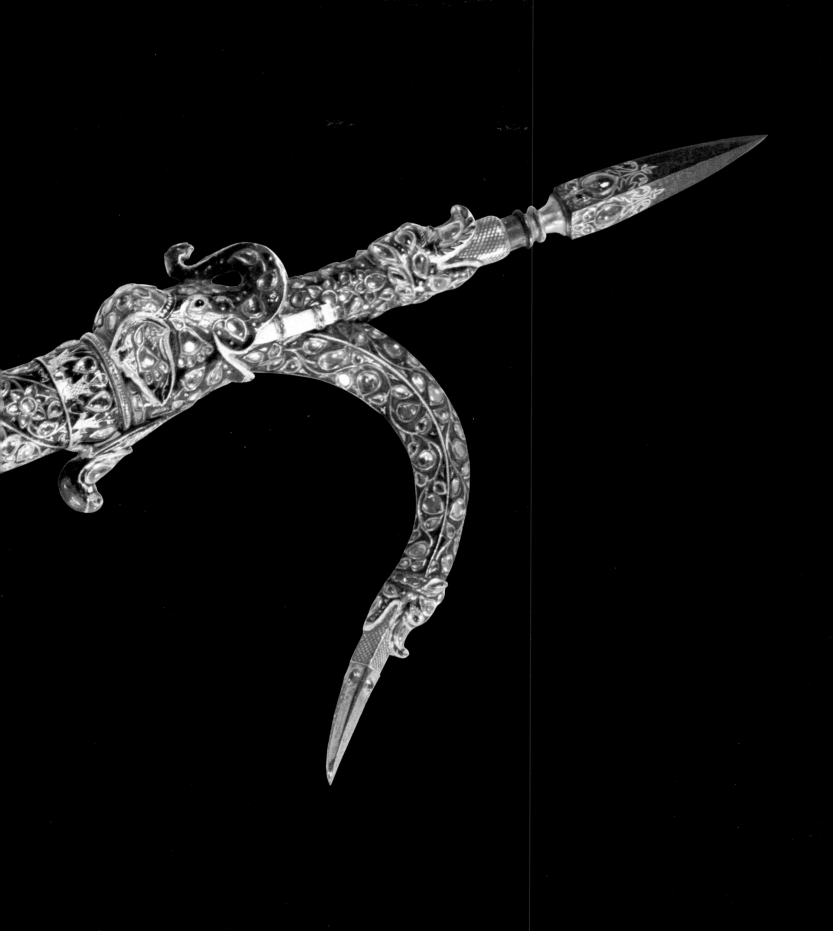

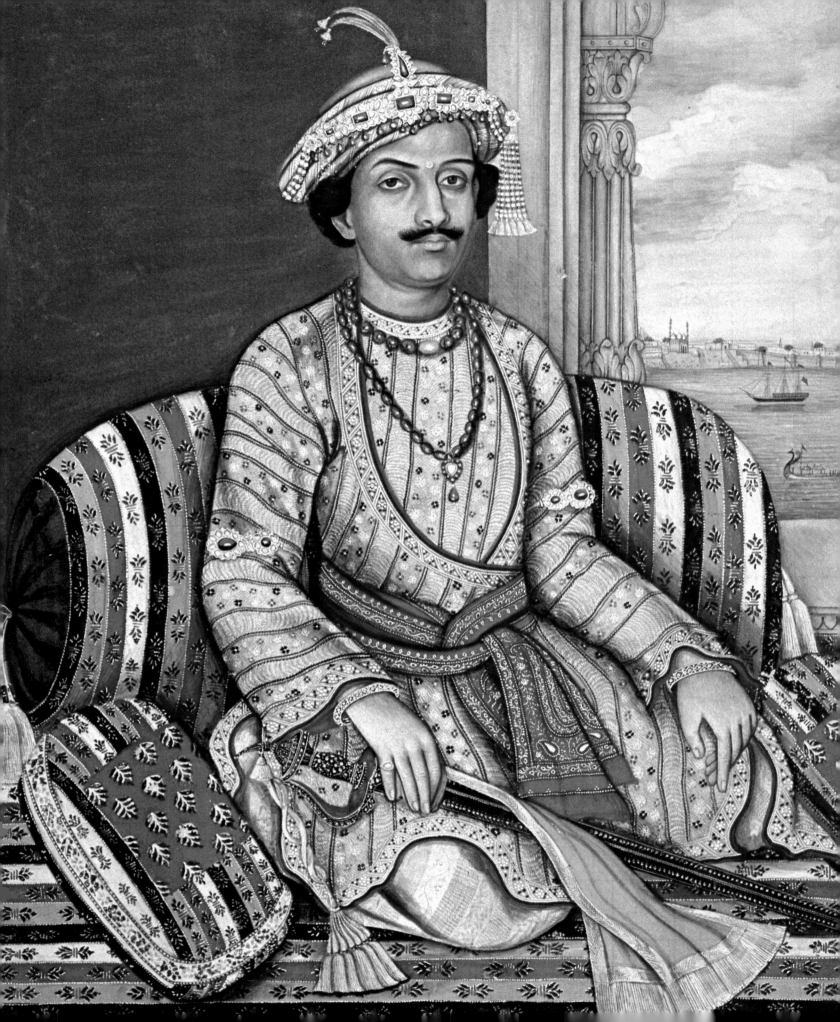

II

SACRED CITY OF THE GANGES

THE MAHARAJAS OF BENARES

When sinful people set out for [Benares]," says Hindu scripture, "all their sins, even those that have affected the very elements of their bodies, stagger and fall off." Each year for at least forty centuries, countless pilgrims have made their way to the city of Benares, the holiest of all Hindu holy places. They have pushed through the city's maze of narrow streets and alleys to worship Shiva and to bathe themselves in the opaque, green-brown waters of the Ganges—a sacred river whose waters they believe fell from heaven and possess the power to purify the soul. Hundreds of thousands more pilgrims have come every year to die, because Hindus believe that to die in the holy city ensures a future life better than the last.

Perhaps two thousand temples and shrines stand in Benares: no one has ever tried to tally them all. Ancient faith, unshakable and unadulterated, lay at the core of the city's being and has permeated every aspect of its life. Shaded by umbrellas, priests in saffron robes dispensed blessings and chanted verses for a price. Beggars crouched

Mahip Narain Singh—maharaja of Benares from 1781 to 1796—sits at a window by the sacred Ganges River, which made his domain a rich center of worship and of trade.

shoulder to shoulder, wailing for alms and displaying truncated limbs as added incentive: almsgiving, too, was thought to reap an eternal reward. Cows nosed through the crowd, garlanded with marigolds by reverent pilgrims. (Hindus considered cows to be sacred animals symbolic of the fertility of mother earth.) There were mendicants and fakirs and madmen and everywhere the sweet smell of flowers and incense and the constant clang of temple bells.

Benares was also famed throughout India as the home of Tulsi Das, the sixteenth-century poet who wrote a popular version of India's epic poem the *Ramayana.* The poem celebrates the exploits of a legendary hero named Rama (see pages 63–67). Every year the maharaja of Benares has sponsored a festival of plays that reenacts Rama's adventures.

The rulers of Benares dwelled above and apart from the teeming riverbank, in the lofty Ramnagar palace. Theirs was a comparatively recent royal family, the descendants of a wealthy priest named Mansa Ram, who was appointed collector of local revenues in 1738 by the Mogul governor of the province of Oudh. The ceaseless file of pilgrims brought them enormous wealth: every traveler was taxed. So was the busy river trade that carried the products of the city's workshops all over India and beyond. "Commerce had as many pilgrims as religion," wrote the nineteenth-century British historian Thomas Macaulay. "All along the shores of the venerable stream lay great fleets of vessels laden with rich merchandise. From the looms of Benares went forth the most delicate silks that adorned the balls of St. James and of Versailles; and in the bazaars the muslins of Bengal and the sabres of (Oude) were mingled with the jewels of Golconda and the shawls of Cashmere."

With all these riches to draw upon, Mansa Ram and his heirs prospered: they rebuilt the great temples that had been razed centuries earlier by Mogul iconoclasts and outfitted a formidable army. The rulers of Benares were so financially adept that when the British East India Company forced the governor of Oudh to cede the city to them in 1776, its officers asked the reigning prince, Chait Singh, to manage their mint. The maharaja was proud of his state's prosperity.

Some of the city's hundreds of holy buildings crowd a Benares riverbank in this brown view by an English painter. The tall minarets of a mosque loom in the background, and, in the foreground, a row of boxlike Hindu shrines have been half inundated by the waters of the rain-swollen Ganges.

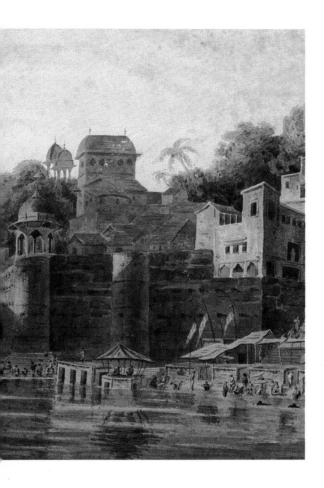

"My fields are cultivated," he wrote, "my country is a garden, and my subjects are happy. My capital is the resort of the principal merchants of India and their treasures are deposited here."

Those treasures proved his downfall. In the late 1770s the British East India Company's steady progress toward the conquest of India slowed momentarily in the face of resistance by the Marathas, Hindu warriors from western India. By 1780 the British governor-general, Warren Hastings, desperately needed money to supply the company's scattered army. He demanded that Chait Singh provide much of it. In asking this, Hastings was acting precisely as an Indian ruler would have acted: in time of war, vassals were expected to open their treasuries to their sovereign. But Hastings' levies grew ever greater, and Chait Singh proved increasingly recalcitrant; he may have been flirting in secret with the Marathas. In any case he stalled: demands for troops and tribute produced silence, then flowery excuses and partial payment.

In 1781 Hastings finally lost patience with Chait Singh and went to Benares to force the issue. When the maharaja met the Englishman and tried to place his turban in the governor-general's lap as a traditional sign of fealty, Hastings brusquely waved him away. Later he ordered Chait Singh arrested and confined to his quarters in the palace. At this insult to the prince, the Benares army rose against Hastings, who barely escaped from the city with his life. Knowing that Hastings would soon return with his army behind him, Chait Singh fled from his palace by boat, after clambering down to the river on a rope of knotted turbans.

There followed a bitter little war that ended when Chait Singh was forced to abandon his forts and flee into the countryside with only the fraction of his royal treasure his camels could carry. He wandered there for thirty years before he died, a prince without a country. In crushing the uprising, Hastings' officers exceeded their orders. Instead of salvaging for the company the riches they found hidden in the prince's various palaces, they split the treasure up among themselves as booty. Hastings was mortified, and when chastened officers sent him placatory gifts that had been stolen from

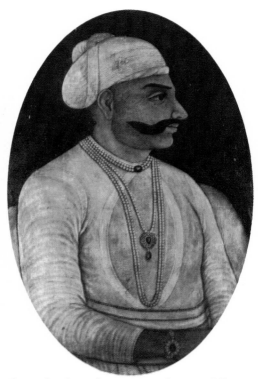

The mid-eighteenth-century maharaja of Benares, Balawant Singh (above), presided over a flourishing city and put its wealth to wise use. From 1740 to 1770 he rebuilt part of Benares, gave it a new army and a new palace, and began a yearly festival of music and dance that delighted his subjects.

Chait Singh's family—"a very elegant sword as a present to me, and a set of dressing boxes for Mrs. Hastings, all beautifully inlaid with jewels"—he coldly sent them back.

The British replaced Chait Singh on the throne with a more pliable member of the royal family, Mahip Narain Singh; then they stripped him of every vestige of his governing power. Thereafter, the title each maharaja of Benares bore was considerably grander than his holdings: he was entitled only to the income from the family lands and to the vast remnants of the fortune that Hastings' troops had failed to find. This development had advantages for Mahip Narain Singh and his successors, for with no onerous duties of statecraft to perform, they were free to pursue their twin enthusiasms: religion and the display of riches.

The piety of the maharajas of Benares, who were believed to be earthly representatives of Shiva himself, was celebrated throughout India. Almost alone among the Indian princes, they were Brahmans, members of the exalted priestly caste. The maharaja was awakened each morning by a cow that was led to the ruler's bedchamber window and gently nudged into mooing. (This custom did not travel well: once, when a prince of Benares was visiting the ruler of Rampur, he was heedlessly given a bedroom on the second floor of the palace; a pulley had to be used to haul the terrified animal up to the royal window.) Once awake the maharaja made his way down to the Ganges, where he bathed and prayed as the sun rose above the horizon; then he returned to his private quarters to perform the first of many devotions that punctuated his day.

The princes' orthodoxy extended to their treatment of their wives and daughters as well. History affords only glimpses of the women of the Benares court: like their counterparts in other princely states, they were kept in great luxury but away from the gaze of strangers. In 1835 George Eden, 2nd Lord Auckland, the governor-general of India, stopped at Benares, and while he busied himself with the prince, his unmarried sisters, Fanny and Emily, were allowed to visit the maharaja's mother, the dowager maharani.

The Edens were ushered into an apparently empty hall and led

behind a gold curtain where they came upon a tiny wizened old woman sitting on a heap of silk pillows. She had enormous curious eyes and wore tight white trousers, a net jacket, and a muslin shawl over her head. Silver necklaces clattered at her throat, and diamonds flashed from every finger as she greeted the Edens by pouring rose water over their hands from a gold pitcher. Then, fingering their gowns with fascination, she questioned them closely about their lives: "Where were their husbands? Had they children? Why did they not cover their heads?" As they talked, younger women filtered into the room—the aged maharani's daughters and daughters-in-law, their relatives and handmaidens—to listen, stare, and pour still more perfume. The Edens' clothes were drenched with rose water when the time came for them to leave, and as they made their way along the corridor, they could still hear the maharani's shrill voice calling after them, begging not to be forgotten.

The royal family's private chambers were sparsely furnished, as befitted priestly rulers, but their reception rooms were the polar opposite. The maharajas of Benares were patrons of the arts as well as priests, and their palace served as a royal showcase meant to impress visitors with the work of local artists and artisans. Their guests often rode to the palace in carriages fashioned from Benares silver, and, when the tangled streets grew too narrow for a carriage to pass, they were transferred to Benares tonjons—sedan chairs made of silver, with handles in the form of fantastic beasts. Guests passed into the royal presence through gates guarded by carved elephants of white Benares marble, inlaid with semiprecious stones; in the reception rooms they sat on state furniture—every inch of whose wooden surface was inlaid with ivory—cushioned by pillows that were upholstered with Benares silk brocade; and they ate and drank from gleaming vessels of Benares brass.

Perhaps the best known prince of Benares—noted for his generosity and his imaginative entertainments—was Ishwari Prasad Narain Singh, the son of the elderly maharani who had interrogated the Eden sisters. He became maharaja at fifteen, in 1836, and ruled—or rather presided over—Benares for more than half a cen-

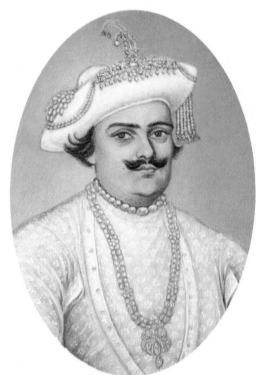

Despite his ropes of pearls and his rakish moustache, Maharaja Udit Narain Singh, above, possessed a contemplative nature. During his reign from 1796 to 1835, the maharaja devoted himself to religion and literature: he commissioned the sumptuous book of illustrations on pages 63–77.

TEXT CONTINUED ON PAGE 60

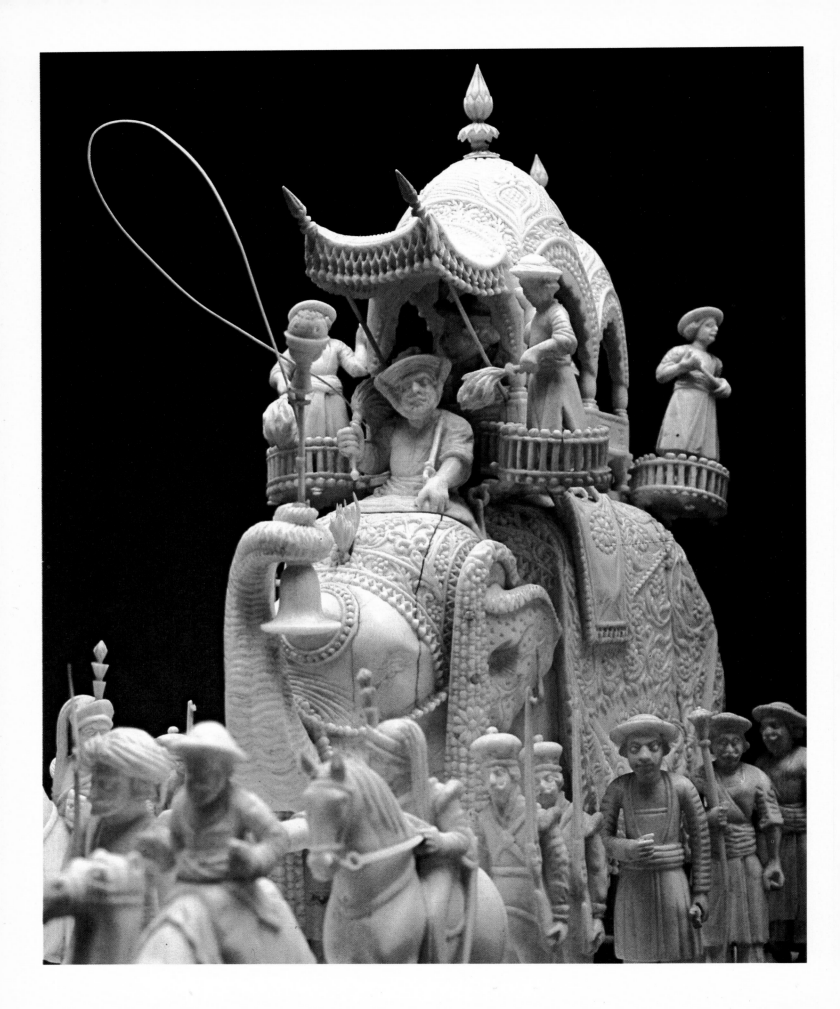

A STYLISH BEAST OF BURDEN

Elephants, among the most intelligent and powerful of beasts, have served as royal transports for India's princes since ancient times. As an especially imposing display of wealth, the maharajas equipped their elephants with rich garments and howdahs, or seating compartments—such as the ones opposite and on pages 58–59 from the royal house of Benares.

A princely fortune was necessary not only to supply costly regalia, but simply to acquire and support the animals. Elephants seldom bred in captivity, so a prince had to employ hunters to capture them and handlers to train and tame them. Only when they were about nineteen years old were the elephants mature and ready to serve their master—while eating as much as a thousand pounds of food apiece a day. Each animal in the palace stable represented a great investment—but one well repaid. In war, elephants with twelve-foot swords fixed to their tusks scattered enemy troops and smashed enemy gates with ease. In peacetime the prince and his friends safely rode out on elephant-back to hunt tigers and amused themselves watching elephants wrestle. Year in and year out, the prince relied on his elephants to carry him—ensconced in an ornate howdah high above the crowds—at countless state and religious processions. On these occasions the prince of beasts—his fringed robe rippling and his jewelry glinting in the sun—doubtless inspired such awe that every expense of his care seemed well worthwhile.

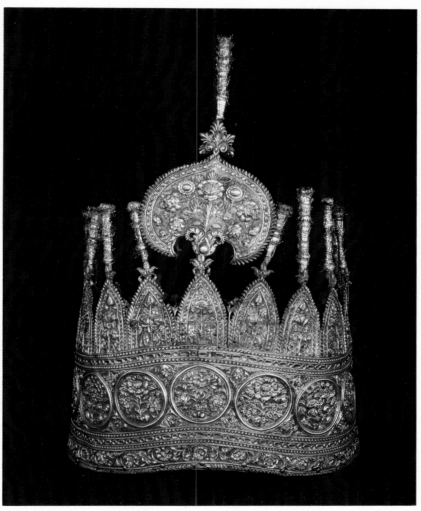

Made to fit a prince's elephant, this mammoth crown is a four-foot circle of silver, embossed with floral designs and trimmed with stiff gold tassels. The animal's head was probably further embellished by a pair of matching silver earrings and intricate designs painted on his wrinkled skin by his own mahout, or handler.

Clad in rich robes and jewelry, the royal elephant opposite marches in a state procession. The beast's trunk clasps a hookah with a long stem that leads into the canopied howdah on his back, where a maharaja sits and smokes as a servant fans him. This tableau is a detail from an ivory carving ordered by the maharaja of Benares in 1884.

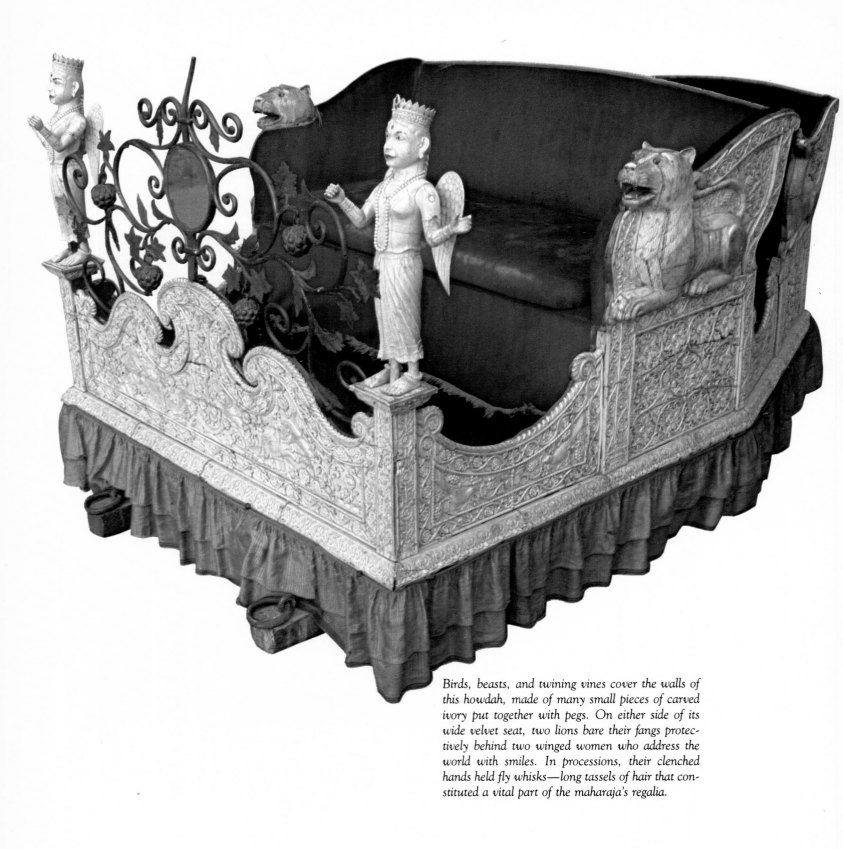

Birds, beasts, and twining vines cover the walls of this howdah, made of many small pieces of carved ivory put together with pegs. On either side of its wide velvet seat, two lions bare their fangs protectively behind two winged women who address the world with smiles. In processions, their clenched hands held fly whisks—long tassels of hair that constituted a vital part of the maharaja's regalia.

Perhaps a dozen servants were needed to lift this heavy wooden howdah onto an elephant for the few solemn ceremonies—such as a maharaja's investiture—in which it appeared. A sphinx, the mythical lion-woman of Egypt, forms each of the howdah's sides, and carved on its front is a wheel: emblem of sovereignty and the sun. Sheathed in gilded copper, the wooden structure has a silk skirt.

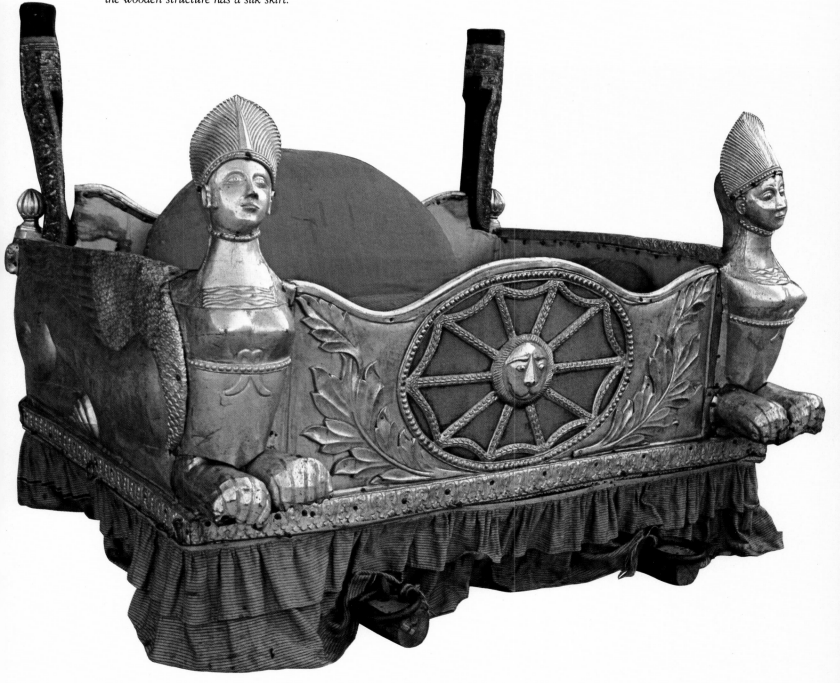

TEXT CONTINUED FROM PAGE 55

tury. He was a gentle and beneficent man, an accomplished poet and painter, learned in Persian and Arabic, as well as Sanskrit. He revered both the Hindu gods and the British queen, and when he decided to found an educational institution for the study of ancient Hindu texts, he built for it an incongruous complex of Gothic buildings named Queen's College, in honor of Victoria.

The prince had a special affection for music and dance. Each spring he officiated at a great music festival on the river. Hundreds of galleys took part, and for weeks the wealthiest Benares families competed to see whose vessel would be the most richly decorated for this event. The pleasure boats were hung with banners. Guests reclined on silk cushions beneath silk pavilions, listening to musicians that played on deck. As the galleys swung out onto the river, scores of smaller craft skimmed among them selling flowers, sweets, and toys for the children. Ishwari Prasad's boat was the most elaborate of all, its crimson pavilion resting on silver pillars, its brilliantly painted prow carved in the shape of a peacock. When his twenty oarsmen rowed the royal galley into view, a thousand musicians seated along the riverbank blared their greeting. The prince nodded his blessing in return, and his boat then glided grandly along the entire four-mile riverfront, with Ishwari Prasad appearing in plain sight to receive the adulation of his people. Afterward the maharaja's galley led the fleet back to the palace, where the finest musicians in India played until dawn while dancing girls whirled to the fevered tapping of drums.

Ishwari Prasad's generosity spread beyond Benares as well. A British acquaintance once casually mentioned that his boyhood village of Stoke Row in Oxfordshire shared some of the hardships endured by Indians: water had always been scarce there, he said, and in the dry summer months cooking water was sometimes passed from house to house, and washing the children "indefinitely postponed." The maharaja was touched and decreed that a well be dug at Stoke Row at his expense, as a symbol of his friendship for the English people and their royal family. The well, sheltered beneath a gleaming oriental dome and surrounded by a cherry orchard, provided the

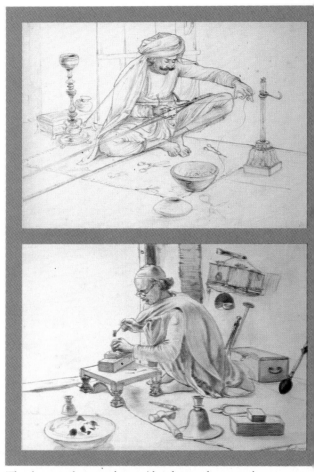

The four craftsmen above, like those whose workshops lined the lanes of Benares, bend to their various tasks—counterclockwise from top left—of making gold fringe, inlaying metal, embroidering precious cloth with gold, and weaving silk.

grateful village with plentiful water. Nine years later Stoke Row was the scene of still another gesture of Benares amity—a day of thanksgiving for the recovery of the Prince of Wales from typhoid fever. Once again the maharaja footed the bill. On the appointed morning, he had royal gifts delivered at the door of every cottage in the parish: a half pound of tea, a pound of sugar, two loaves of bread, and a pair of blankets. There was lunch for everyone, too—roast beef and two pints of beer for each cottager—and the guests cheerfully toasted their distant benefactor. Fireworks ended the evening, with the maharaja's name—"Ishree"—brilliantly (if inaccurately) picked out in flame against the soft English night.

The cottagers of Stoke Row were suitably dazzled; they would have been stunned by the sort of spectacle the maharaja could orchestrate on his home ground. In 1875 Edward, the Prince of Wales, whose recovery Ishwari Prasad had celebrated with the festivities in Stoke Row, made a royal progress through Britain's Indian dominions and scheduled a stop at Benares. The maharaja was politically impotent, of course, but his riches were legendary, his symbolic importance to Hindus in India could not be ignored, and his kind gestures toward the English and their future king should not go unrewarded.

Prince Edward and his party glided to the Ramnagar palace at nightfall in a flotilla of state galleys. The prince himself rode in splendor in the maharaja's own barge. As he disembarked and Ishwari Prasad came forward to greet him, every terrace and dome, archway and battlement of the palace was brightly outlined with fire from tiny earthen oil lamps. With flaring silver torches, ranks of servants in gold and crimson livery lit the great stone staircase that led up from the river. The maharaja and his guest were carried above the crowd in gold and silver palanquins as drums thundered and bells rang in their honor. Then, led by platoons of spearmen and mace-bearers, and followed by musicians and dancing girls, they were borne through the palace gates and across a courtyard that was filled with glittering cavalry and state elephants, who were trumpeting and swaying in place.

Inside the palace Edward and Ishwari Prasad sat side by side on

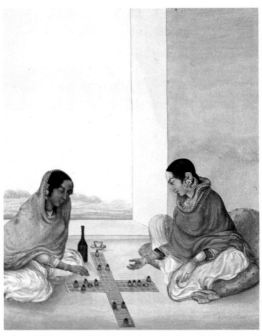

Two richly garbed women pass the time with refreshments and a round of pachisi—an Indian board game. Hindu custom prevented high-ranking women, such as those of the Benares royalty, from leaving home to pay social visits or to appear unchaperoned in public. However, custom also required their men to provide the women with luxurious food, jewels, and dress.

silver thrones as servants wound past them, displaying the first of scores of royal gifts: bolts of Benares kincob—splendid webs of silk and silver and gold brocade—were swiftly unrolled at the princes' feet and as quickly covered up by more. Then came Benares muslins of a variety so soft that it was said to have been chosen, more than two thousand years before, to wrap the corpse of Gautama Buddha, the founder of Buddhism. Next the servants brought Kashmiri shawls the size of sheets, but woven so fine that they could easily be drawn through a ring. Watching all this, wrote the English newspaper correspondent William Russell, "the Maharaja sat, like a benevolent old magician in spectacles and white moustache, smiling...with his hands joined in a deprecating way, as though he would say 'pardon that unworthy offering.'"

When the brilliant heap of presents threatened to engulf his guest, Ishwari Prasad conducted Edward to an adjoining chamber filled with tables on which rank upon rank of Benares wares sparkled and flashed. The maharaja was particularly proud of a special edition of Queen Victoria's chatty memoir of her visits to Scotland, *My Life in the Highlands,* which palace scholars had translated into Sanskrit. His artists had illustrated and gilded the pages and bound them between highly polished slabs of inlaid marble and solid gold. A large diamond set off each corner.

The royal party proceeded through still another hall where two sumptuous banquets were laid out, one English, the other Indian. These were meant for viewing: caste laws prevented the maharaja from actually dining with his guests, and the British had tactfully planned a late supper for themselves back at their camp.

Finally Ishwari Prasad led his guests out onto a marble balcony overlooking the river. To the north as far as Edward could see, the city's riverfront now seemed to be ablaze: the shoreline and temples and mosques and private homes of Benares were all lit with hundreds of thousands of oil lamps. As many more had been set afloat on the slow-moving Ganges itself; its half-mile width was so alive with flame, Russell wrote, that "it seemed as though a starry sky were passing between banks of gold."

INDIA'S
EPIC HERO

Bound in kincob—a special brocade of silk, gold, and silver threads—this elegant volume is part of an 1813 edition of the famed Indian epic the Ramayana.

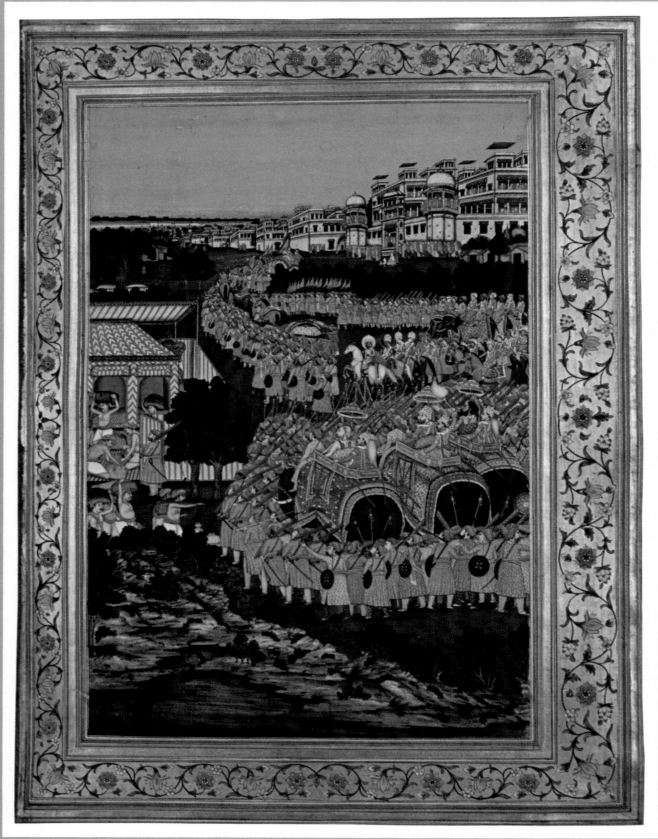

Prince Rama, his head framed by a halo, rides a handsome white horse (above, center) in a wedding procession from the home of his new bride, the princess Sita, to his father's sprawling palace on the Ganges. Spear-carrying soldiers march in colorful costumes, while privileged nobles and holy men ride beautifully caparisoned elephants. Servants probably offer refreshments to elegantly dressed guests in the tents at left. Red, the color of pomp, dominates this painting of the lavish royal celebration.

One of India's greatest literary treasures is the *Ramayana*—the "way of Rama"—the story of Prince Rama and his faithful wife, Sita. Perhaps as early as the third century B.C., a sage named Valmiki wrote the *Ramayana* in Sanskrit—the scholarly language of India—and generations of Indians, hearing the epic poem read aloud as folk history, took its lessons of honor and fidelity to heart. The *Ramayana* gained an even greater hold on the popular imagination in the sixteenth century when the Hindu poet Tulsi Das rewrote the story in the everyday Hindi language. Soon virtually everyone knew the story: students recited favorite verses, children thrilled to Rama's adventures, actors performed the poem's most dramatic scenes. And artists found great inspiration in the *Ramayana's* romantic and heroic episodes.

Wealthy Hindus commissioned their own editions of Tulsi Das's *Ramayana* such as the one here, which belonged to Maharaja Udit Narain Singh. The miniature, flower-bordered paintings from the volumes, made by a number of artists in the nineteenth century, illustrate the beloved tale in exquisite detail.

The epic features Rama (an incarnation of the god Vishnu) as the favored of the four sons of Dasaratha, the benevolent king of Kosala, in northern India. Rama wins the hand of the lovely Sita in an archery contest and, after a splendid marriage ceremony, settles into a pampered courtly life as the next in line to his father's throne. However, Dasaratha's jealous wife—who is not Rama's mother—demands that the king fulfill his rash promise to grant her any wish and orders the king to banish Rama so that her own son, Bharata, may take the crown. Rama insists that his father be true to his word and retreats to a forest with Sita, where they live as ascetic hermits. When Dasaratha dies, Bharata offers the throne to Rama, but he chooses to remain in exile. Bharata then agrees to rule in his stepbrother's absence.

Rama and Sita live peacefully for fourteen years, until demons start to terrorize the forest. Rama fights back, slaying the demons one by one until their chief, the multi-headed Ravana, avenges his fallen comrades by kidnapping Sita. Rama, with a hastily assembled army of men, monkeys, and bears, storms Ravana's castle and saves the abducted princess.

Though free of her captor, all is not well for Sita, for, by dwelling even unwillingly under the roof of another man, she has violated sacred laws. Sorrowful and penitent, she throws herself upon a funeral pyre; yet the flames do her no harm. Knowing Sita to be faithful, Agni, the fire god, spares her life. Rama, overjoyed, returns to his kingdom with his virtuous princess to claim the throne—which Bharata gladly relinquishes to his heroic demon-slaying stepbrother.

In the *Ramayana,* the text here brilliantly illustrated with page-size paintings, Hindus saw the triumph of good over evil—and found an exemplary lesson in the fulfillment of dharma, or personal duty. For centuries Indians have worshiped Rama and the other benevolent characters of the epic as gods.

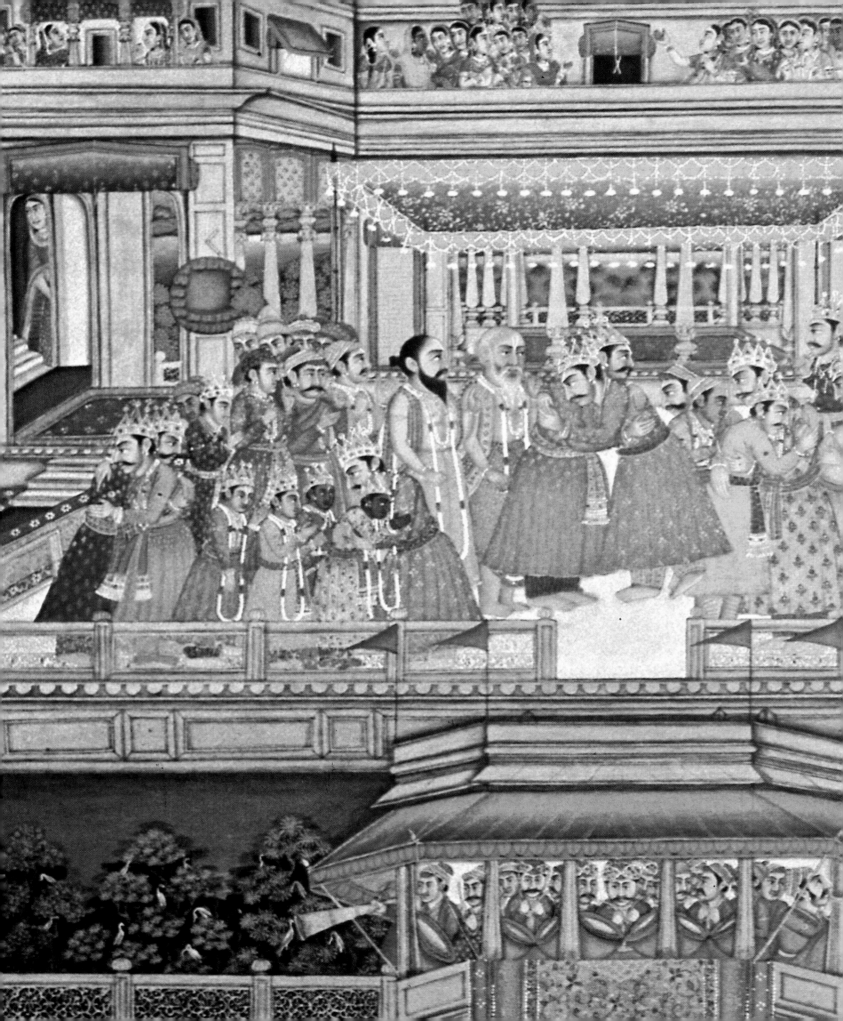

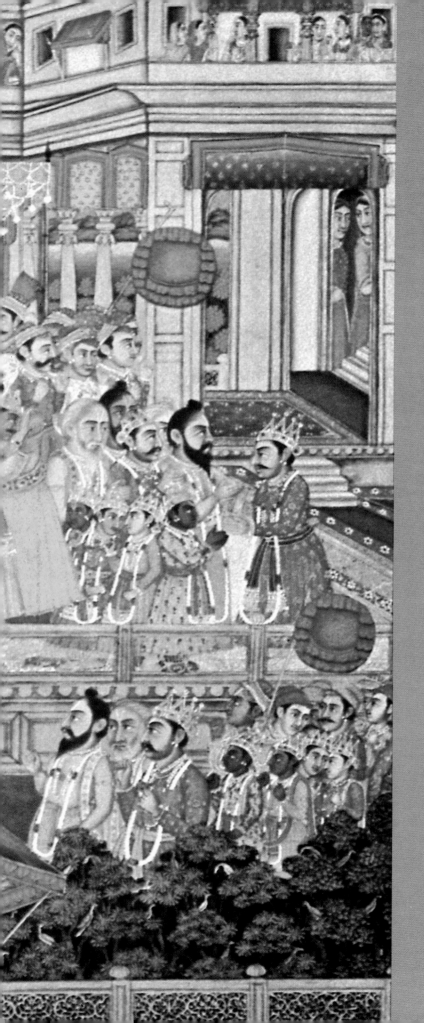

Rama, fulfilling his dharma, prepares for exile in the double-scene miniature above, from the Ramayana. In the lower panel Rama bids farewell to his father, King Dasaratha, at the palace door, as members of the royal family, close friends, and courtiers look on. At left—in a detail from the upper half above—Rama embraces a sage who has counseled him on the complexities of such matters as dharma. Women view the poignant leave-taking from the palace's upper windows, and mythological creatures fill the sky.

King Dasaratha receives his minister Sumanthra at his concubine's quarters, top right, as his chariot and horses wait for him outside. When the minister tells the king about Rama's arduous journey through the wilderness to reach his forest hermitage, the king collapses with grief and never recovers: "He died even as Sumanthra was speaking," says the Ramayana. The unknown artist also included vignettes of a white-haired holy man teaching in his house, center left, and an accountant working, top left.

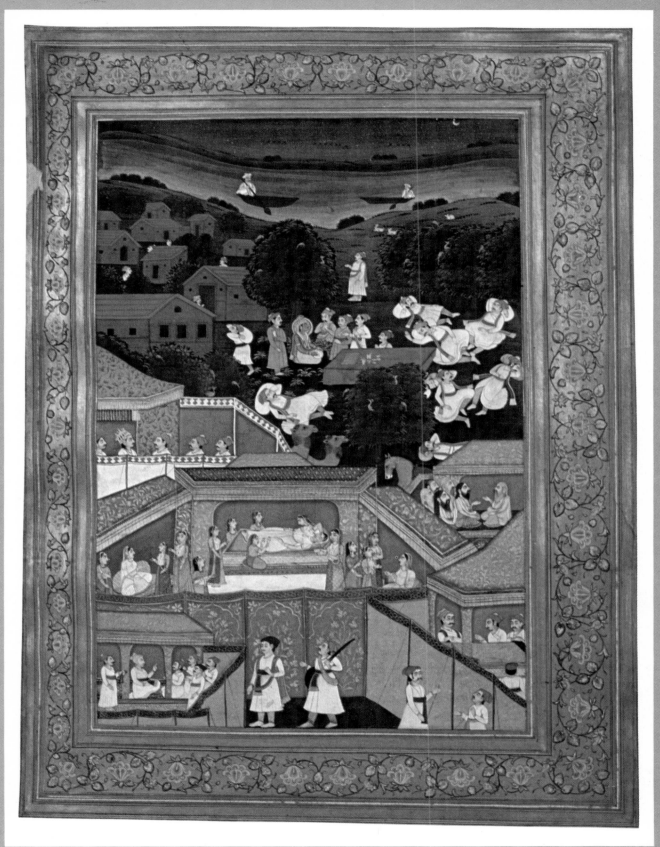

Behind an elaborate encampment near Rama's hide-away, Bharata begs his brother Rama, at top, to claim their dead father's throne. Rama, kneeling and tinged in blue to symbolize his link with Vishnu, refuses Bharata, reminding him that they must up-hold their late father's word. In this nighttime scene, Bharata agrees to occupy the throne as regent and takes Rama's sandals as a symbol of the ascetic prince's ultimate authority. "I shall rule," Bharata tells Rama, "on behalf of that symbol."

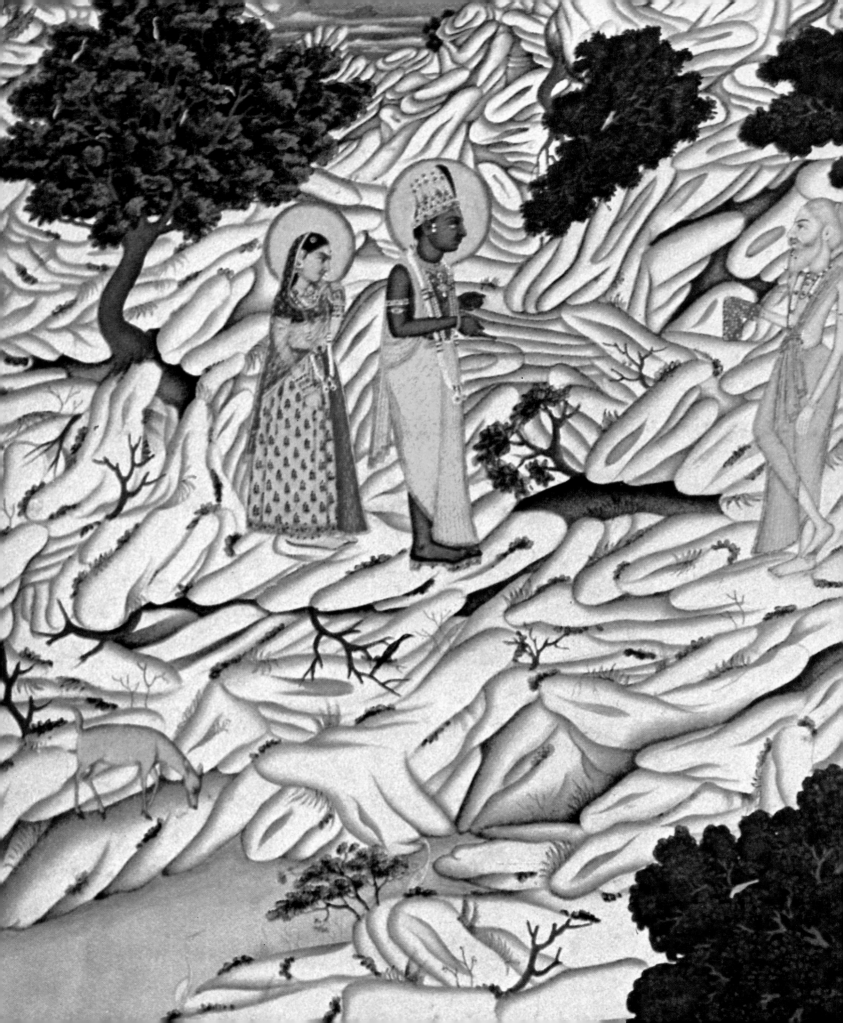

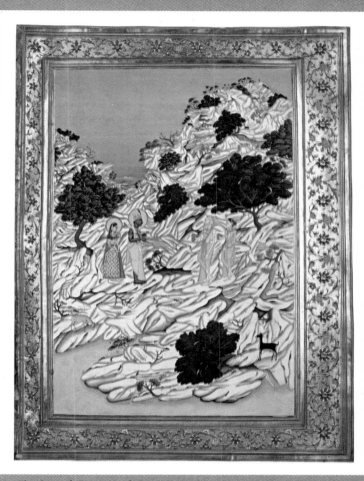

The haloed Rama and Sita, garbed in fine cloth, come upon two ascetics while in exile, above and in detail at left. The prince and princess met several sages and hermits in the wilderness, all of whom welcomed the bejeweled visitors and shared their knowledge with them. The rocky landscape in this scene, relieved by a few scrubby trees, suggests the foothills of the Himalayan mountains. The rivulets running through the rocks are sacred waters flowing into the Ganges.

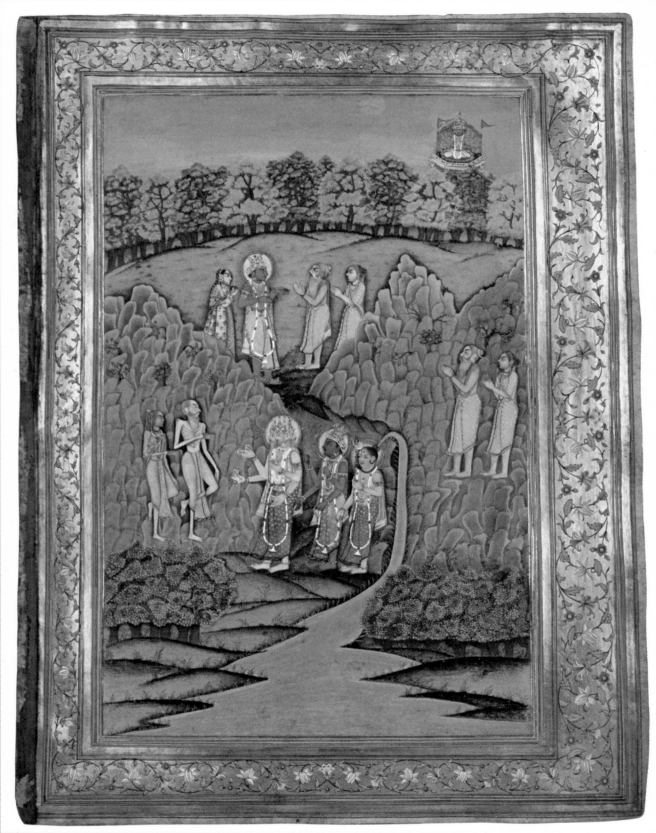

Rama finds the right path through the wilderness to enlightenment in this scene from the prince's epic mission. An ascetic couple appears three times to direct Rama and Sita. The ascetics grow older and more emaciated in each appearance—in the background, then at right, and finally at left. Waiting for Rama at the end of the path in the foreground are three Hindu deities: Brahma (at left); Vishnu, who is blue skinned like his incarnation Rama; and Shiva, from whose head springs the Ganges.

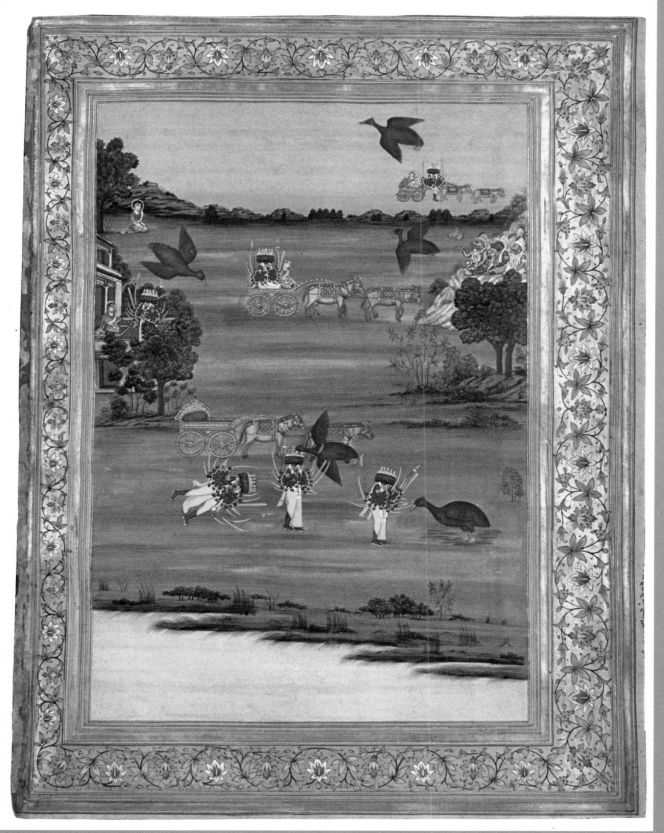

The demon Ravana, garbed in yellow, abducts Sita in several episodes above. He lures her out of the hut at left, but the princess has an ally in Jatayu, the benevolent Vulture King, who temporarily rescues her from the demon's clutches, warning his well-armed foe: "Fear to do evil in my sight, Ravana, for I know the right way of life." On the riverbank in the foreground, Ravana appears in triplicate, representing sequences in his fight with Jatayu. The demon finally whisks Sita off in his air-borne chariot.

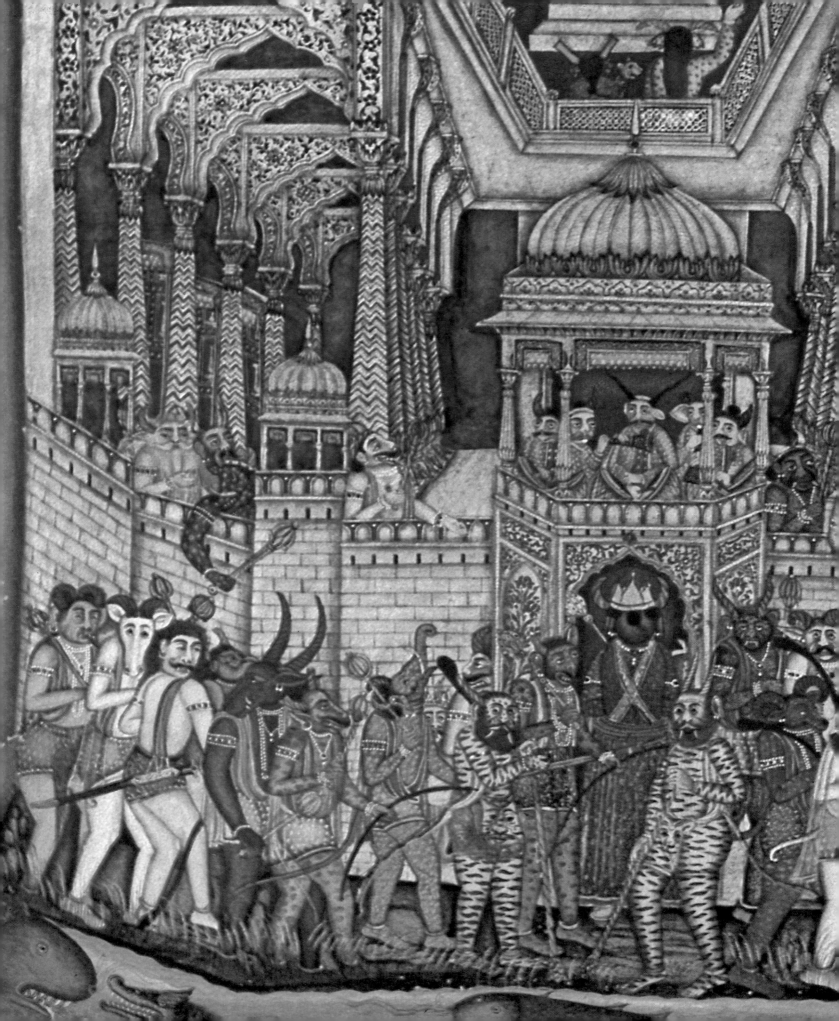

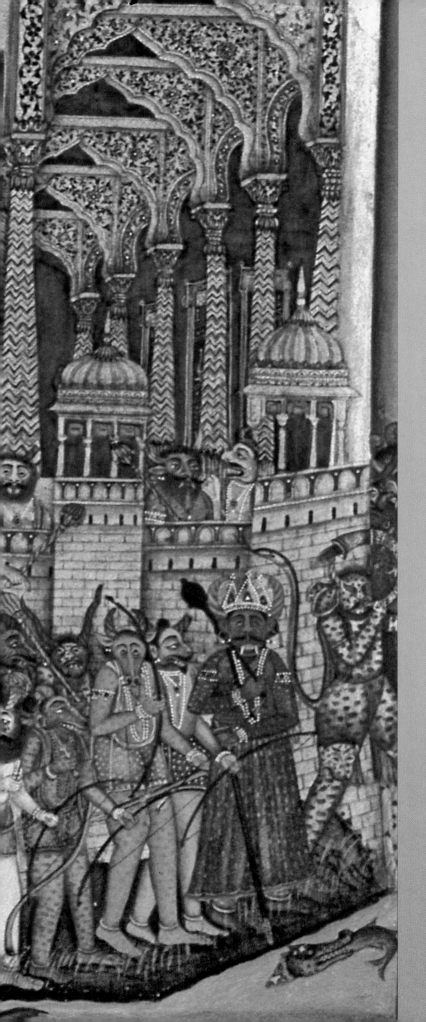

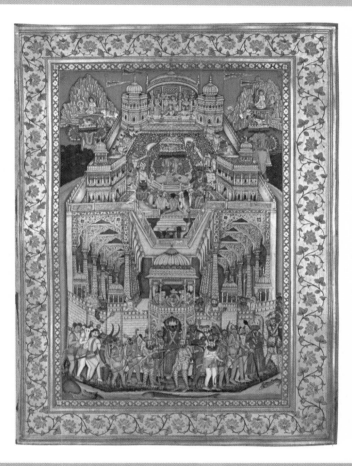

Enthroned at the center of his opulent palace, above, Ravana displays his heads and arms. The demon surrounded himself with beautiful singers and dancers and forced former kings and even gods to do menial chores for him. In the detail at left, lesser monsters form a mob outside the palace entrance. In the Ramayana a man trying to track down Ravana follows "the pleasures of the senses." The directions were apt, for Ravana's palace was heavy with the scents of rich food, wine, and incense and so lavishly appointed that jewels encrusted the ceilings and filled garden pathways.

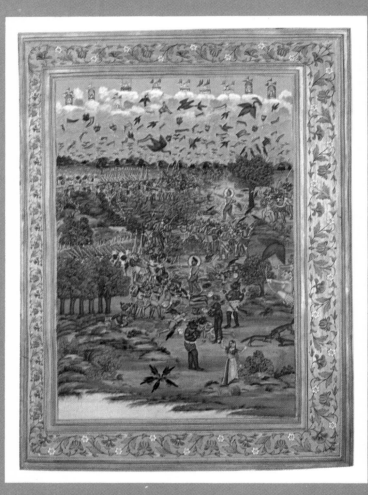

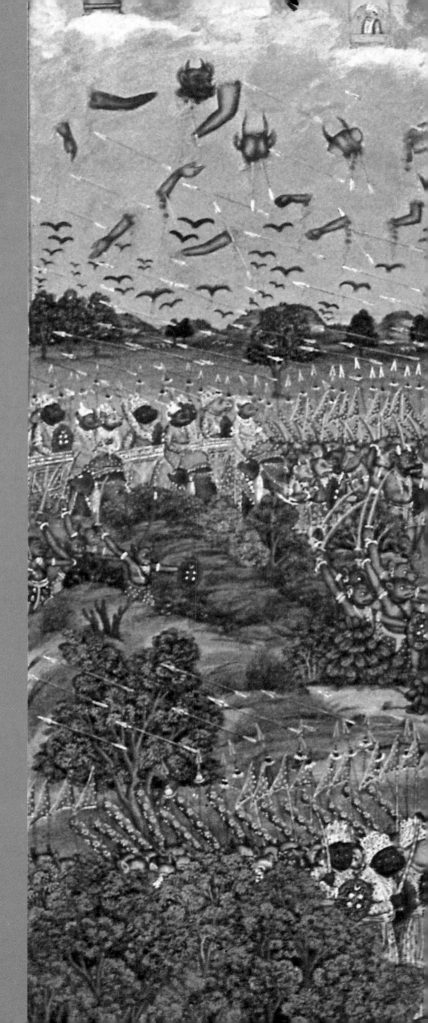

The forces of good and evil clash in the riotous scene above and in detail at right, as Rama leads his army against Ravana and his demon-warriors. Beneath a grisly canopy of arms, heads, and vultures, Ravana magically summons many armies onto the battlefield. Rama, fortified with divine powers, finally beats the demon chief, piercing his body with showers of arrows. Princess Sita, who is the reason for all the bloody commotion, stands on the banks of what is probably the Ganges in the foreground. Upon Ravana's fall in the Ramayana, "the remaining demons of night in terror, their lord destroyed, fled in every direction."

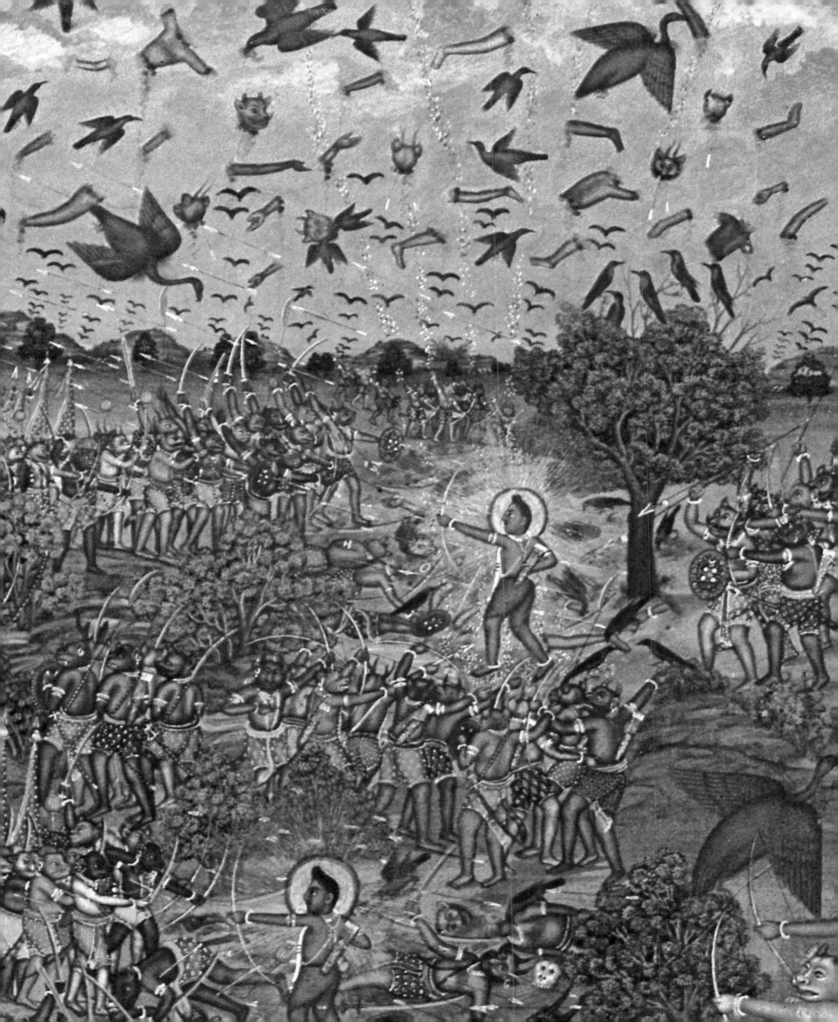

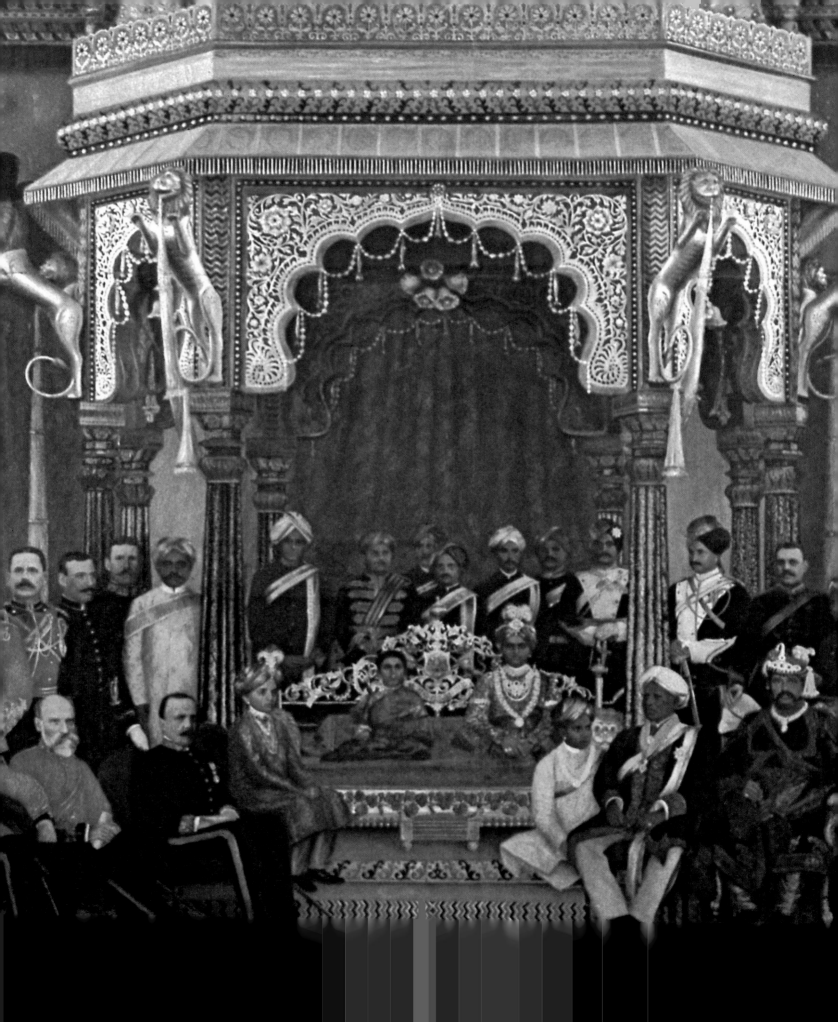

III

A MAHARAJA DIVINE

NINE DAYS OF WONDER

The rulers of Benares may have been revered for their piety, but only the maharaja of Mysore could turn himself into a goddess. This happened each autumn during the ten-day festival of Dasehra, whose astonishing pomp and fervor were unmatched anywhere in India. At its climax even local Britons made obeisance to the prince.

Mysore is an ancient south Indian kingdom. According to legend its capital, also called Mysore, was built on the spot where the goddess Chamunda slew a buffalo-headed demon in a fierce battle. A particularly splendid solid-silver, ten-armed statue of Chamunda, blackened by time and perpetually tended by an army of priests, still resides in a temple on Chamundi hill, three thousand feet above the town. It is her victory over evil that the Dasehra festival has celebrated every autumn (see pages 106–111), her divinity that entered into the soul of the living prince.

The Wadiyars—the ruling family of Mysore—traced their ancestry all the way back to the moon. Like the rulers of Jaipur, they were

Krishnaraja IV Wadiyar sits beside his new princess at their wedding in 1900, shortly after he became the maharaja of Mysore.

79

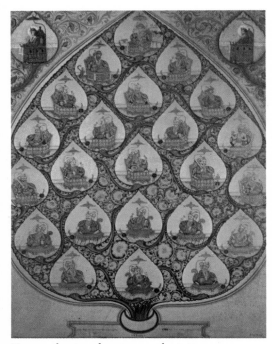

Twenty-three maharajas, each sitting on an umbrella-shaded throne, fill this Wadiyar family tree, which hangs in the palace at Mysore. The two haloed princes flanking the top of the tree may be the deified fourteenth-century founders of the dynasty.

Rajputs, descendants of 2 fourteenth-century warrior-princes who had wandered far south of their desert home to visit Hindu holy places. In Mysore the Rajput princes came to the rescue of a local chieftain, whose rival they bested in battle. The grateful king awarded his daughter to one of the princes and made him his heir.

The Wadiyars ruled Mysore more or less peacefully until 1759, when Haidar Ali, an illiterate but ambitious Muslim officer in their army, seized power. He placed the maharaja and his family under house arrest—to have killed them might have unduly agitated the overwhelmingly Hindu populace. Haidar Ali then allied himself with the French in hopes of holding off the growing might of Britain and eventually capturing all of southern India for himself. He was a shrewd, cynical statesman whose power rested primarily on terror— teams of floggers patrolled the halls of his fortress at Seringapatam, lashing officials at random on the grounds that everyone deserved chastisement from time to time. And he was a great soldier: the British took terrible losses to beat him back in 1781. When he died the following year, the British were happy to make an uneasy peace with his son, Tipu Sultan (see pages 82–83), the self-styled Tiger of Mysore. That peace did not last long, however, and in 1799 the British, under Arthur Wellesley, the future duke of Wellington, seized the kingdom.

The treasures of Mysore caused a riot among the victorious troops, who emptied vaults and stripped palaces until Wellesley admitted that "scarcely a house was left undisturbed and in the camp bazaars jewels of the greatest value and bars of gold were offered for sale by soldiers at indiscriminate prices.... Single pearls are said to be exchanged for a bottle of liquor...."

The British found the terrified five-year-old prince of the Wadiyars among the ruins of the city and placed him on the throne of Mysore as Maharaja Mummadi Krishnaraja Wadiyar. In exchange for an annual payment of tribute, the British pledged to support Mummadi; but if the maharaja ever failed to make his payments, the British had the right to intervene in the government of Mysore.

In 1804, when the maharaja was only eleven years old, a British

official paid a call at court. Mummadi proved himself already a master of grave royal courtesy. "I paid the usual compliments," the Englishman reported, and the prince replied that "he owed everything to the British and that his gratitude was unbounded." Mummadi, he said, was "of middle size, neither tall nor short for his age, nor handsome, but of an intelligent countenance. He seemed lively. But on such a public occasion it would have been indecorous even to have smiled. He did so once but was immediately checked by a person who stood by him." The Englishman had brought a gift, a saber with a handle of agate set with rubies. The little prince solemnly accepted it and responded with a trinket of his own—a string of fine pearls with a medallion of diamonds and rubies suspended from it. Just as cannons fired a salute from the palace battlement, courtiers stepped forward to drape more pearls around the necks of Mummadi and his guest.

Soon, however, trouble developed between the maharaja and the British. Mysore had suffered greatly during the wars waged by Haidar Ali and Tipu Sultan, and the prince spent vast sums restoring his capital, refurbishing temples, and rebuilding irrigation systems in the countryside. Greedy officials evidently skimmed off some of the money, and the prince himself was never thrifty when it came to his own comforts: even he later admitted that he had been "extravagant as to pecuniary matters in my younger days."

In any case he proved slow to make his annual payments to the British, providing them with all the excuse they needed to take over the government in 1831. Mummadi continued to reign; but for the next four decades a British commission ruled.

The prince never stopped trying to reassert his authority. He wrote streams of letters to London, blaming corrupt advisers for his earlier extravagances, yet insisting on his right to do as he pleased with his own money. "Even now, I confess," Mummadi wrote in 1846, "I have no wish to hoard my income or bury it in the earth, but to spend it in my country, and amongst my people, from whose industry I derive it."

Mummadi produced no heir, and when aphrodisiacs compounded

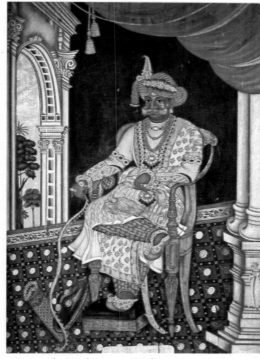

Mummadi Krishnaraja Wadiyar, resting his right hand on a bow in the portrait above, assumed the maharaja's throne in 1799, when he was six years old. The British stripped Mummadi of his powers in 1831 for extravagance and corruption—charges that turned out to have been exaggerated.

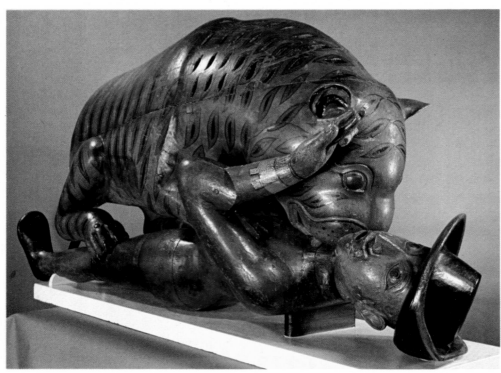

Tipu Sultan's animosity toward the British inspired this near-life-size figure of a tiger that is mauling a European. A pipe organ inside the beast's body simulated the cries of the victim.

THE TIGER OF MYSORE

Though the Wadiyar family proved to be one of India's stablest dynasties, its rulers temporarily lost their power in the eighteenth century to two ambitious Muslim adventurers. In 1759 Haidar Ali, a junior officer in the Wadiyars' own army, seized control of the military, imprisoned the maharaja, and proclaimed himself ruler of Mysore. Determined to expand his dominions, he invaded states to the south, provoking attacks from British forces protecting those territories. After a series of wars, Haidar Ali died in 1782, but his fight against the British was carried on by his son Tipu Sultan, who if anything was more bellicose than his father.

In the language of Mysore, *tipu* means "tiger," and Tipu Sultan identified completely with this most ferocious of India's jungle beasts. Inside the palace at Seringapatam, his capital, the huge form of a tiger covered with gold supported the royal throne, while outside live tigers on chains growled at visitors. Matching his reverence for the tiger was Tipu's hatred of the British. They whittled away at territory his father had acquired, provoking a bitter war in 1789 that lasted two years and ended with the British forcing Tipu to give up land and wealth.

Tipu reviled the British in writing, in speeches, and in pictures: at his order houses along main streets bore caricatures of Englishmen being disgraced or murdered. But the most original expression of Tipu Sultan's anglophobia sat in his music room. Executed by an Indian artisan, the object—above—consisted of a six-foot tiger devouring a hapless European. The tiger's body ingeniously housed a fourteen-pipe organ and a bellows, which together produced the sounds of ani-

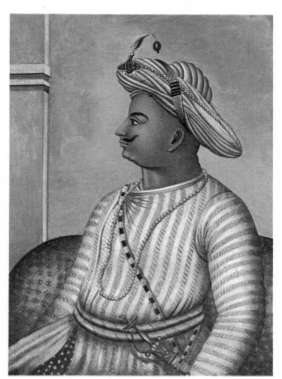
Gems and pearls adorn Tipu Sultan in a 1792 portrait.

mal growls mingled with humanlike screams.

In 1799 Tipu's defiance of treaties, and his maltreatment of prisoners, incited the British to invade the capital. A bullet felled Tipu; then—according to one story—a British soldier killed him for his gold belt buckle. After the battle, British soldiers looted Mysore, and their officers seized the treasures in Tipu's palace. They sent the most vivid objects—including the musical tiger and parts of the tiger throne—to England, where they added to the awe and horror aroused by the mention of Tipu Sultan's name.

from finely powdered jewels failed to help, he resolved to adopt a son. British officials threatened to depose him entirely if he tried it; they wanted to determine the succession themselves. One official warned that if the prince persisted in this scheme, "His Highness might be put into a cage like a parrot and shown to the world." When Mummadi refused to change his mind, colonial officials threatened to annex Mysore.

Mummadi's plight at last found sympathizers in Britain, who reminded the government of the maharaja's loyalty to the British during various campaigns fought in India. Mysore had supplied one hard-pressed British army with five thousand troops and thirty-two thousand bullock carts loaded with supplies. Mummadi's supporters managed to quash the annexation attempt and generally to boost his reputation; just a few months before the maharaja died, in 1868, Queen Victoria named him knight commander of the order of the Star of India—one of the highest honors she could bestow on an Indian. As Mummadi had wished, his adopted son succeeded to the throne, with the Wadiyar family's powers fully restored.

The greatest of the modern maharajas of Mysore was Krishnaraja IV Wadiyar—the son of Mummadi's successor—who was just eleven when he was installed in 1895. His English adviser, Sir Stuart Fraser, labored hard to make him into a model Western prince: under Fraser's tutelage he became a crack polo player, a golfer, and so good at squash that Edward, the Prince of Wales, was said to have "enjoyed being beaten by His Highness when other Indian opponents had appeared to think that Eastern politeness did not allow royal guests to lose at games." The prince's mother, the dowager maharani, was an important influence on him as well. She was deeply conservative—when her teeth needed pulling, a dentist was summoned to the palace and did his work through a slit in the purdah screen—but she encouraged her son to become a progressive prince provided he did not neglect the ancient traditions of his family. At her urging Krishnaraja undertook a lifelong series of arduous pilgrimages to Hindu shrines.

Mysore was a rich, luxuriantly green mountain kingdom about

TEXT CONTINUED ON PAGE 90

MYSORE'S PALACE OF
CURVES AND CARVINGS

In the darkness, Amba Vilas glows as thousands of lights outline its many towers, domes, and archways.

As if to separate business from pleasure completely, the Wadiyar dynasty in the nineteenth century moved all administrative affairs to a government complex in Bangalore and reserved the city of Mysore—the traditional capital—for matters of pomp and spectacle. Dedicated to entertainment, the rulers built a number of impressive palaces and villas, the greatest of them being Amba Vilas—erected during the reign of Krishnaraja IV. Construction began in 1897 on the foundation of an older palace destroyed that year by fire. The architect, an Englishman named Henry Irwin, was given gloriously free rein and contrived a colossal three-story main building, made from a local gray granite, above which rose a tower capped by a gilded dome. Irwin's plan for Amba Vilas blended Mogul, Hindu, and European styles, combining onion domes like the ones on the Taj Mahal at Agra, arching canopies inspired by northern Rajput palaces, and stained-glass ceilings—such as those opposite and on page 88—executed by a foundry in Scotland.

Building Amba Vilas took fifteen years, and the maharaja saw to it that the construction served as yet another diversion for his subjects. As workmen hammered, chipped, and carved, the public wandered freely through the palace rooms. When completed in 1912, the palace dazzled visitors. "In effect," wrote one, "there seems not an inch of repose on all its surface; it is all curves and carvings."

Beneath a curved ceiling of stained glass, two immense chandeliers illuminate the aisle of the maharaja's throne room. On either side a mezzanine of ornate grillwork rests on painted pillars.

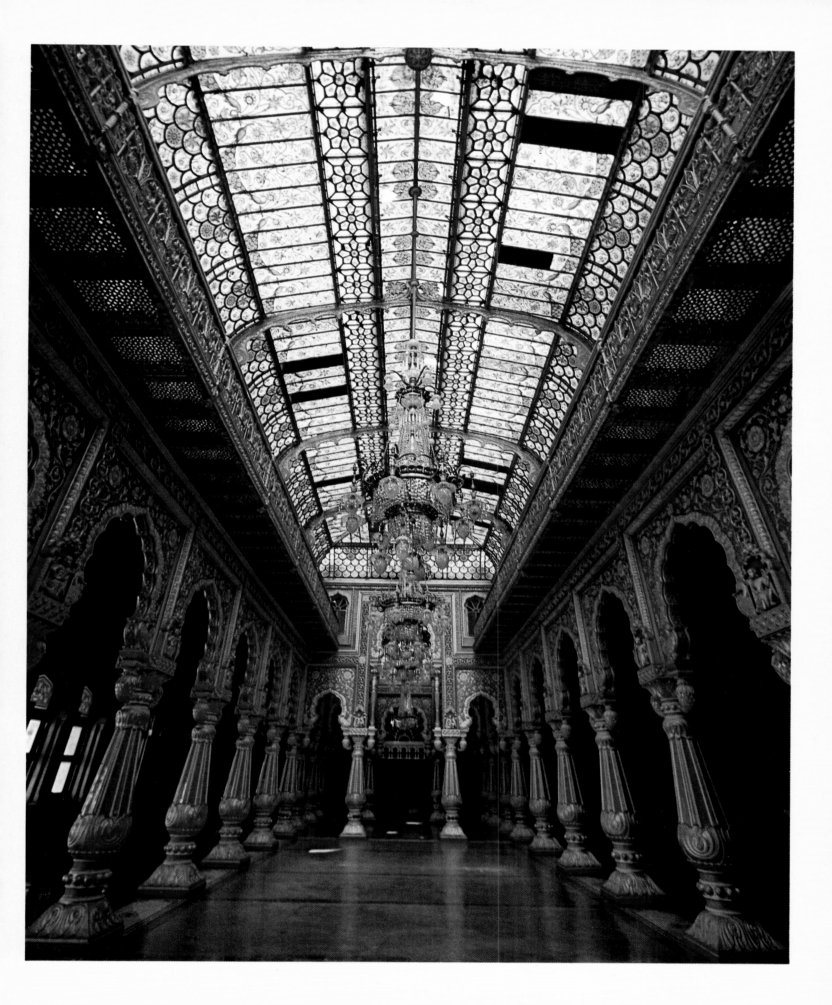

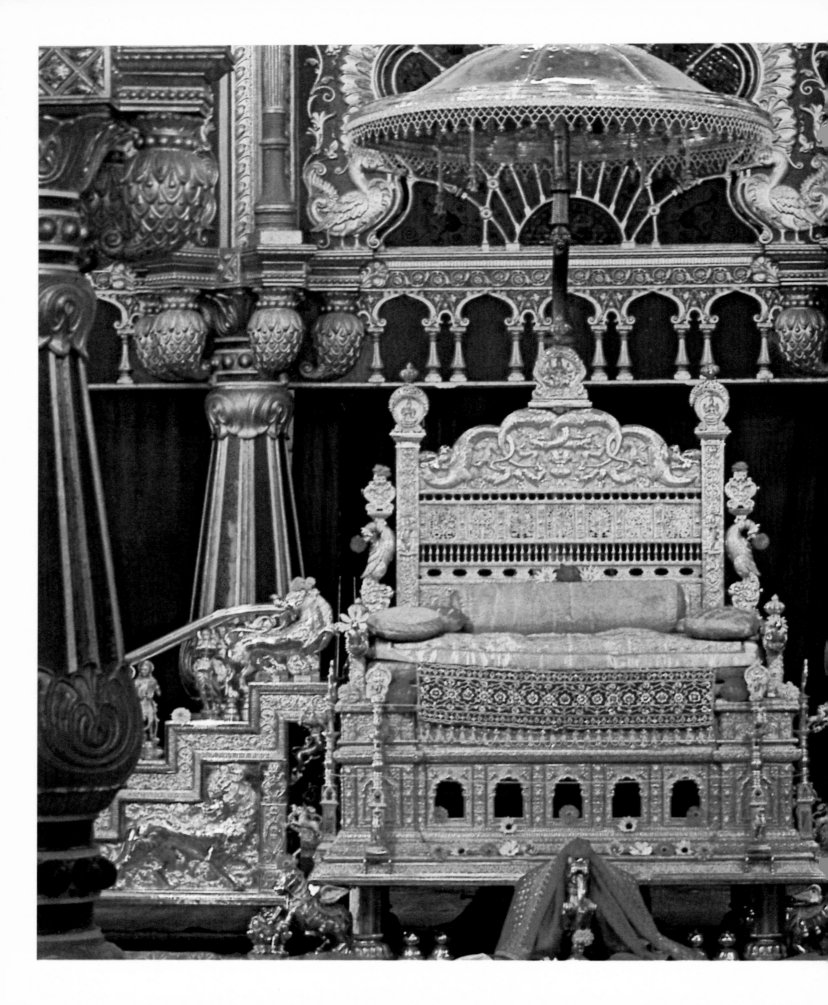

A flight of golden steps leads up to the maharaja's throne—called the Lion Throne—that was displayed in the throne room only on auspicious occasions. Of obscure origin, the throne was recovered from the palace of the tyrant Tipu Sultan after his fall in 1799 and used in the coronation of the new maharaja. It is made of fig wood embellished with gold leaf and gold and silver figurines; a wheel in back adjusts its height to accommodate a prince of any size. Above the royal seat a post supports a gold umbrella that, according to an inscription on its rim, "evokes the awe of the whole world."

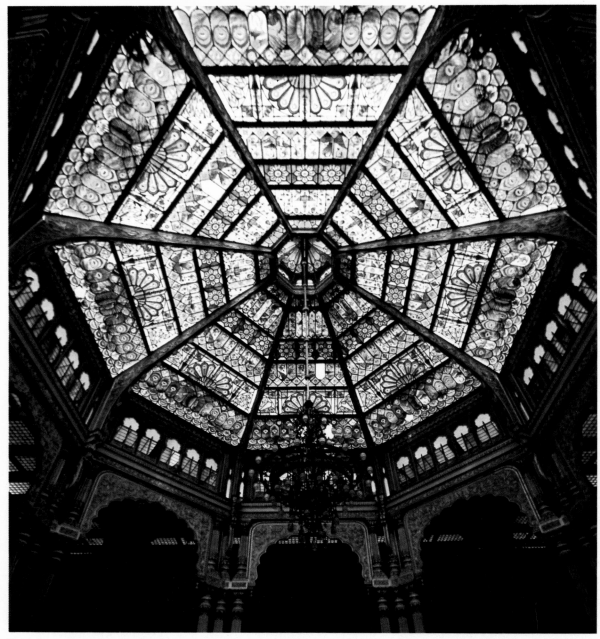

Raised on groups of triple pillars, an octagon of exquisitely designed stained glass forms a canopy over the Peacock Hall—so called because the principal decorative motif is the peacock, a princely emblem.

In warm colors that give it the appearance of an oriental carpet, the mosaic floor of the Peacock Hall contains peacock, star, and diamond patterns within its octagonal frame. The royal family used this hall for weddings, concerts, and receptions.

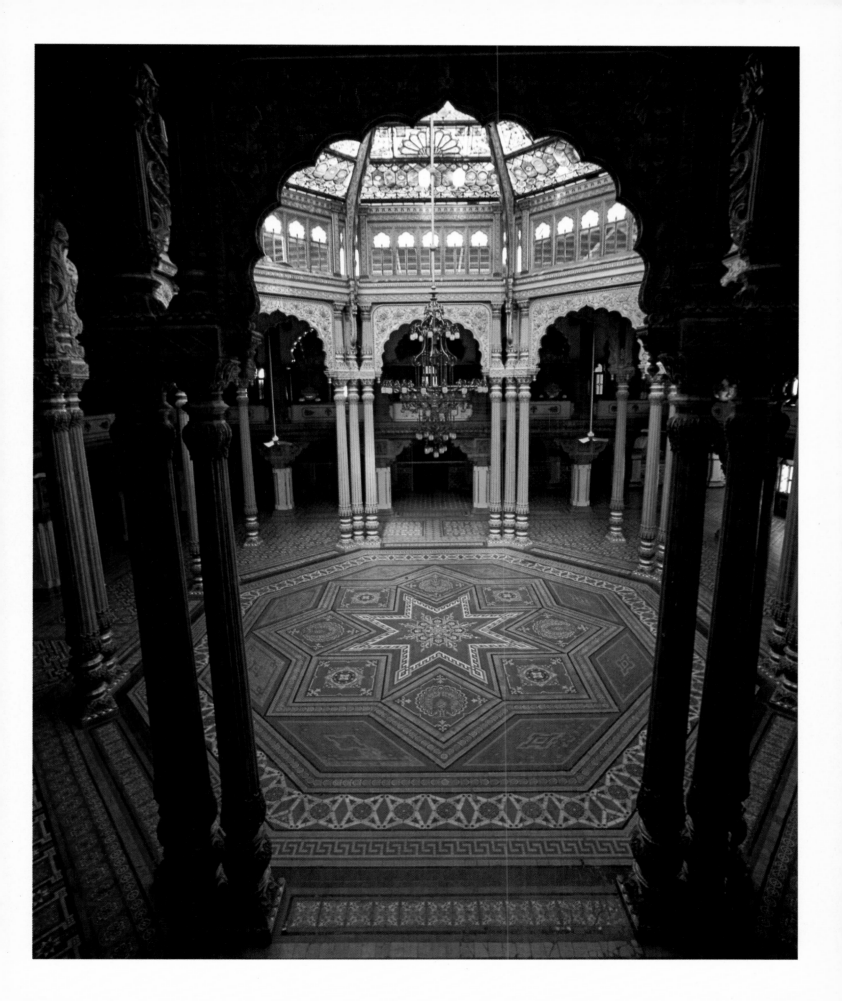

TEXT CONTINUED FROM PAGE 83

the size of Scotland; its slopes were ideal for growing coffee, sandal-wood, and the mulberry trees upon which silkworms feed. When-ever the coffers of the maharaja ran low, he had India's only substantial gold mine to replenish his funds. A weaker prince might have simply indulged himself; instead, Krishnaraja made Mysore a model of enlightened monarchical rule. He spent fully one fifth of the state's revenues on education, and he relied for counsel on a Muslim dewan, or prime minister; their lifelong friendship provided India with a much needed lesson in Hindu-Muslim amity. The maharaja established a great university, sponsored artists and writers, built hospitals and India's first birth control clinic, and inaugurated the first hydroelectric plant on the subcontinent. He also permitted an elected assembly to provide at least a modicum of democracy.

But he never neglected princely grandeur. The crumbling old palace in the Mysore fort was something of an embarrassment to the new regime: its pediments were shaky with age and its interior badly scarred by generations of miniature sacred cows that Mummadi had bred and encouraged to wander through the royal apartments. A fortuitous fire had damaged part of the old residence in 1897, and the royal family happily abandoned it for a new one, built to their own grand specifications (see pages 84–89). Broad avenues converged on the new palace, which had dozens of onion domes, many covered with eighteen-carat gold. There were four temples within the palace and some six hundred rooms, twenty of them given over to hunting trophies: perpetually snarling tigers, dusty bears, and massive gaur—the largest hooved animals on earth.

Many states had splendid palaces, of course; the Dasehra festival made Mysore distinctive. Every Hindu prince celebrated this holiest of holidays with as much ostentation as his treasure could pay for. But Mysore's version was unsurpassed. The festivities began with a great procession to the ancient temple on Chamundi hill where priests anointed Krishnaraja: it was then, behind the temple doors, that the spirit of the goddess began to overcome him. For the next nine days (after which the prince reverted to mortal status once again), the maharaja was neither shaved nor washed. The logic of this was

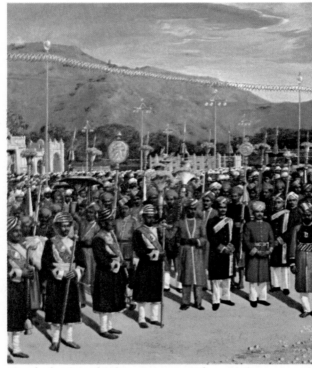

Hundreds of royal infantrymen, turned out in their finest uniforms, escort Krishnaraja, riding in a howdah with his brother and nephew. The maharaja and the magnificent gold-armored elephant are lead-ing a religious procession from his palace.

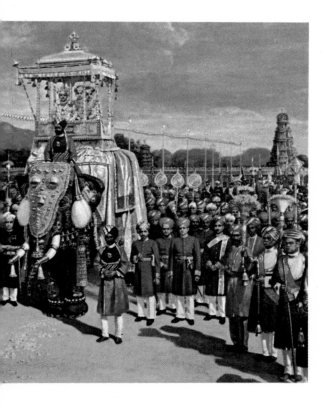

unassailable: because he was a divinity, no mere man was worthy of touching his revered person; because he was also a prince, he could not perform such lowly tasks himself. At ceremonies during the festival, when Krishnaraja walked hand in hand with his dewan, a sheet of beaten gold separated their palms so that no human contact would sully the prince's fragile divinity.

On the evening of the tenth day, the burden of his divinity having finally departed from him, Krishnaraja ascended in a gaudy procession to a hilltop pond. There thousands of his subjects lined the shore to celebrate their ruler's return to the world of mortals. The surrounding forest was strung with lights, which blazed on all at once as the prince, seated in a silver pavilion on the raft of state, glided out onto the surface of the lake. Four priests stood chanting at the corners of the vessel, bearing witness that Krishnaraja was once again a man.

This annual event was among the most eagerly attended of the Indian social season. So were the elephant roundups the maharaja arranged for his guests each year. Mysore was the chief supplier of elephants to the Native States. (This trade fell off sharply after India became an independent republic in 1947: "It is a regrettable but definitely established fact," wrote a rueful British officer who saw it all coming in the 1920s, "that democracy is bad for elephants, which are on the decline everywhere.")

Hundreds of tame elephants and thousands of beaters drove the wild herds into bamboo enclosures, where they were tethered and then terrified into submission over a period of days by elephant drivers armed with torches and hooks. The jungle encampments from which the maharaja's guests watched the roundup were fitted out with elegant furniture, electric lights, and a substantial library. In the evenings bands performed concerts.

The maharaja's Hindu orthodoxy did not interfere with his admiration for Western culture. During his frequent visits to Bangalore, where his bureaucrats carried on the day-to-day business of governing, the maharaja stayed in a smaller palace modeled after Queen Victoria's castle at Windsor. He was a patron of both Western and

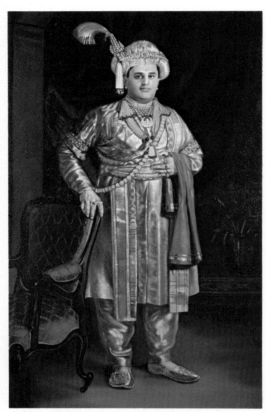

A bejeweled Jayachamaraja Wadiyar—nephew of Krishnaraja—appears as the most affable of rulers in this portrait. He ascended the throne in 1940. Well educated and widely traveled, the portly maharaja was an enlightened ruler, championing the rights of women and the disadvantaged.

Indian music and was himself an accomplished violinist. His British private secretary played second violin alongside the maharaja in chamber groups. Krishnaraja often presented musicales in his blue-and-gilt music room, the women of his court listening in silence behind a gold curtain strung between the pillars.

When the full blast of summer heat drove the maharaja to take refuge in the cool Nilgiri Hills, his court took up residence in an enormous English-style country house called Fernhill. (Next door stood Woodstock, the vacation home of his good friend Sayaji Rao II Gaekwar, the equally modern-minded maharaja of Baroda.) There the prince rode to hounds, played polo (he owned two hundred ponies), and several times each season invited the British community to a formal ball and open house. The prince is said to have enjoyed these events immensely, though religious strictures kept him from dining or dancing with his guests. As a special treat his women were allowed to watch through latticed windows as the foreigners waltzed in each other's arms. (They were permitted to watch the local horse races, too, cheering on their favorites from the dark interior of a special retreat built for them beneath the grandstand. An Englishwoman placed their bets.)

For many years Krishnaraja was reluctant to travel abroad, and when he finally did so for the first time in 1936, he hired an entire floor of a fashionable London hotel. One room was made over into a temple and another became a kitchen for preparing undefiled meals. Royal servants slept on the floor of the corridor outside the maharaja's suite. He liked England so much that he returned again three years later, bringing with him 650 pieces of luggage and a retinue that included a troupe of Indian singers and musicians.

When Krishnaraja died, at fifty-six in 1940, thousands of his grieving subjects crowded around the palace gate to watch one last great procession bear his body to the cremation ground. His state elephant led the mourners; behind it pranced his riderless horse. As the procession moved off from the palace, the keening of the princesses could be heard from the upper stories blending with the sound of the royal orchestra playing a European funeral march.

THE MAGIC OF
GEMS AND GOLD

Jewels and gold thread embroider the satiny royal emblems above. The pair of saddled beasts are mythological lion-elephant hybrids offering protection to all Hindus.

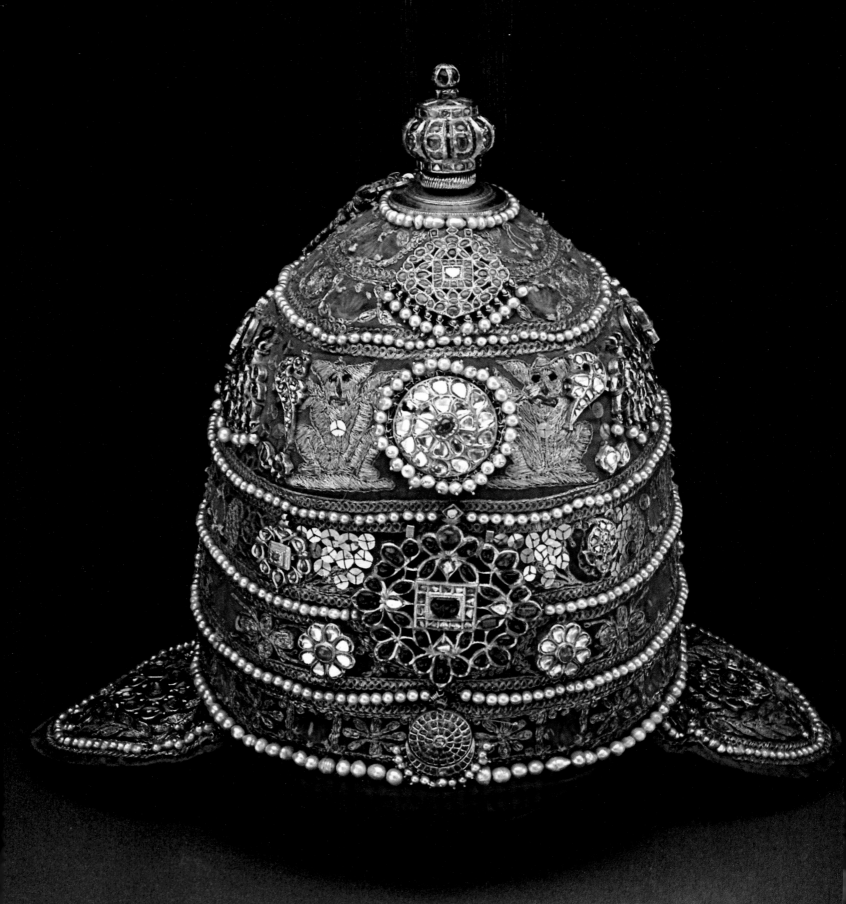

By the seventeenth century the Wadiyar maharajas of Mysore had emerged as some of India's most extravagant rulers, with their lavish coronations, weddings, birth celebrations, and such royal recreations as tiger and elephant hunts. The princes' parties and parades were all glittering events, none more so than the annual Dasehra festival honoring the goddess Chamunda (see pages 106–111). For what they deemed their most important occasions, the maharajas required pageantry and opulence on a dizzying scale, with enormous orchestras, dancers, and wrestlers to entertain. Religious holidays were noisy, colorful spectacles, and the regalia displayed on these holidays—such as the richly jeweled objects of gold and silver on these pages—had deep symbolic meaning as well as practical use in the celebrations.

Making the regalia, Indian goldsmiths (organized into guilds since the third century B.C.) used only gold, silver, and gemstones, which Hindus considered not just precious but magical materials. The most important gems were sapphires, rubies, diamonds, pearls, jacinths, emeralds, topazes, and cat's-eyes—each, according to Hindu beliefs, possessing beneficial powers derived from the planets or the sun. To those fortunate enough to receive them as gifts, perfect gems imparted the blessings of power, friends, riches, youth, and success. Similarly, a flawed gem could bring its owner bad luck. Hindus also believed that gems had curative powers and powdered the stones to mix them in tonics.

The maharajas prized stones for their color, their brilliance, and especially their large size and thought that the gems possessed distinct, nearly divine personalities. Stealing a gem was a crime punishable by death.

The finest tribute the maharajas could make to the luxury-loving gods in the Hindu pantheon was to commission divine images in gold or silver studded with rubies, diamonds, emeralds, and other gems—a homage only the very wealthy could afford.

Nine different kinds of precious stones, including rubies, diamonds, emeralds, and pearls, fill the gold brocade crown opposite, which stands nearly a foot high. The jewels—singly embroidered into the cloth and clustered to form medallions—displayed the maharaja's power and position. Probably made in the eighteenth century, the crown has the tall, turban-like construction that Hindus associated with the Himalayan mountains, abode of their gods.

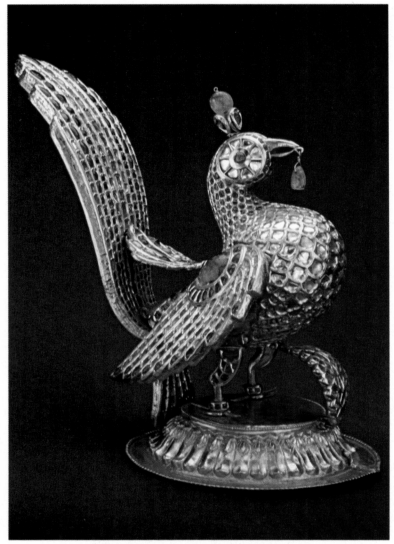

The proud, ruby-eyed bird above and in detail oposite, a mythological peacock, perched on top of the maharaja's throne umbrella at the palace at Mysore. According to an ancient Indian myth, a visitor who fell under the shadow of this mythological bird would become king.

With an enormous emerald dangling from its beak, and an elaborate jeweled crest and plumage of rubies, diamonds, and more emeralds, the Mysore throne bird exemplified the maharajas' fondness for large, unfaceted gemstones displayed in profusion.

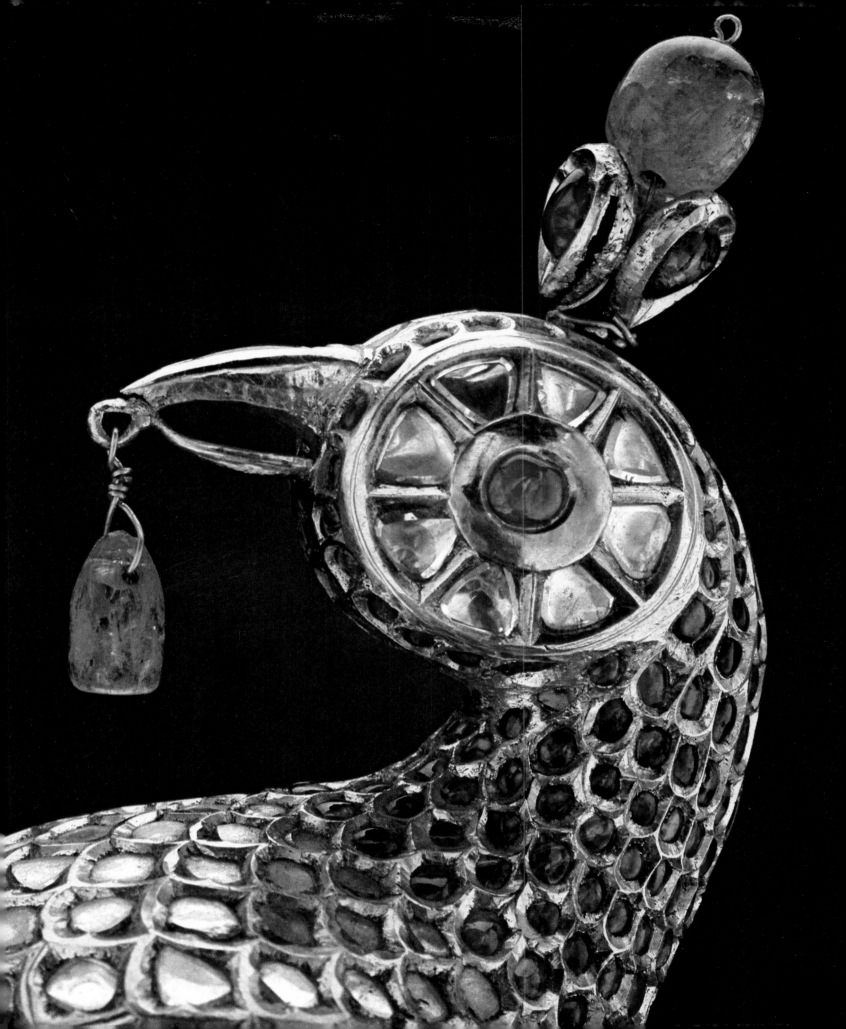

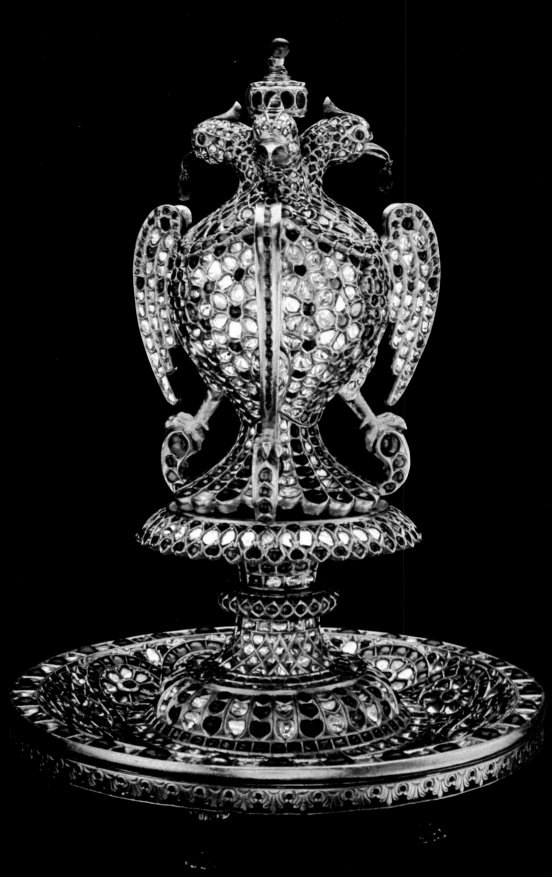

Diamonds, rubies, and emeralds fill the network of gold cells jacketing the scent bottle above. Perched on a pedestal, the multi-headed eagle is an emblem of the maharaja's sovereignty. The nine-inch-high vessel held strong perfume that princes dabbed onto the backs of their hands and wrists before weddings and religious ceremonies.

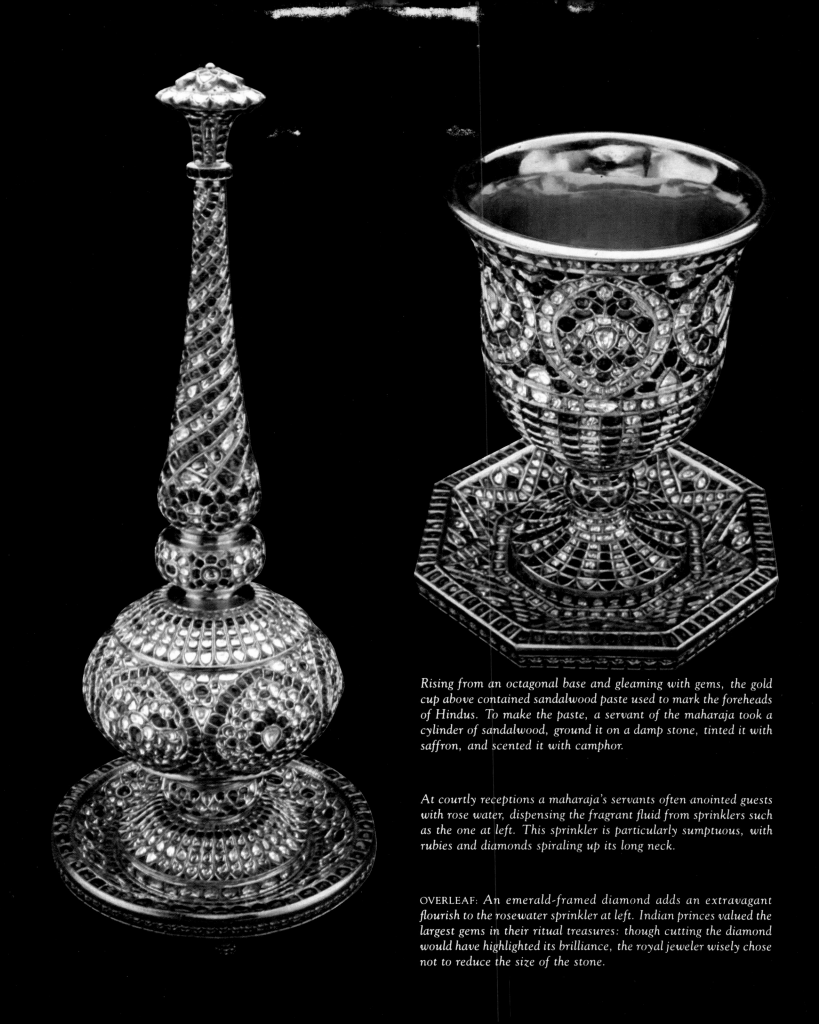

Rising from an octagonal base and gleaming with gems, the gold cup above contained sandalwood paste used to mark the foreheads of Hindus. To make the paste, a servant of the maharaja took a cylinder of sandalwood, ground it on a damp stone, tinted it with saffron, and scented it with camphor.

At courtly receptions a maharaja's servants often anointed guests with rose water, dispensing the fragrant fluid from sprinklers such as the one at left. This sprinkler is particularly sumptuous, with rubies and diamonds spiraling up its long neck.

OVERLEAF: An emerald-framed diamond adds an extravagant flourish to the rosewater sprinkler at left. Indian princes valued the largest gems in their ritual treasures: though cutting the diamond would have highlighted its brilliance, the royal jeweler wisely chose not to reduce the size of the stone.

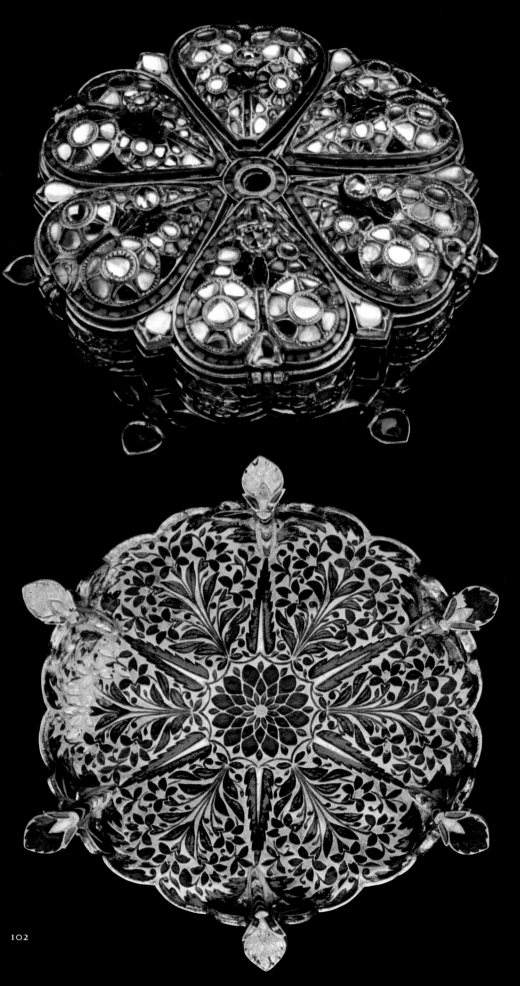

The jeweled, compartmented box shown here in three views held the makings for pan—a fragrant and slightly narcotic delicacy that maharajas and commoners alike chewed frequently. However, only princes could regularly afford all the expensive ingredients of pan and a splendid container to hold them. To prepare pan the maker wrapped a leaf of the betel palm tree around six ingredients: chunam, or powdered limestone; a piece of bark of the kathal tree; cardamom; cloves; betel nut; and khimam, an opiate. Each ingredient had its own compartment in this box. Maharajas enhanced their betel chewing with treasured accessories. The artist who made this pan box missed no opportunity to beautify his work, filling even the underside (bottom left) with floral patterns. Pan was more than a mere treat, for betel leaves were said to possess medicinal and aphrodisiac powers: a twelfth-century Indian prince included pan in his list of the enjoyments of life, along with unguents, incense, women, beautiful clothes, and good food.

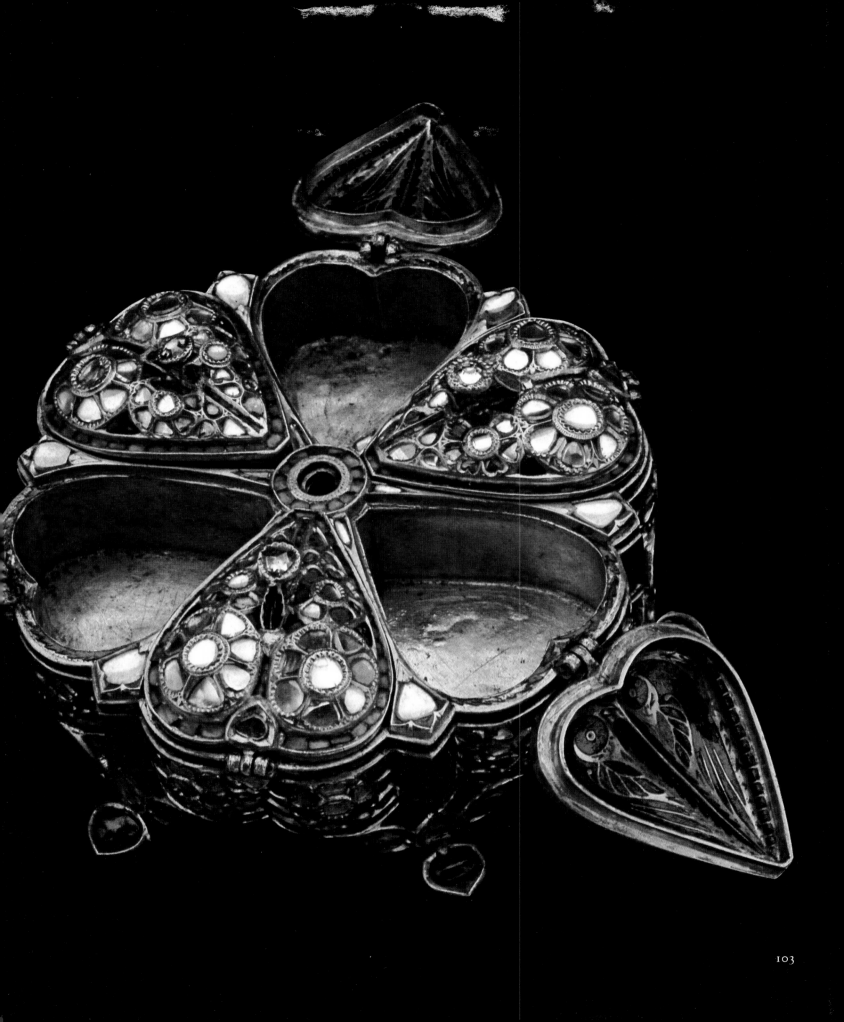

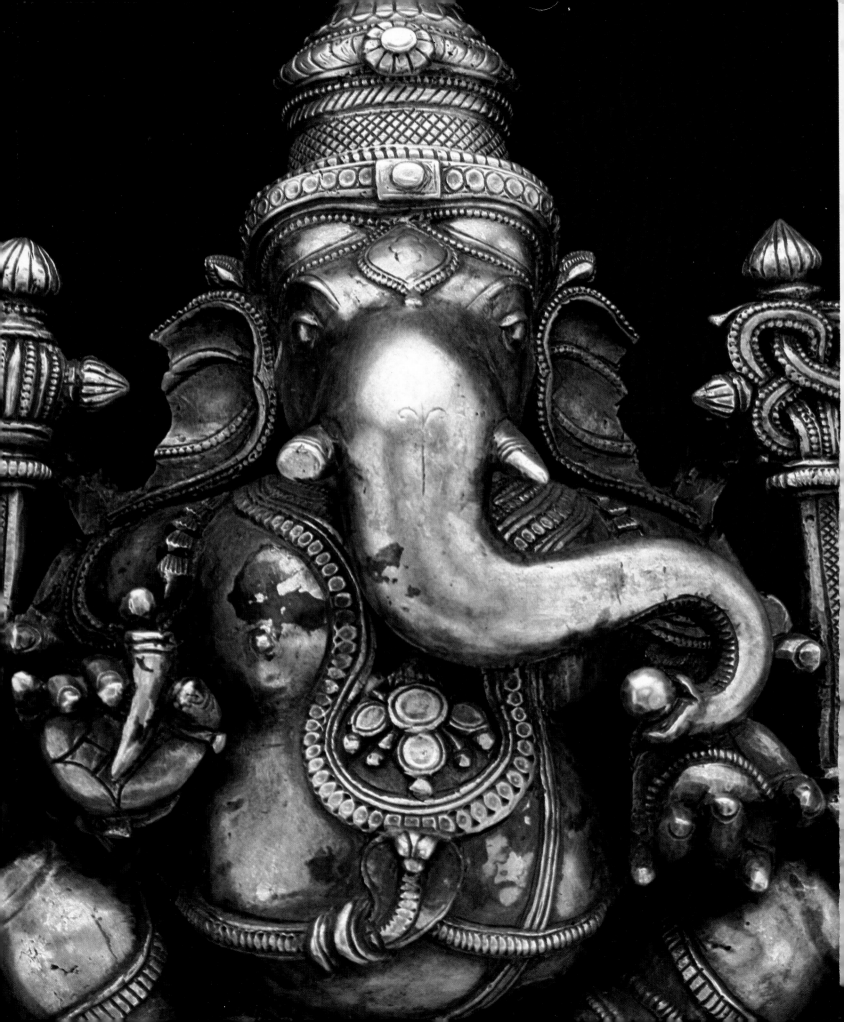

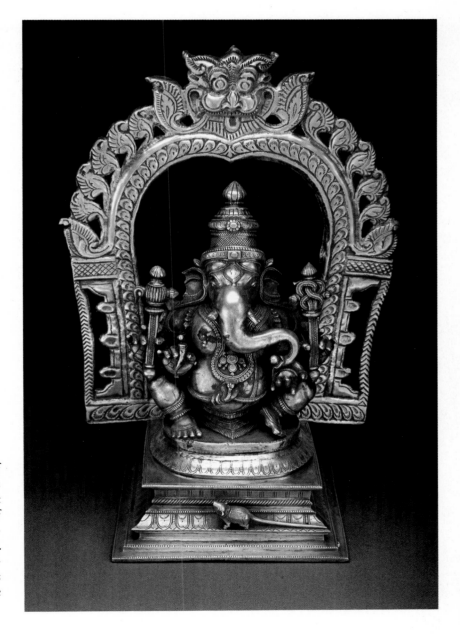

The elephant-headed god Ganesha was a favorite of the Wadiyar family, who worshiped beautiful images of this benevolent Hindu deity, such as the statue at right and in detail opposite. Ganesha is the god of wisdom and abundance and bestower of good fortune—revered for his ability to overcome obstacles. Thus Hindus pray to him before undertaking ventures of any importance. Here the silver Ganesha sits beneath an arc of light that is represented by the canopy over his throne.

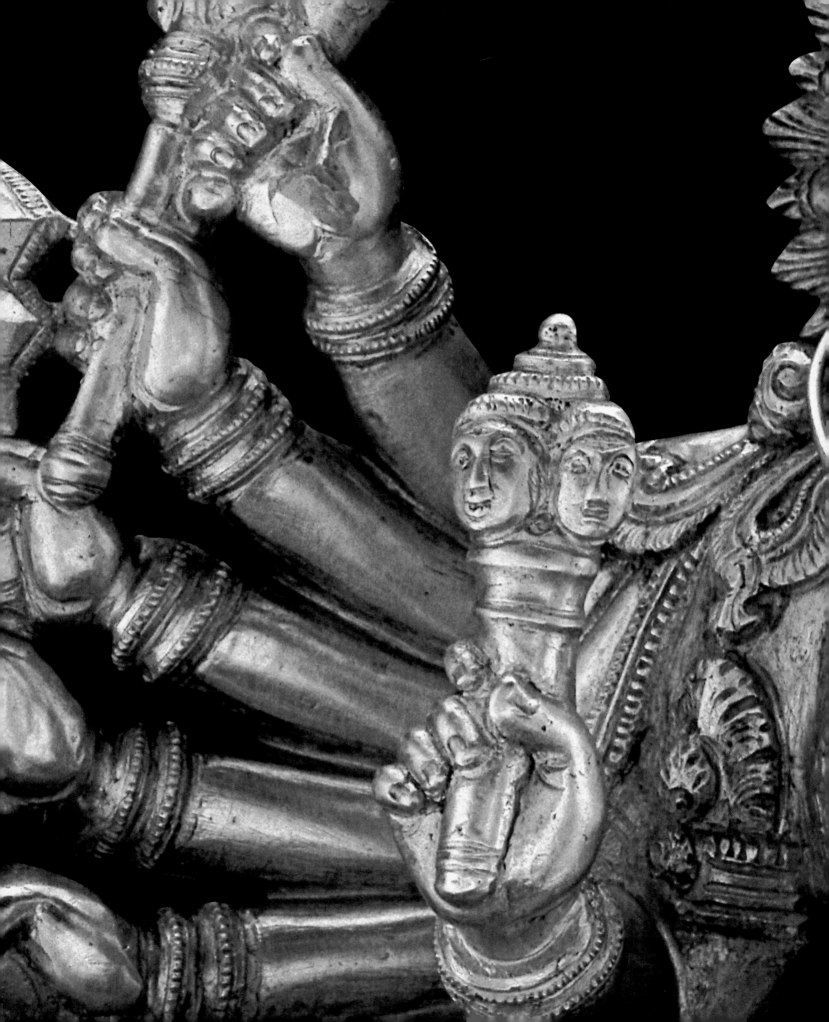

The golden Chamunda, in detail here, is a steely faced goddess, strong and victorious with her mighty fans of arms grasping the weapons and other objects she used in her role as demon slayer. In the right hand extended in front of her body, Chamunda holds the vajra-dhara, or thunderbolt, a triple-headed ritual dagger. Chamunda's impassive expression contrasts with the exuberance of her flowing garments and her jewelry, wrought in rich detail by a nineteenth-century goldsmith. The large ruby in the center of her forehead is a talismanic third eye. In the ancient Indian symbolism that linked certain gemstones to the solar system, a ruby stood for the sun. Only a diamond can scratch a high-quality ruby, and the deeper the red the more valuable the stone: the color of a maharaja's ruby should match pigeon's blood. Being diamonds, Chamunda's earrings represent the planet Venus. The lavishness of the goddess's jeweled garb expresses the devotion of the Wadiyar family, who commissioned the work.

The grandest and holiest of all royal occasions in Mysore was the autumnal Dasehra festival, which the Wadiyar family first celebrated in 1610. During this ten-day festival—a commemoration of the mythical battle between the goddess Chamunda and the demon Mahisa—the maharaja became the goddess. Unfed, unwashed, and untouched by human hands, the temporarily divine maharaja embodied the power and grace of Chamunda, one of the many aspects of the Great Goddess, along with the goddesses Durga, Uma, and Parvati.

During the Dasehra festival the maharaja meditated upon the mysteries of the goddess and worshiped an image of her, like the one opposite and in detail in the foldout, every day. Through intense and rigorous devotions, the maharaja sought to comprehend the mystical truths of the Chamunda myth.

According to the myth of Chamunda, a demon called Mahisa once lived on a hill above Mysore and terrorized all the peaceable people and gods. Consistently bested by Mahisa, the gods finally called upon the goddess Durga, the avenger aspect of the Great Goddess. One by one the defeated gods turned over their arms to Durga, who went off to face the demon: among her weapons were a dagger, a flaming dart, a discus, a quiver and bow, a sword, a battle-ax, and a trident. Even with the collective power of all the Hindu gods, it took Durga nine days to slay Mahisa, for her diabolical foe kept changing form, from water buffalo to lion to man to water buffalo again. She then killed his two generals, Chanda and Munda, from whom she took the name Chamunda for herself—and Chamundi for the hill where the demon had lived. It was Chamunda's nine-day battle that the maharajas celebrated with the Dasehra festival—a time of immense joy in Mysore.

Each night the maharaja held a great durbar, or reception. The sweet aroma of sandalwood and rose water filled the vast golden throne room on these occasions, and the maharaja played host to a huge audience for dances, demonstrations of horsemanship, concerts, and wrestling matches. Each evening's durbar concluded with his highness's elephant waddling up to the pearl-canopied throne to raise its trunk and spew pink and red rose petals into the air.

On the tenth day the maharaja shed his divinity to end Dasehra in a blaze of glory. Caparisoned in gold, the royal elephant and camels led thousands from the palace to Chamundi hill. The colorful and raucous procession included immaculately outfitted infantrymen and cavalry, drummers and trumpeters, and devotees of Chamunda carrying silk banners, umbrellas, and fans of peacock feathers. At a lake near the hill, priests shaved, bathed, and fed the maharaja, who then led final homage to Chamunda, draping her silver image in garlands of jasmine.

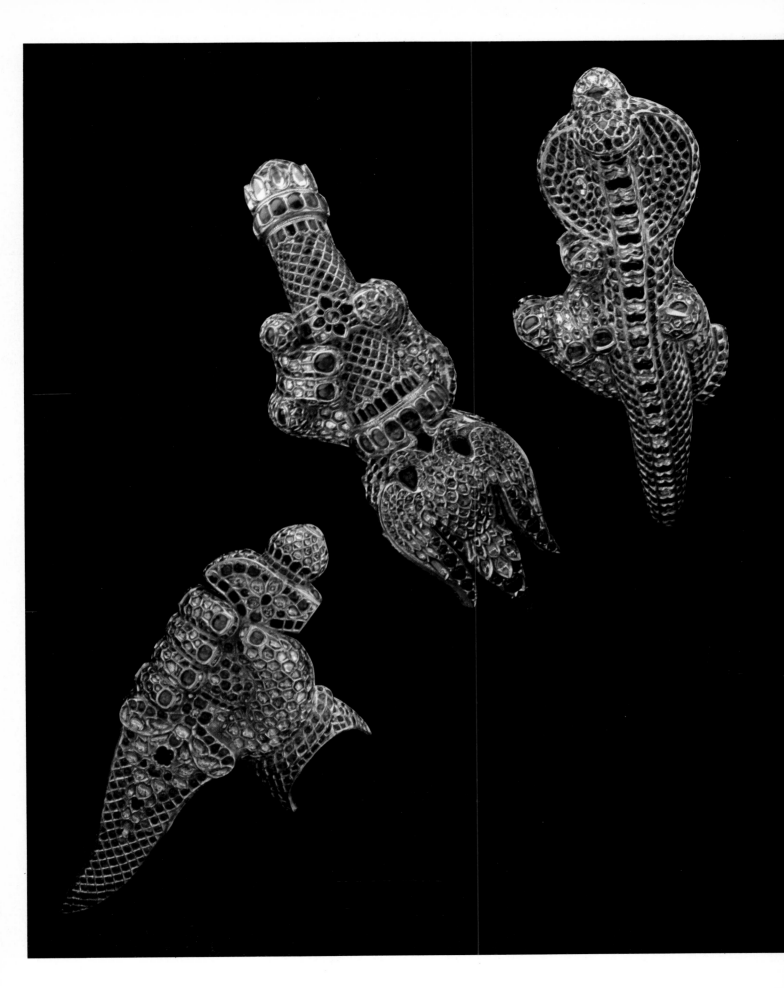

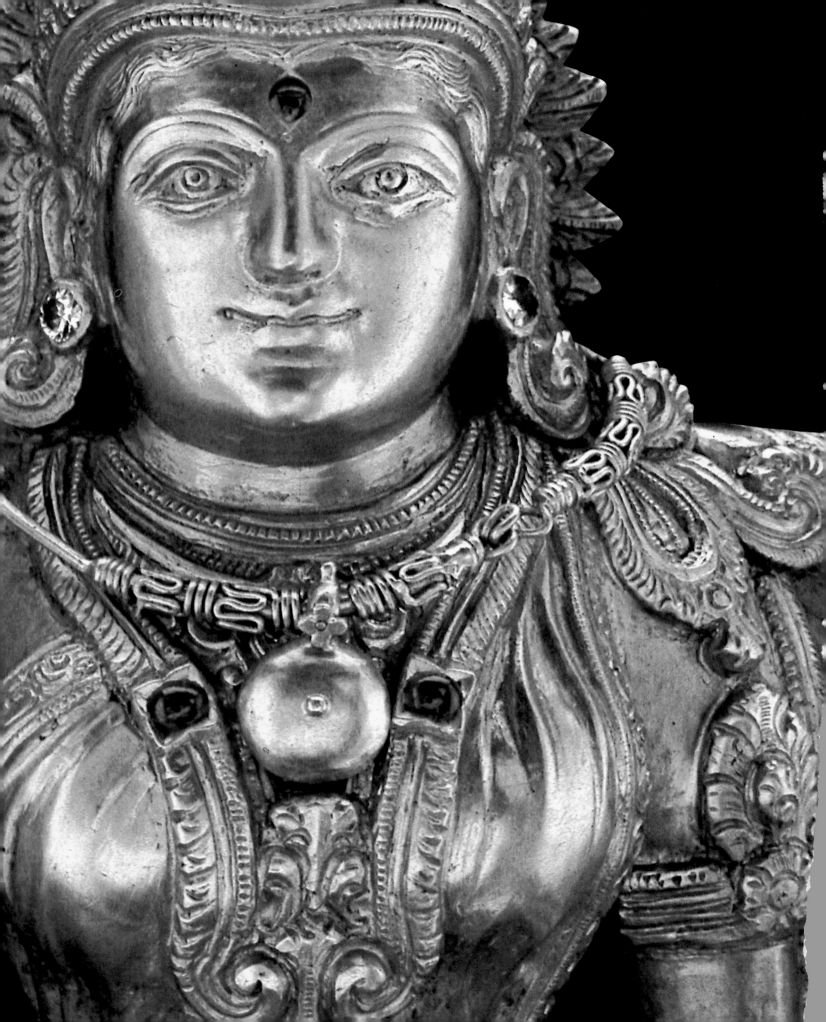

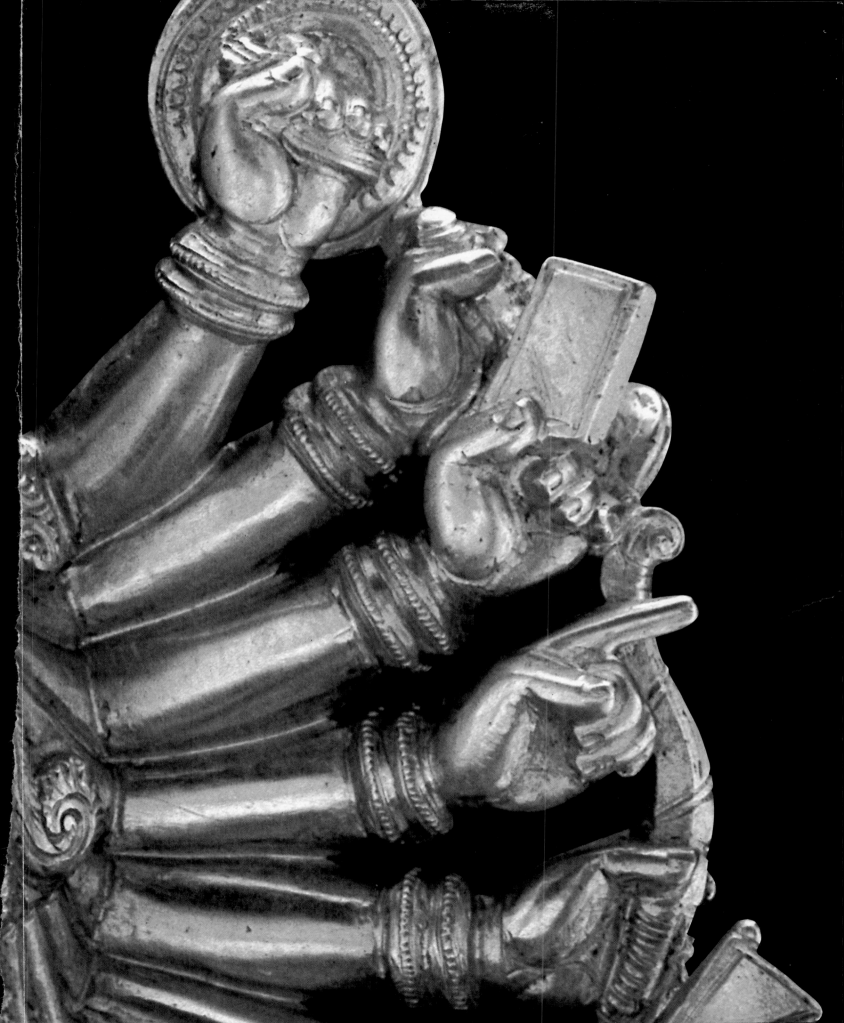

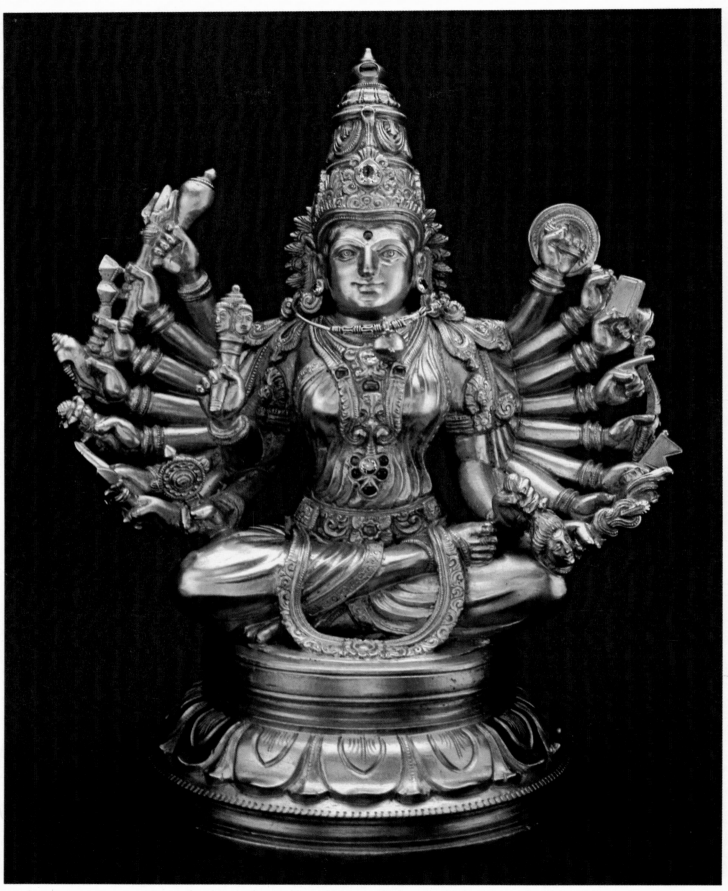

Chamunda, the guardian goddess of Mysore, displays the fabulous array of weapons given to her by her fellow deities. This sixteen-inch-high sculpture, with huge gemstones in the headdress, is one of several images of Chamunda in the Wadiyar family's temples.

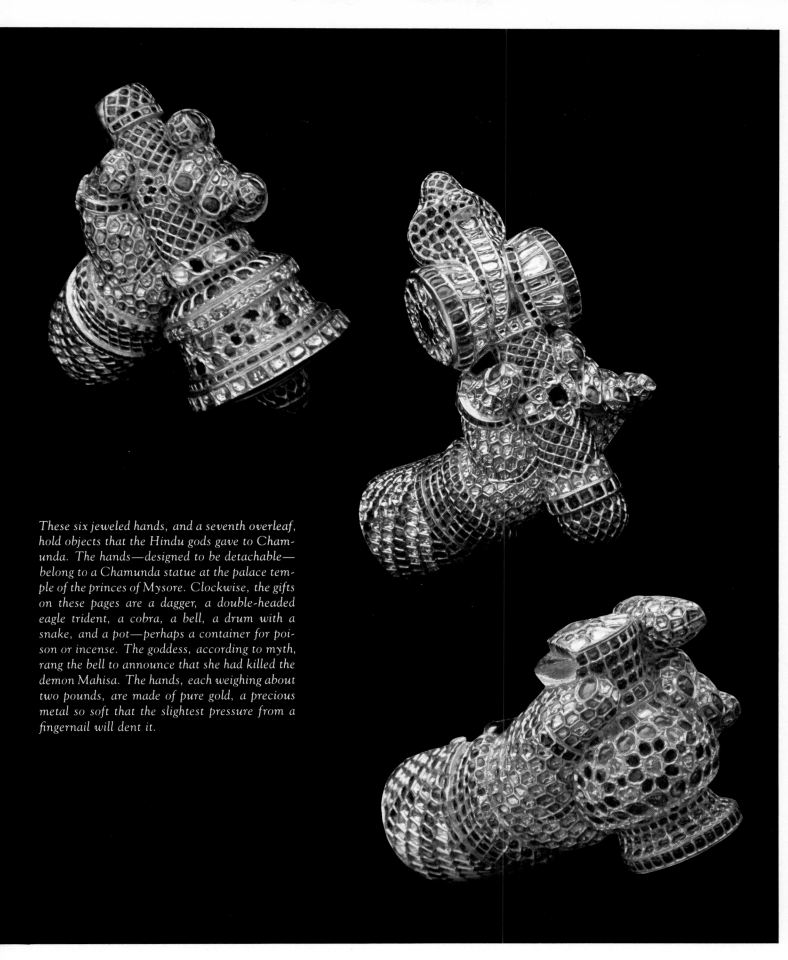

These six jeweled hands, and a seventh overleaf, hold objects that the Hindu gods gave to Chamunda. The hands—designed to be detachable—belong to a Chamunda statue at the palace temple of the princes of Mysore. Clockwise, the gifts on these pages are a dagger, a double-headed eagle trident, a cobra, a bell, a drum with a snake, and a pot—perhaps a container for poison or incense. The goddess, according to myth, rang the bell to announce that she had killed the demon Mahisa. The hands, each weighing about two pounds, are made of pure gold, a precious metal so soft that the slightest pressure from a fingernail will dent it.

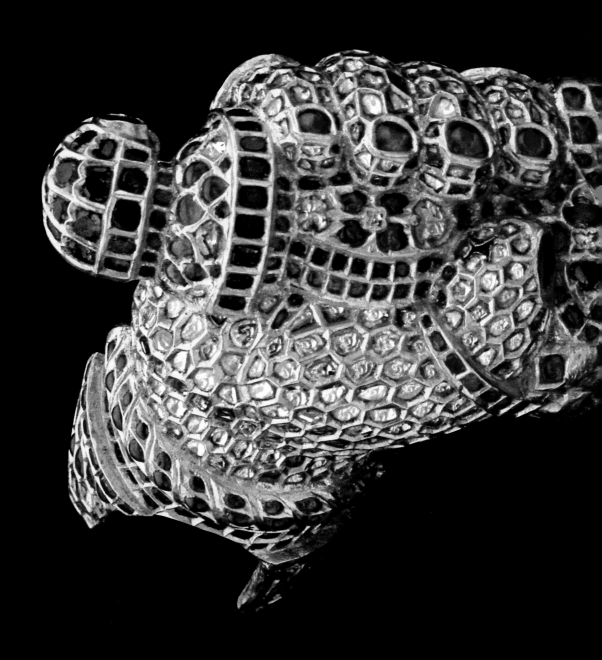

Seemingly fitted into a diamond gauntlet, a hand of Chamunda grasps a ruby-handled, diamond-bladed dagger—a sumptuous representation of one of the weapons that the goddess used in her battle against the enemy demon.

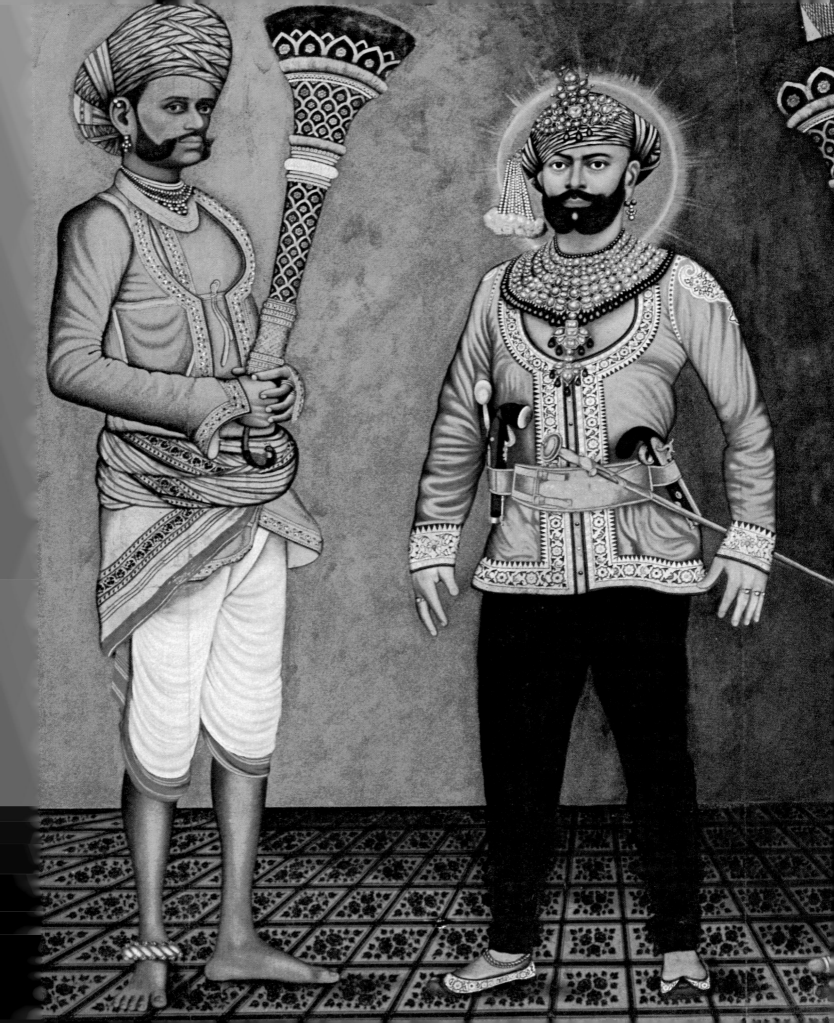

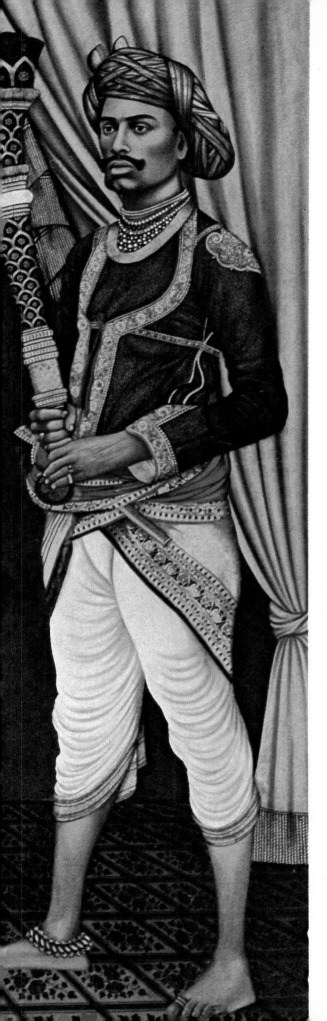

IV

THE TALE OF THREE PRINCES

A DARK REALM ENLIGHTENED

The Native States," wrote the English author Rudyard Kipling, "were created by Providence in order to supply picturesque scenery, tigers and tall writings. They are the dark places of the earth, full of unimaginable cruelty, touching the Railway and the Telegraph on one side, and on the other the days of Harun-al-Raschid," the mercurial eighth-century Arabian prince who appears in many of the fantastic tales of the *Arabian Nights*.

No maharaja tried harder to bring light to those dark places, or to bridge the chasm between the modern and medieval worlds, than Sayaji Rao III Gaekwar, the greatest of all the princes of Baroda.

The Gaekwar clan were Marathas, and their hero was Shivaji, founder of the Maratha kingdom and a daring and unstoppable soldier most fondly remembered for disemboweling a Mogul general with steel tiger claws lashed to his fist. His successors came close to conquering all of India in the early eighteenth century. Maratha power eventually was divided among a number of states, of which the three greatest were Gwalior, Indore, and Baroda.

Flanked by attendants bearing ornate fly whisks, Maharaja Khande Rao, despotic ruler of Baroda from 1856 to 1870, strikes an aggressive pose.

Of these Baroda was by far the wealthiest, with rich black soil, lush forests, and a vast royal treasure—the glittering booty of a century of intermittent warfare. The Gaekwars owed much of their power and wealth to the British, who sided with them in a long, bloody struggle for power, in exchange for a share in state revenues and the right to station their representative, the resident, in the capital. The British interfered very little in Baroda's affairs at first, and the maharajas remained serene in their isolation, believing that London lay somewhere south of Calcutta. Then two successive princes threatened to bankrupt the state with their profligacy.

The first of these was Khande Rao Gaekwar, who came to the throne in 1856. He was almost a caricature of a despot: generous and hospitable to those he wished to impress, cruel and unpredictable toward those whom he already controlled. A perceptive French traveler, Louis Rousselet, spent several months in 1866 as Khande Rao's guest and later wrote a revealing memoir about the daily goings-on at the court.

Life in the palace centered around the maharaja's flickering moods and intense enthusiasms. He thought pillows effeminate, so his courtiers had to spend their days sitting on the hard floor of his audience hall without complaint. When one of his jesters knocked off a noble's turban—as they did almost daily, so fond was Khande Rao of this joke—the maharaja would fall sideways on his throne, helpless with laughter. A royal yawn was the sign for all his courtiers to snap their fingers to keep flying insects on the move—and out of the royal mouth.

Already in possession of an immense hoard of jewels, he sent agents all over the world in search of more. When he bought the great Brazilian diamond known as the Star of the South in 1866, he was so pleased that he gave it a welcoming parade. Thousands of his troops marched in the jewel's honor, along with a corps of musicians, whose drums were so enormous that a pair of elephants was required to carry each one of them. Horsemen in chain mail, with shields of rhinoceros hide, escorted a cloth-of-gold state banner on a forty-foot staff. The state elephant brought up the rear, so huge and so heavily

An enormous crowd of Indian rulers, British officials, and spectators assembles at pavilions outside Delhi on January 1, 1877 to hear the British viceroy read the proclamation declaring Queen Victoria queen-empress of India. The proclamation was met with cheers, a 101-gun salute, and the toast "Monarch of monarchs, may God bless you."

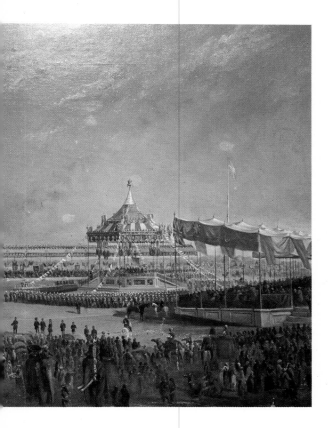

caparisoned that it seemed to Rousselet a moving "mountain of gold." Even its tusks were sheathed in gold; only its tiny wicked eyes showed. Heralds rode footboards on either side of the elephant, waving peacock-feather fans and shouting "Behold the King of Kings! Khande Rao Gaekwar, whose army is invincible, whose courage is indominatable!" Inside the swaying covered pavilion, or howdah, atop the elephant sat the prince himself, his new diamond indistinguishable at three feet from the scores of other stones flashing from his turban. As he passed, his subjects prostrated themselves.

Jewels were a constant joy, but Khande Rao had other hobbies as well. He collected pigeons until six thousand of them cooed among the carved domes and pavilions of his great wooden palace. He staged a wedding for two of his birds; the couple was borne before the priest on silk cushions and wearing tiny jeweled collars. A banquet and fireworks followed. A palace cat made the bride a widow, and the maharaja turned his attention briefly to the breeding of bulbuls—small, elegant songbirds loved by Indian poets. Soon he had five hundred of them and, perhaps weary of their incessant singing, had them loosed in a closed chamber and watched, fascinated, as they pecked one another to death. His fondness for birds in the wild was severely limited: when a roosting jungle parrot offered what Rousselet called "a terrible affront" to the maharaja's clothing as he rode out of his city, he decreed that all the lower branches of the trees along the road be hacked off; only the most delicate tact exercised by his ministers kept him from having every tree felled.

Field sports, too, delighted Khande Rao. He set cheetahs hurtling after antelope and, when they had downed their prey, rewarded them with silver bowls of blood. He also had lynx in his menagerie and sent them coursing after rabbits. And he loved to stage public spectacles reminiscent of those in ancient Rome. The whole court came to watch with him, sitting along the top of the arena walls; thousands of ordinary subjects crowded nearby rooftops. Elephant fights were the mainstay of these performances. Bull elephants were goaded into a state of sexual frenzy with a three-month diet of sugar and butter, forced first to battle with one another, and then to endure

In a court portrait, Chimanabai, wife of Maharaja Sayaji Rao III (opposite), shows off her ropes of exquisite pearls and the fine silk of her sari. Sensitive, kind, and renowned for her beauty, Chimanabai was also the best female rifle shot in India.

hours of torment from mounted lancers and from running bands of men waving red scarves and shooting off rockets. Battling rhinoceroses often followed, one painted red, the other black so that bettors could keep track of their favorites. These game but myopic beasts often missed one another while charging, but they were kept at it by attendants who dowsed them with water whenever exhaustion threatened to cut short the fun.

Human combat pleased Khande Rao as well. The maharaja invited the finest Indian wrestlers to his court and personally supervised every detail of their care and feeding. After prayers each morning he would take one on for exercise. His opponents had to exercise diplomacy as well as skill, allowing him always to win without ever letting him know he was being patronized. The maharaja did not himself take part in his favorite contact sport, an especially barbaric Baroda speciality—fighting with claws. The two combatants, nearly naked, had claws made of sharpened bone tied to their hands (in earlier times these had been steel, like those worn by Shivaji). Fortified with opium and shouting religious songs to keep up their courage, they ran at each other, tearing wildly until one or the other could take no more. Then the victor would stop and ask the maharaja whether his torn victim should be spared. Rousselet attended one of these exhibitions and watched in horror as Khande Rao, his eyes "wild" and "the veins of his neck swollen" with excitement, answered "Strike! Strike!" The winner, blood streaming from his wounds, was awarded a necklace of particularly fine pearls.

The American Civil War helped to pay for Khande Rao's excesses. The Baroda economy depended largely on cotton, and when the Union clamped its blockade on southern ports, cotton prices soared. When the war was over, the prince reverted to more traditional ways of refilling his treasury: he raised the levies on his peasants annually (those who complained were tortured into acquiescence). When that did not make up the deficit, he issued the following order to his nobles: "His Highness has seen with regret that corruption has found its way into various departments of his administration, but he hopes that this state of things will forthwith come to an end. He counsels

all those officials who have allowed themselves to be corrupted to bring into the royal treasury the sums received in this way. . . . His Highness, considering this restitution as making honorable amends, will forget the past."

The results surprised even Khande Rao. Believing the prince had secret informants, even his closest ministers thought it wise to pay up. It is not hard to see why. Khande Rao's justice was known to be rigorous. Miscreants were tied by a leg and an arm to the hind legs of an elephant and bounced through the streets to a field just outside the city; there, if they survived the trip, they were revitalized with a tumbler of cold water, then had their heads crushed under the elephant's foot.

Khande Rao died in 1870 and was succeeded by his younger brother, Malha Rao. The new maharaja had spent the previous seven years in prison for attempting to poison Khande Rao with a brew of wine and ground diamonds; and incarceration had done nothing for his character. Once in power Malha Rao had his late brother's favorite commander slowly starved to death, dispatched agents into the streets to kidnap girls for his zenana, and imposed new taxes so heavy that even the most prosperous landowners began to beg the British resident to intercede. The poorest farmers left the land to become bandits, raiding farms and villages in neighboring British-ruled Gujarat.

Things finally came to a head in 1873, when the British charged Malha Rao with trying to kill the resident with another diamond-laced drink. No one will ever know whether he was guilty or whether one of his many enemies framed him; but the result was the same: the British deposed Malha Rao for "incorrigible misrule."

The British asked Khande Rao's widow to pick a successor. In consultation with family priests, she chose the twelve-year-old son of an illiterate farmer only tangentially linked to the Gaekwar family. The startled, sad-eyed boy was swept up, brought to the palace, given the title Sayaji Rao III, and turned over to the care of a zealous English tutor. The transition from cowherd to prince must have been bewildering. Visits from his parents were thought unwise, but the

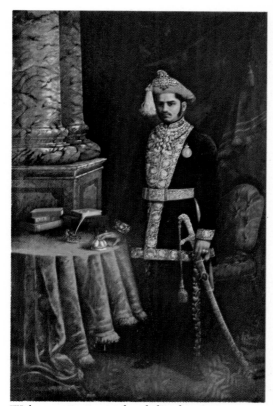

With a majestic air that belies his origins as an illiterate farm boy, Sayaji Rao, maharaja of Baroda from 1875 to 1939, sports a dazzling diamond neck-lace and a richly filigreed gold scabbard. The artist who painted this portrait, Ravi Varma, was himself a nobleman—a prince of Travancore.

boy sometimes waved secretly to his father from his palace balcony.

The Prince of Wales, on his 1875 tour of India, saw the young maharaja shortly after he gained the throne. "The little Gaekwar of Baroda...seems really a very intelligent youth," he wrote, "though but six months ago he was running about the street adorned with the most limited wardrobe." A member of the English prince's entourage remembered that "all eyes were dazzled" when the shy youth ventured into the room; Sayaji Rao seemed "a crystallized rainbow...weighted—head, neck, chest and arms, fingers and ankles—with such a sight and wonder of vast diamonds, emeralds, rubies and pearls, as would be worth the loot of many a rich town."

Sayaji Rao took what the British taught him with great seriousness. His guiding principle became the belief that by adopting Western institutions he could best enhance the prestige and power of his state—and of his rule. And in this he had the strong backing of his wife, Chimanabai, the beautiful, fiercely intelligent daughter of a Maratha noble. She too came to the palace unable to read; but English tutors soon set that to right. Chimanabai became an outspoken champion of women's rights, wrote a well-received book on the subject, and in 1927 served as chairman of the first All India Women's Conference. Unlike most maharanis, she rode and played and hunted and ruled alongside her husband.

Together Sayaji Rao and Chimanabai transformed their once-medieval kingdom into India's most advanced princely state. Sayaji Rao was the first maharaja actively to oppose the worst abuses of the caste system. He reorganized Baroda's government to include cabinet ministers and a legislative assembly, built India's first state-owned railroads, opened hospitals and public libraries, encouraged industry, and made sure there was a school in every village—and that the children attended it. He established an art gallery, a scientific institute, and a fine university.

He also built a gloriously eclectic museum, where the most popular exhibits were a stuffed buffalo calf with two heads and six legs, and a life-size plaster cast of the famed American strong man Eugene Sandow in a loincloth. In addition, its collections included

This gold-clad cannon, one of two commissioned by Sayaji Rao to fire a salute for the 1875 visit of the Prince of Wales, weighs 280 pounds. Regarded as sacred, the cannon received daily offerings of incense and flowers from watchful priests.

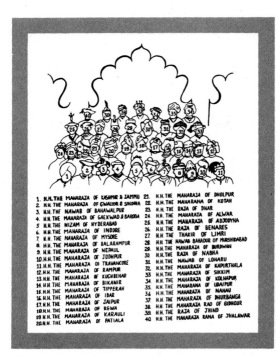

This handwritten key, prepared by the artist who made the collage opposite, identifies each of the princes.

THE GUNS
OF HONOR

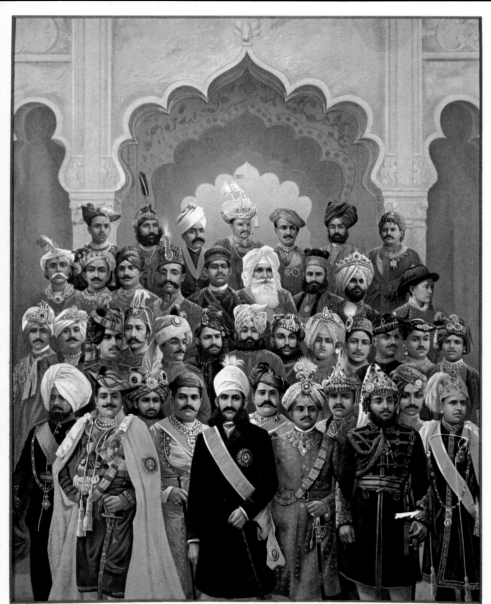

An unknown artist assembled this collage of forty princes' portraits in about 1900.

A bewildering array of almost seven hundred rulers lorded over Indian domains large and small—a profusion of princes that the British strove to arrange in a coherent pecking order. The British were able to gain some control over princely vanities by adapting the European protocol of honoring royalty with cannon salutes. The British established a strict system of ranks, in which the number of guns firing a salute to a particular ruler depended upon his importance and pliability. Some princes scheduled state arrivals at a quiet time, when the full measure of the salute would resound in the surrounding silence.

Sayaji Rao, second-richest Indian ruler and warm ally of the British, was one of only five maharajas who merited the ultimate sonic accolade of twenty-one guns. The nizam of Hyderabad, as the lord of India's largest and most populous state is called, was also among this elite.

The sixth nizam, who ruled from 1883 to 1911, was one of India's finest shots, a fanatical tiger hunter, and a fancier of fine gems. After the nizam's death his heir found a 162-carat diamond hidden in an old slipper.

Maharaja Bhupinder Singh of Patiala (a northern princely state in the Punjab) whose reign lasted from 1909 to 1938, was a slightly less grand potentate—his most famous diamond weighed only sixty carats. A robust man, the maharaja stood more than 6 feet tall, weighed 280 pounds, and reportedly dined on 50 pounds of food a day; but he kept in excellent shape by vigorous polo playing and wild-pig hunting. Though the pink walls of his quarter-mile-long palace housed some thirty-five hundred servants, the maharaja was deemed worthy of only a nineteen-gun salute.

superb religious statuary (see pages 127–141), some pieces obtained by Sayaji Rao himself and others acquired by agents commissioned by the maharaja to seek out choice examples.

His relations with the British were not always cordial. Sayaji Rao took at face value their pledge to treat him as an equal and always remembered, with profound emotion, that when Queen Victoria received him in England in 1887, she had pronounced him her "favorite son." Thus he was deeply wounded when British colonial officers sought to restrict his independence in matters of trade and defense and when they demanded that he banish Indian nationalists from his university. By the 1920s a movement for Indian independence from Britain had spread throughout the subcontinent. Led by Mahatma Gandhi, Jawaharlal Nehru, and other nationalists, it found especially strong support among students, and British authorities watched their campuses closely. Sayaji Rao, however, had no fear of agitators: his subjects were content.

Outside interference with his royal prerogatives upset him; trouble within his own family drove him to despair. Two of Sayaji Rao's four sons drank themselves to death. His beautiful daughter Indira horrified her parents, first by backing out of a marriage they had arranged with the middle-aged maharaja of Gwalior, then by eloping with the handsome crown prince of Cooch Behar, of whom they did not approve. Sayaji Rao and Chimanabai did not speak with their daughter again for six years, even though she had only practiced what they had been preaching for decades.

For all their modernism, Sayaji Rao and his wife remained very much a prince and princess of India. When their tennis ball went astray, there were twelve boys in green-and-gold jackets to scramble after it. They liked to preside over animal combat, just as Khande Rao had, though theirs was scaled down, and the clawmen no longer took part. (The pacing was oddly anticlimactic, too, beginning as before with bull elephants, but then working rapidly down from buffalo to rams to fighting cocks, to the finale: a scruffy parade of servants carrying parrots in cages.)

They also enjoyed blood sports. On the way home from a hunting

Maharaja Pratap Sinha, wearing the red turban, posed with his wife, Seta Devi, and family for this photograph in the 1940s. The maharaja and his wife spent much of their time—and several huge fortunes—in Europe and America, where they frequented racetracks and the salons of high society.

trip during which they had killed a dozen tigers between them, they stopped for another morning's shooting in one of their royal preserves. A lofty stone wall with three gates surrounded the vast killing ground, where each day for a week cartloads of food had been spread through the forest as bait. Now the great gates were swung shut, the royal hunters took up their positions in masonry towers, and beaters began driving the game toward their guns. Soon hundreds of deer were milling helplessly beneath the towers, and, after several dozen had been killed, Chimanabai ordered the shooting stopped as it had become "mere butchery." At that moment a tigress with three cubs padded out of the jungle, and Chimanabai could not resist shooting one. The enraged tigress then attacked five beaters, three of whom eventually died of their injuries. "Her highness," wrote a sympathetic English guest, the Reverend Edward St. Clair Weeden, "was much concerned at this sad termination of the expedition which she had so much enjoyed: she requested that she might be kept informed of the condition of the sufferers and sent suitable compensation to their families." This sort of casual slaughter was common enough among the princes: Ganga Singh, the maharaja of Bikaner, and thirty-nine houseguests once accounted for more than four thousand sandgrouses in a single busy morning; another maharaja bagged some eight hundred tigers before he wearied of the sport.

Though Sayaji Rao took pleasure in many royal pastimes, he refused to conform to the flamboyant image of his fellow maharajas. He did not drink, had no interest in dancing girls, and wore his jewels only on rare occasions, such as sitting for a portraitist (see pages 2 and 121). Nevertheless, he jealously guarded the Gaekwar treasures. The Reverend Weeden was taken to see them in 1909. On the way to the vaults beneath Khande Rao's old palace, where the jewels were kept, Weeden passed "cupboard after cupboard crammed with ancient gold and silver vessels belonging to former Maharajahs." Whenever Sayaji Rao was "in the mood for a little more household plate," Weeden was told, a few old pieces were "just popped into the melting-pot," and then the bullion was sent to London to be made over.

The royal treasure was so rich and so jumbled that Weeden later had trouble remembering everything he had seen; but there were streams of diamonds, he recalled, and a huge black pearl. The Star of the South, Khande Rao's pride, had been set into a necklace of other diamonds nearly as large. One choker contained five hundred diamonds, and he saw a profusion of jeweled plumes to be worn on the maharaja's turban: on some the diamonds had been individually mounted on tiny springs to provide added shimmer as the prince turned his head. There was an earring composed of three pearls, said to be the finest on earth, and four brilliantly colored tapestries that on close inspection proved to be made up entirely of gems—diamonds and rubies, emeralds and pearls, and turquoise—sewn onto silk. With four gold corner posts, each topped with hundreds of additional diamonds, the tapestries had been made as a canopy for the tomb of the prophet Mohammed at Medina, in Arabia. (This was still another product of Khande Rao's erratic interests: toward the end of his life he had become fascinated by Islam. The canopy was unfinished at his death, and his successors—not sharing his ecumenical enthusiasm—canceled plans to ship it off to Arabia.)

Storehouses and stables nearby held the larger trappings of state, among them a dozen gold carriages with silver wheels and countless gold and silver howdahs, including one so heavy that twenty-four men were required to lift it into place. The eighty-year-old elephant that carried it was traditionally rewarded for his patience during the ordeal with a gulp of sherry.

The guardian of all this splendor, Sayaji Rao, died in 1939. All his sons had died before him, and his genial grandson Pratap Sinha managed to squander much of the family fortune before the government of independent India decided finally to strip him of his titles.

It was a tribute to the benevolent vision of Sayaji Rao that when the kingdom of Baroda was merged into the new state of Bombay in 1949, his former subjects mourned. For them, the bright but untried promise of democracy seemed a risky exchange for the half century of tranquillity and progress that had been provided for them by the peasant's son.

A MAHARAJA'S MUSEUM

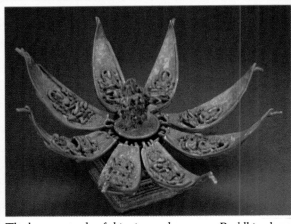

The bronze petals of this sixteenth-century Buddhist devotional object, collected by Sayaji Rao, can be closed to hide the tiny divinities within the four-inch-tall lotus bud.

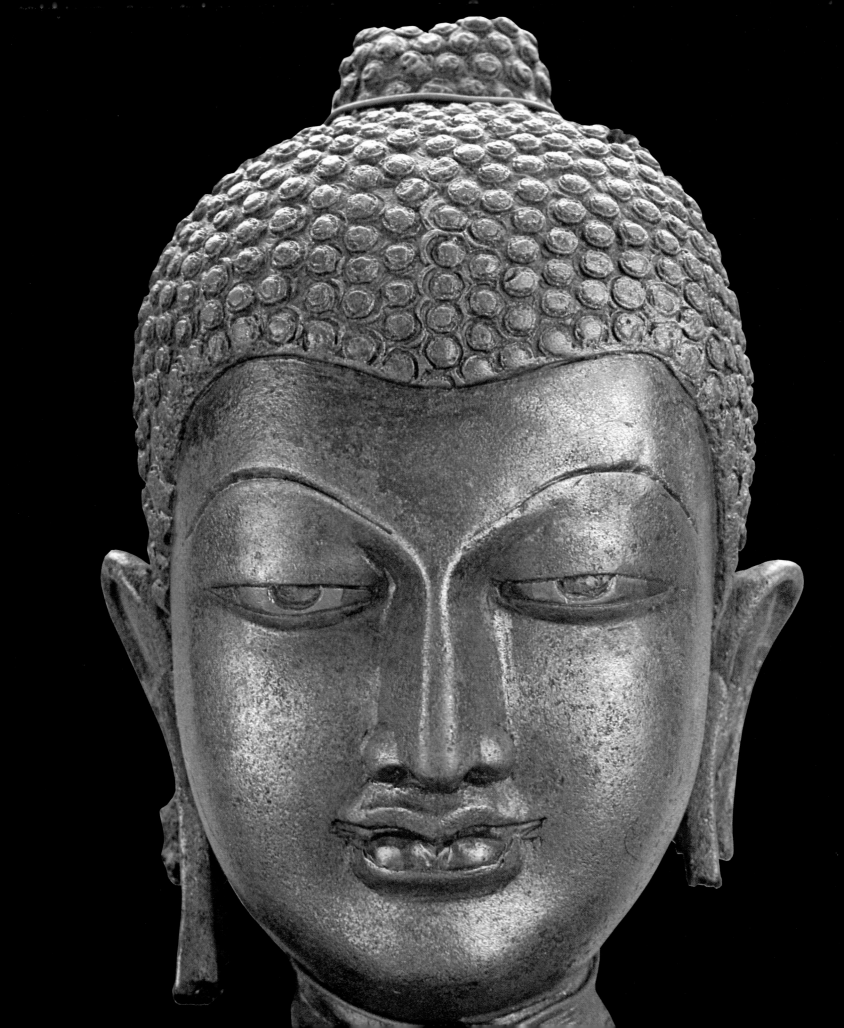

The deeply sensitive Sayaji Rao III, considered by the British to be a most enlightened maharaja, devoted himself to improving the lot of Baroda's poor, uneducated millions. He wanted the least of his subjects to learn to read. To instill appreciation of their own cultural heritage and to teach them about other lands, he founded the Baroda Museum in 1887.

A tireless and eclectic collector, Sayaji Rao bought masterpieces on his wide travels and also sent out a few trusted connoisseurs to scout the market for important pieces. Among the prizes they obtained for him were sculptures from Nepal, such as the objects on pages 138–141. Most astonishing is the unique hoard of western Indian bronzes—unearthed at nearby Akota—that includes works from the second century B.C. to the eleventh century A.D. This hoard may have been a temple treasure, buried by priests in time of war and forgotten.

Hinduism, Buddhism, and Jainism—India's major native religions—inspired many of the sculptures collected by the maharaja and his buyers. The three faiths make use of similar types of religious art and symbolism, and all three teach that men must transcend the wretched human condition by seeking spiritual enlightenment.

Buddhist statuary often tried to convey the inner peace attained by the Buddha in meditation. A sixth-century-B.C. Indian mystic, Gautama Buddha preached a so-called middle way between the extremes of asceticism and worldliness. His pose in a statue, or a certain symbol, might indicate a specific stage along the way to enlightenment.

Jainism is a religion without divinities; but the faithful, known as Jainas, revere twenty-four saintly Jinas, or conquerors, who have appeared on earth as ascetic teachers. Mahavira, the twenty-fourth Jina and the founder of the religion, was a contemporary of the Buddha. Jainism possesses an extremely complex philosophy, whose most basic tenets are nonviolence toward all living things—from humans to plants and insects—and the belief that a person can strive for purity of soul through self-denial and meditation. Because images of the Jinas can aid meditation, the Jainas regarded the making of beautiful statues, such as the portrait of a Jina opposite, as a holy act. For their part Hindus believed that a religious work of great beauty might actually lure a god to inhabit it.

Despite the great emphasis Jainas and Buddhists placed on asceticism, they shared with the Hindus a taste for highly sensuous religious sculpture. A Jaina meditating upon the alluring statue on pages 132–133, for example, may not have found in it any encouragement to persevere on the hard road of self-denial.

The half-closed, silver-inlaid eyes of this bronze portrait of Rishabhanatha, first of the twenty-four Jinas, indicate a state of blissful meditation. According to Jainist belief, Rishabhanatha lived at the end of man's ancient golden age and established religion and government in an attempt to stem the growing power of evil in the world. Rishabhanatha's daughter invented writing because men's minds had become too feeble to remember thoughts.

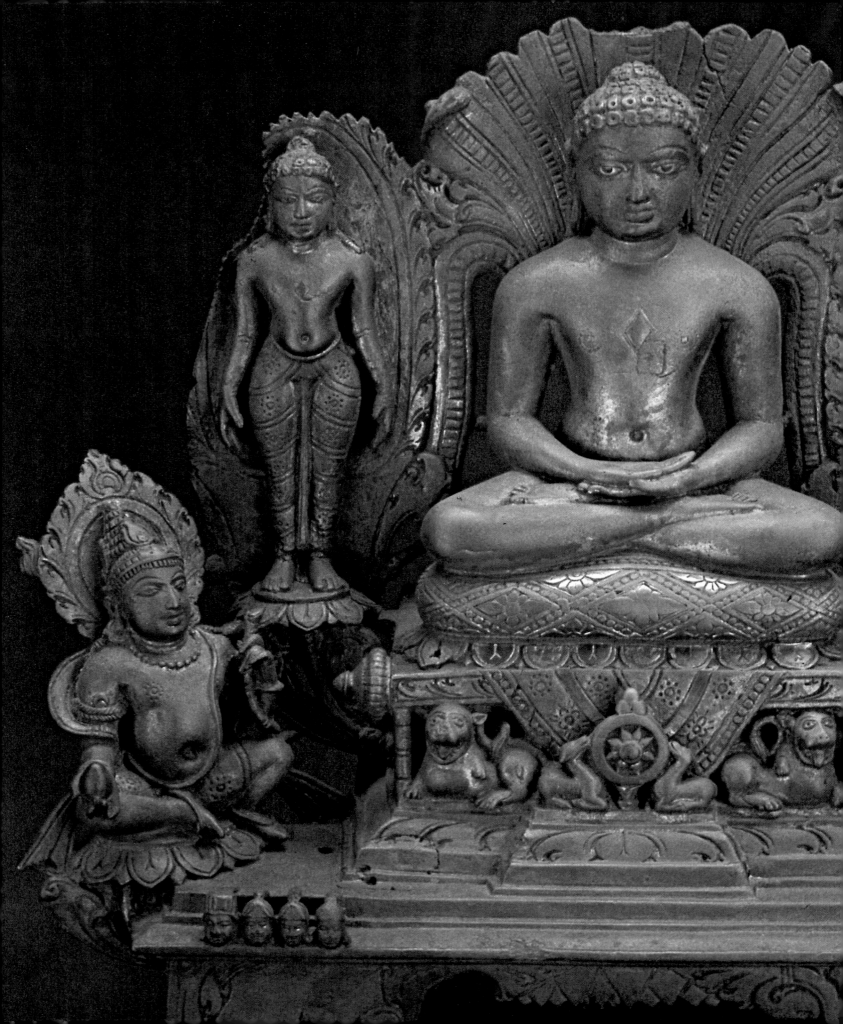

Protected by a canopy of cobras, the twenty-third Jina, Parshvanatha, rests on a silver-inlaid cushion, flanked by two other Jinas, standing on lotus blossoms, and two seated earth spirits. In front of this devotional object, believers began the day by offering fruit and prepared foods as an invitation to the Jina's spirit. The devotees also chanted ritual prayers and addressed the saintly presence, who offered the food back to the congregation so that it could be distributed to the poor.

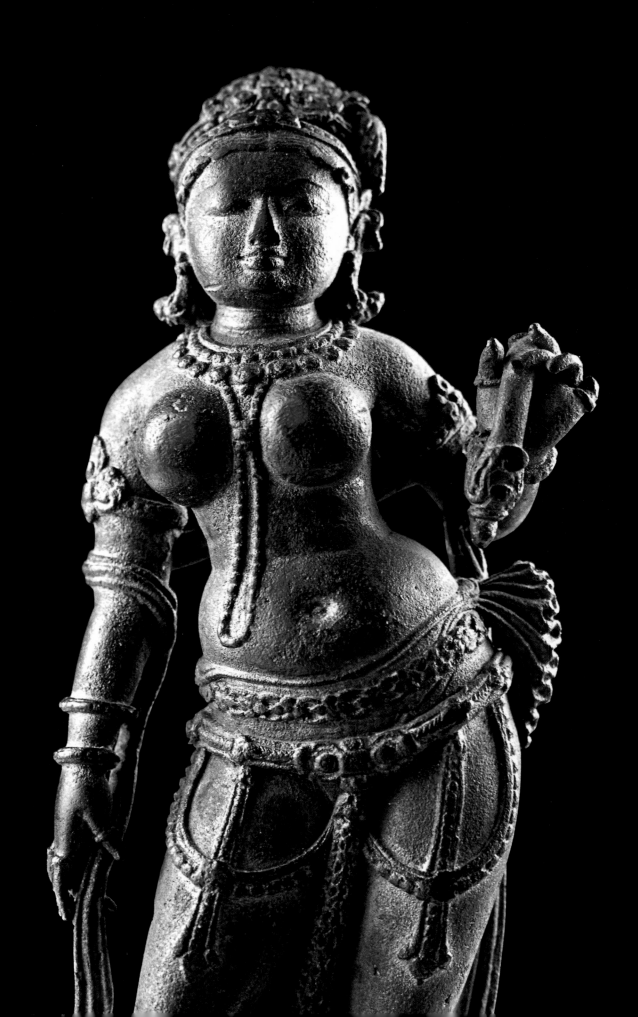

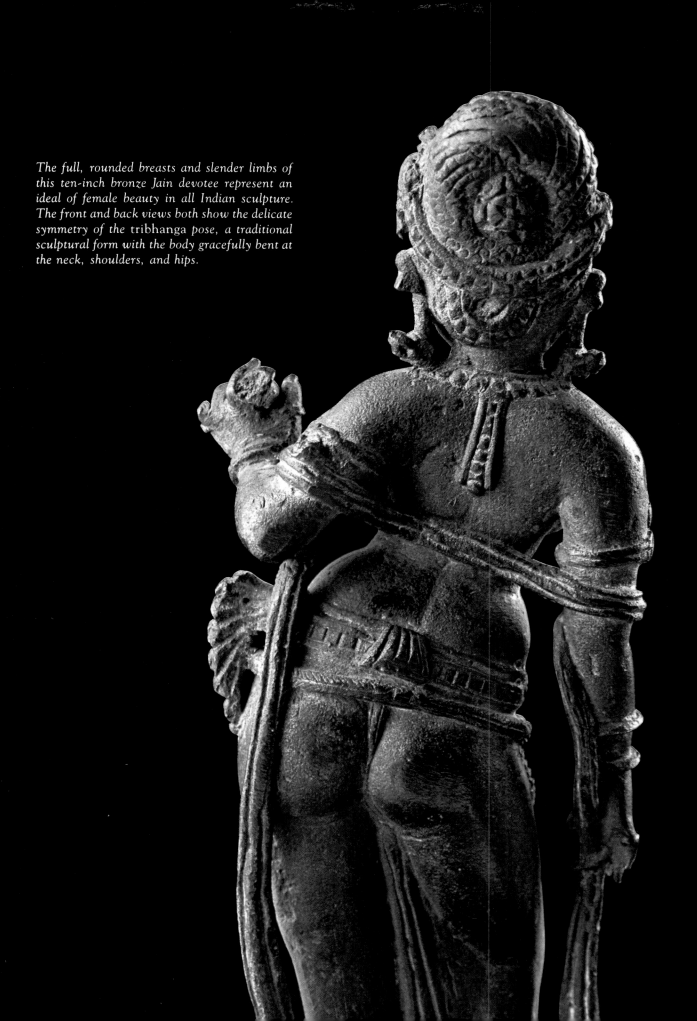

The full, rounded breasts and slender limbs of this ten-inch bronze Jain devotee represent an ideal of female beauty in all Indian sculpture. The front and back views both show the delicate symmetry of the tribhanga pose, a traditional sculptural form with the body gracefully bent at the neck, shoulders, and hips.

In the four-foot-high bronze sculpture above and in detail at right, the god Shiva dances the fierce dance of bliss inside a ring of fire. The dance of Shiva creates, maintains, and destroys the world, according to Hindu belief. Shiva's four hands represent aspects of this eternally recurring activity. With the small drum in his right hand, for example, Shiva sounded the note of creation; the flame stands for fiery devastation Shiva will ultimately wreak on the world.

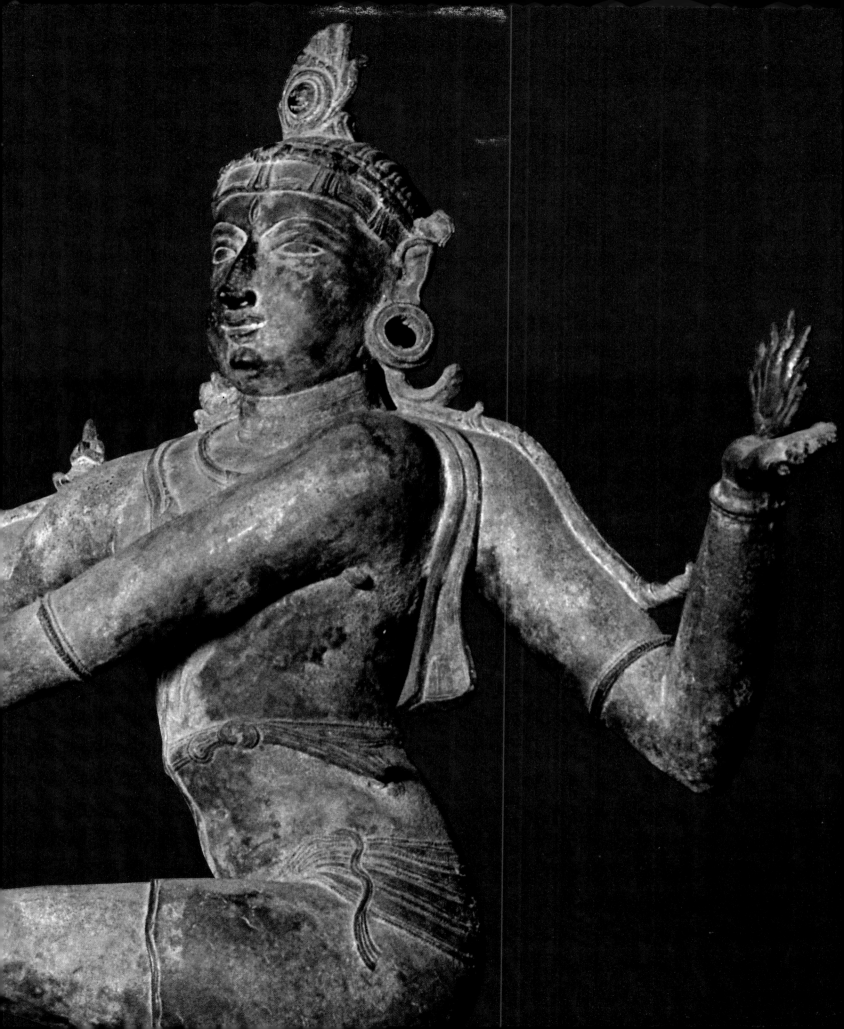

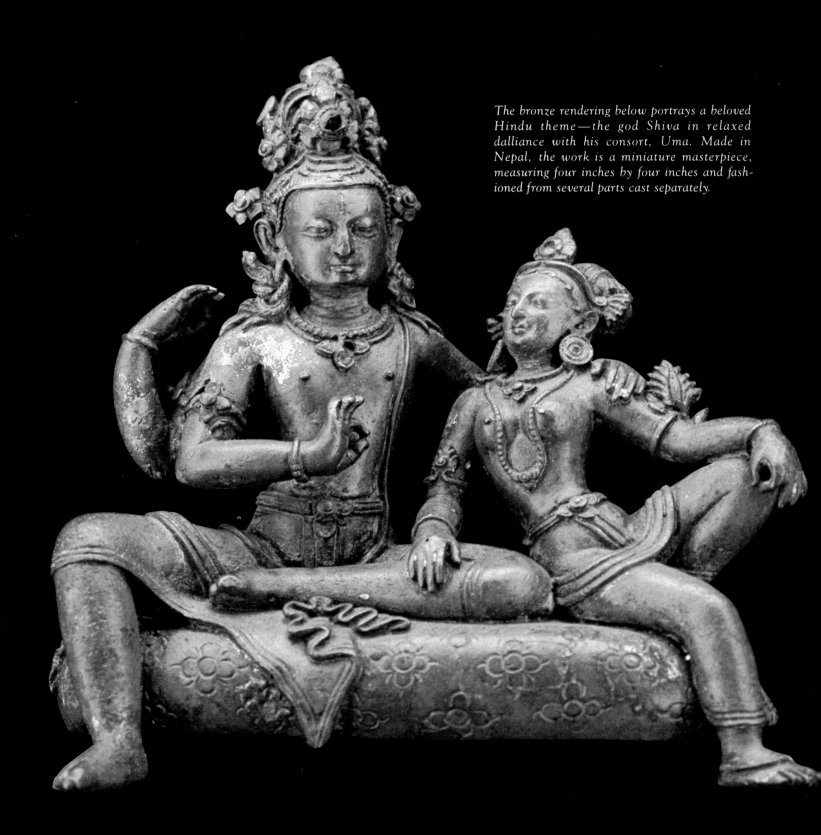

The bronze rendering below portrays a beloved
Hindu theme—the god Shiva in relaxed
dalliance with his consort, Uma. Made in
Nepal, the work is a miniature masterpiece,
measuring four inches by four inches and fash-
ioned from several parts cast separately.

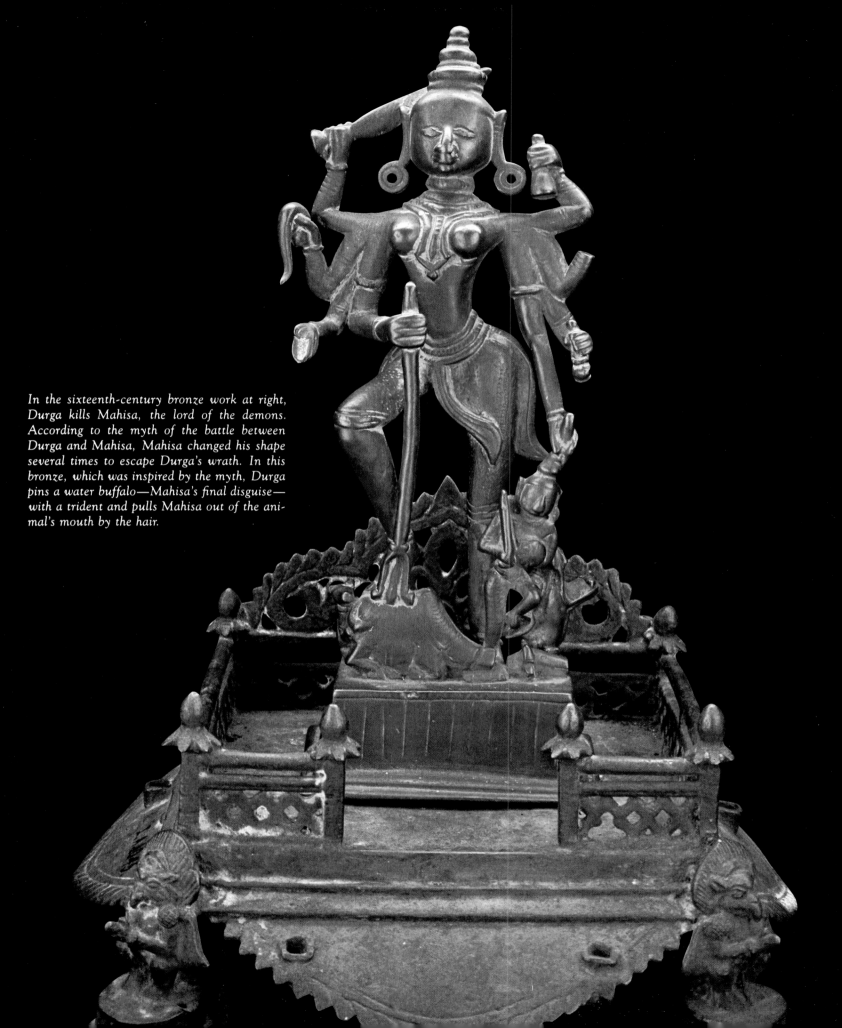

In the sixteenth-century bronze work at right, Durga kills Mahisa, the lord of the demons. According to the myth of the battle between Durga and Mahisa, Mahisa changed his shape several times to escape Durga's wrath. In this bronze, which was inspired by the myth, Durga pins a water buffalo—Mahisa's final disguise—with a trident and pulls Mahisa out of the animal's mouth by the hair.

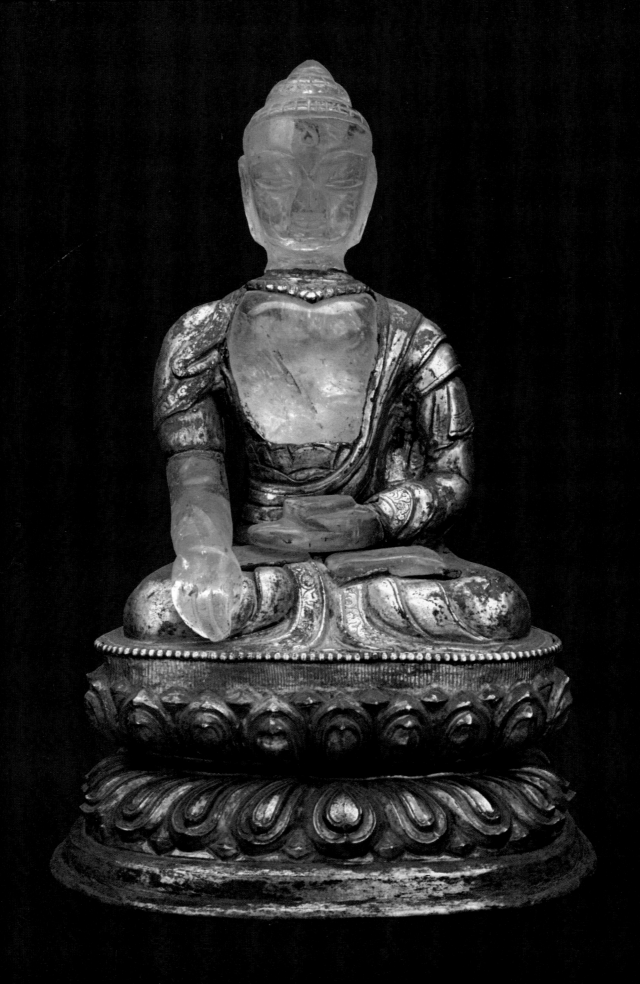

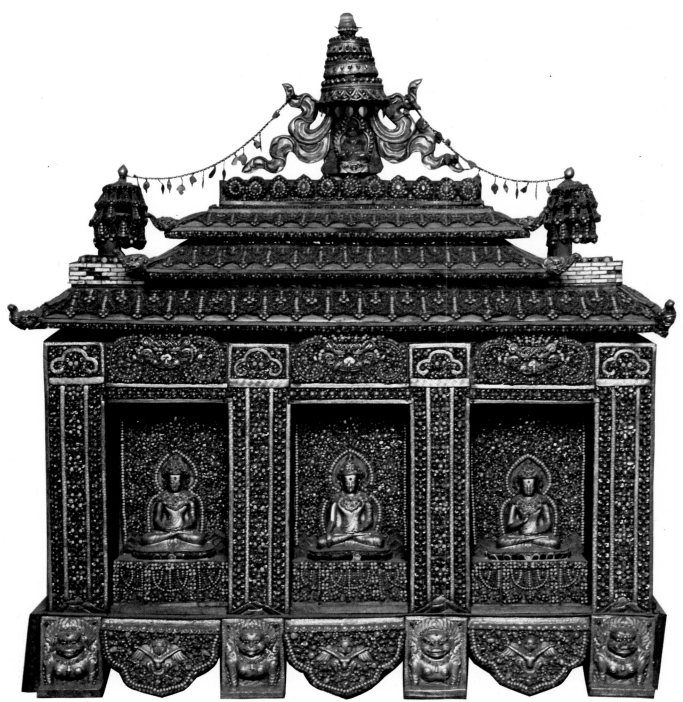

This nineteenth-century Buddhist shrine from Nepal, colorfully inlaid with a variety of semi-precious gems, displays three images of Buddhist deities in niches in its front. When worshiping at this shrine, Buddhists burned incense, which permeated the air with scent to suggest a pervasive divine essence, and walked clockwise around the shrine making a circle symbolizing the perfect unity of the cosmos. The shrine may once have contained a tooth or other relic from the Buddha's body.

The rock crystal body of the Buddha opposite—a seventeenth-century Nepali carving—possesses an ethereal mysteriousness. The statue represents the purely spiritual essence of the Buddha Maitreya, who has not yet appeared on earth.

OVERLEAF: The face of a guardian deity, one of three over the Buddhist deities on the shrine above, glares fiercely with black eyes and a fiery red mouth. The images of these beings protected the shrine from evil and made it safe for worshipers.

V

THE DEFIANT ONE

PROUD FATEH SINGH

In 1911 George V and Queen Mary, the newly crowned king and queen of England, traveled to Delhi to appear before their Indian subjects as emperor and empress. No ruling British monarch before them had ever done this, and the king said it was his way of paying tribute to the people of the subcontinent. In fact it provided India—and particularly her princes—with an opportunity to pay spectacular tribute to him.

There were 223 royal camps at Delhi for the great 10-day event; 40,000 tents and 300,000 people packed into 25 square miles of campground specially prepared for them with broad avenues, running water, and imported English roses. There can have been few greater displays of wealth and pomp in human history; certainly there has been none since.

The ceremonies began with a five-mile procession through the streets. One hundred and sixty-one princes took part, each in his own state carriage, resplendent in his richest garments, wearing his most impressive medals and most blinding jewels, and surrounded by

Seated at the rear of a courtyard, Fateh Singh—the maharana, or great prince of Mewar—receives a delegation of British dignitaries in 1890.

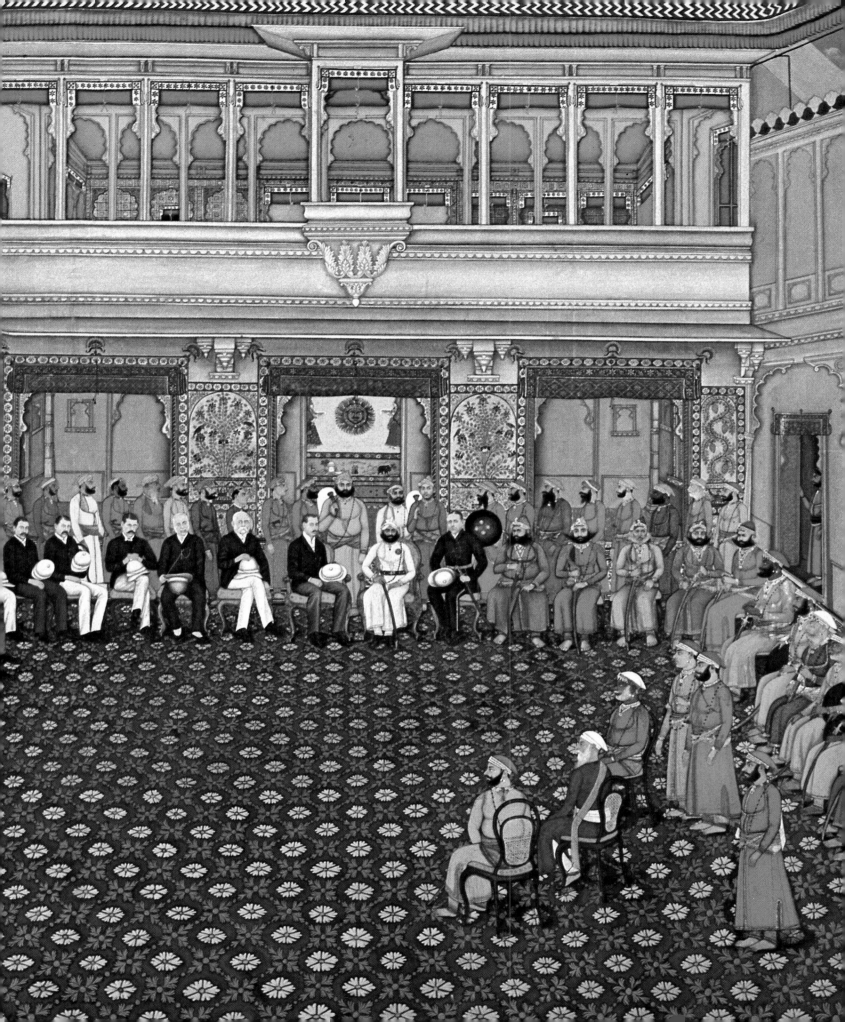

his only slightly less splendid retinue. George V himself led the march, riding a brown horse and wearing a helmet and simple military uniform in an effort to become less intimidating to his Indian subjects. This was a mistake: against the brilliant background of the princes, he seemed just another Englishman, and many of the thousands who turned out to see him never recognized the king.

The climax was the imperial durbar on December 12. The emperor and empress sat enthroned at the center of a massive stepped-marble platform beneath a canopy of crimson and gold, surrounded by a glittering entourage that included a covey of young nobles with jeweled daggers who served as imperial pages. More than 100,000 people watched as one by one the maharajas came forward to pay obeisance to the British crown. Maharaja Madho Singh II of Jaipur outdid himself in public fealty: wearing a black velvet robe embroidered with gold, and a gold turban brilliant with diamonds, he laid his sword on the steps and salaamed to each of his sovereigns.

Conspicuous by his absence from this parade of obsequious rulers was the most exalted of all the Indian princes, Fateh Singh, the maharana of Mewar—as the rulers of Mewar are called. He had feigned illness to avoid being present. A splendid-looking white-bearded old Rajput, he was the living symbol of the oldest of all the ancient royal houses. Not even the emperor of India could command his presence.

In this Fateh Singh was upholding the time-honored tradition of his family, the Sesodias. It was the boast of the Sesodia clan that no ruler of Mewar had ever surrendered a daughter to a Mogul ruler, the crudely symbolic way by which all the other Rajput princes had been made to profess their subjugation.

For eight hundred years the Mewar capital had been the fortress of Chitor, a place with a terrible history. Chitor fell three times to invading Muslim armies—in 1303, 1535, and 1567. Each time, rather than surrender to the enemy, the women of the fortress—thousands of them, dressed in their finest saris, wearing all their jewels, and led by the Sesodia queens and princesses—burned themselves alive in cavernous fire pits beneath the walls. Thirteen

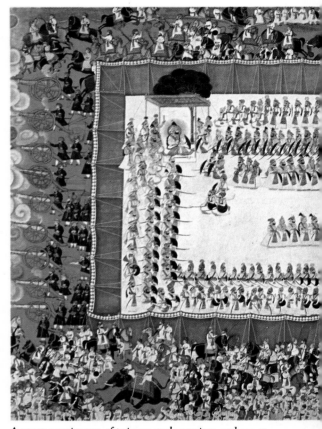

A great contingent of princes and warriors gathers at a military festival presided over by an ancestor of Fateh Singh, the maharana Jawan Singh, who reigned from 1828 to 1838. Troops mounted on camels and horses form ranks around the perimeter as cannons discharge (at left). Inside red tentlike walls the maharana sits under a canopy.

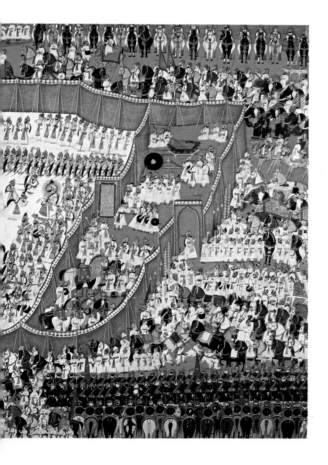

thousand women are said to have immolated themselves during one siege alone. Each time the warriors then put on the saffron robes of sacrifice, threw open the gates, and rushed out to fight until they were hacked to death. The last general to seize Chitor was Akbar, the greatest of all the Moguls. The valor of two particular defenders so impressed him that he set up statues of them on either side of the entrance to his own palace.

Yet Mewar resistance continued. Udai Singh, the last Sesodia to rule from Chitor, had slipped away before the final siege and began to build Udaipur, a new capital that he named for himself, on the shores of a hidden mountain lake. He was succeeded in 1572 by his son Pratap Singh, who waged unceasing guerrilla war against the Moguls for a quarter of a century. His tireless horsemen beat back army after army sent to subdue them, and the implacable Pratap refused even to council with other Rajput chieftains because they had disgraced their race by submitting to the invaders. His father had pledged that he and all his successors would atone for the "sin of the sack of Chitor" by sleeping on straw and eating off leaves. (This pledge was honored: even in times of astonishing opulence, the rulers of Udaipur would rest their heads on straw mats and use large leaves as place mats beneath their gold dinnerware.)

Mewar and the Moguls made a gingerly peace in 1614, which tacitly recognized that the ferocity of the Sesodias and the unforgiving landscape of red deserts and fortified hilltops they defended made permanent conquest impossible. Thereafter, the rulers of Udaipur were technically vassals of the Mogul emperor, but they were never required to attend court, as were all their fellow Rajput princes.

Maharana Pratap Singh had died, in 1597, in a makeshift hut surrounded by the beginnings of his father's city on the shores of Lake Pichola. "These sheds," he warned as he lay dying, "will give way to sumptuous dwellings, thus generating the love of ease; and luxury, with its concomitants will ensue, to which the independence of Mewar which we have bled to maintain, will be sacrificed."

Pratap Singh was right on every count. No Indian city was more sumptuous—or more beautiful—than Udaipur, and its very richness

bred a complacency that nearly destroyed the kingdom. On the hillsides around the broad blue lake grew a profusion of forts and palaces and pleasure gardens, all built of blinding white marble. The greatest of these, the so-called City Palace, was possibly the largest and the most spectacular of all of India's royal homes. Its lofty towered walls were left unadorned, as suited a warrior people always worried about attack. But inside was a four-hundred-acre city within a city, which housed all the retainers whose services the most demanding prince might require for his safety and comfort during a long siege—everyone from armorers to dancing girls, dairymen to elephant trainers. Another palace, in which the women of the court lived in enforced isolation, stood next door, huge and nearly windowless.

The heart of the palace proper was a grandiloquent dream landscape of domes and turrets, balconies and gardens: there were miles of marble corridors and great courtyards whose walls were covered with brightly painted scenes from the campaigns of Pratap Singh. Light rainbowed into the royal bedchambers through fretworked windows filled with colored glass. On the upper stories were hanging gardens with splashing fountains, blankets of flowers, and marble paths leading beneath pomegranate and orange trees. Clouds of green parrots billowed and spun above the gardens in the evenings, and peacocks preened and shimmered on the battlements.

From here the maharana could view his many smaller palaces, including two built on islands that seemed to float in the middle of the lake. One of these, the Jagmandir palace, was built in the 1620s as a sanctuary for Prince Khurram, the rebel son of the Mogul emperor Jahangir. The prince lived to become the emperor Shah Jahan and eventually built the famous marble mausoleum outside Agra, the Taj Mahal. (In 1857 the island became a sanctuary again, this time for British women and children seeking to ride out the mutiny's storm under Maharana Swaroop Singh's protection. He had no special love for the British; but he believed war should be waged only among men and confiscated all the boats on the lake so that none of his subjects who lacked his sense of chivalry could reach his guests.)

A noble in an elephant-borne hunting party fires his musket at a tiger in one of the royal game preserves outside Udaipur. Wild boar, deer, hyena, and hare also abounded in the countryside. Hunting parties often included cooks, who roasted the kill for an outdoor feast that capped the day's shooting.

The larger of the island palaces, the Jignawas, was wholly devoted to summer pleasures. On his visits there the maharana could stroll amid fountains and kiosks, through groves of lemon and mango trees, and dally at a secluded marble pool built in the form of a maze. On a high marble chair in the center of the maze, the maharana often sat and watched the women of his harem bathe before they found their way to him. On that island, wrote Colonel James Tod, the British chronicler of the Rajputs, the maharana and his nobles "listened to the tales of the bard, and slept off their noonday opiate amidst the cool breezes of the lake, wafting delicious odors from myriads of the lotus flowers which covered the surface of the waters; and as the fumes of the potion evaporated they opened their eyes on a landscape to which not even its inspirations could frame an equal.... Amid such scenes did the princes and chieftains recreate ... exchanging the din of arms for voluptuous inactivity."

The bards of whom Tod wrote did their best to remind the ruler and his nobles of Chitor and the warrior past; but the languid life the maharanas came to lead in their beautiful city inevitably made the memory of their proud history recede. Even hunting, once a vigorous activity done on horseback, became less than arduous. When the maharana went into the jungle, three thousand retainers went with him. A city of carpeted, richly appointed tents was set up each night. The maharana and his guests slept on string beds with silver legs and rode out each morning on elephants, preceded by minstrels singing hymns of praise and waving palm branches interwoven with ropes of wild roses. The hunters did their shooting from impregnable stone boxes built at the narrow ends of ravines into which the game was driven. The strenuous reloading of the muskets was left to liveried gunbearers. At day's end the gullies were heaped with dead animals—boars, deer, jackals, leopards, hyenas, porcupines—anything unlucky enough to have come within range. Back at camp in the evenings, long files of servants brought dish after dish to the banquet table, while troupes of dancing girls entertained by firelight.

The martial skills of Udaipur withered. The maharana's grip on his nobles loosened dangerously: they warred against one another

and quarreled with him. Roving bands of raiders pillaged the countryside. Udaipur was in chaos when the British finally took it under their protection in 1818.

Udaipur had two nineteenth-century redeemers. The first was Colonel Tod, who was sent to Udaipur as resident with a mandate to restore order. A seasoned soldier and amateur scholar with a rhapsodic nostalgia for the Rajput past, he chose to do it by reasserting the ancient power of the throne. At Tod's urging the reigning maharana, Bhim Singh, compelled his nobles to reaffirm their loyalty and further proclaimed that if they dared disturb the maharana's peace thereafter, "their heads shall instantly be taken off."

The second redeemer was Maharana Fateh Singh, who came to the throne in 1884. A slim, handsome prince with an air of intimidating hauteur, he had been raised in a remote village far from the languor of Udaipur, and his boyhood had been filled with hunting and the ornate legends of the Rajput past. The memory of Chitor and the duty it imposed on him remained fresh in his mind during more than forty years of rule: he was determined to be the keeper of Rajput honor and the unyielding defender of the old ways. Just as his forebears had not bent their knees to the Mogul emperor, he refused even to consider traveling to England; he was usually allowed to plead ill health when the other princes scurried to Delhi to display their enthusiasm for their British masters. In the hope of luring Fateh Singh to the 1911 durbar, the British had tactfully appointed him to the emperor's personal staff because in that role the maharana could stand on the platform beside the king and would not have to bow; even then the maharana managed to absent himself entirely from the ceremonies.

Fateh Singh knew that open defiance of the British was unrealistic, but he did all he could behind the scenes to slip their yoke. When he was awarded the highest British honor that could be conferred upon an Indian prince—grand commander of the Star of India—he professed himself grateful but pledged in private never to wear its broad crimson sash because, he said, it made him look like a chaprassi, a government messenger boy.

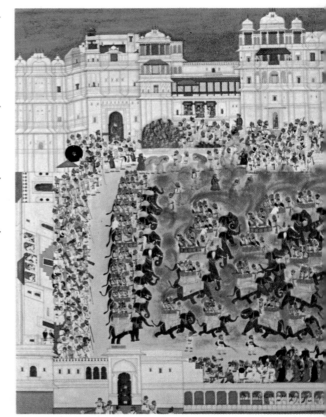

In front of the magnificent City Palace, the maharana's principal residence, a mixed crowd of nobles and commoners celebrate Holi, a Hindu festival of spring. After entering through the gate at right, elephants proceed onto the vast courtyard, where their riders fling red powder into the air—part of the general merrymaking of this holiday.

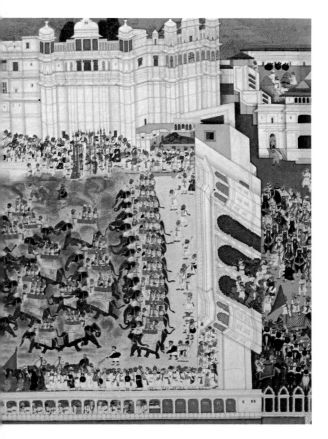

British-run railroad crews were laying track to Udaipur when Fateh Singh became maharana: he ordered them to stop, and, when the British protested, Fateh Singh said that the work could continue only if he were permitted to dismiss the dewan they had imposed upon him. The British agreed, the dewan was fired, and Fateh Singh allowed the railroad to come within three miles of his capital, but no closer. If the modern world ever came to Udaipur, it would not come by rail. A famine killed thousands of the maharana's subjects in 1899, and the British proposed an irrigation system to ensure that this not happen again. Fateh Singh said no. The surrounding hills were pitted with ancient lead and copper mines, scoured out centuries before: might the maharana be interested in reopening some of them, using modern methods? No. There was precisely one secondary school in the state: Fateh Singh saw no need for another. The fragile web of British-built, all-weather roads disintegrated for want of repair: Fateh Singh's ancestors had had no need of roads.

Udaipur revenues were sparse, provided mostly by poor farmers who were still tilling the parched land with the traditional warrior's shield on their shoulders and sword at their sides well into the 1920s. But Fateh Singh spent so little money on services that there was usually a surplus in his treasury, enough of one for him to hurl fistfuls of silver coins into the crowds whenever he rode out from his palace, just as the first maharanas had done a thousand years before. And he often made the fourteen-mile pilgrimage to the great temple at Eklingji, where the rulers of his state had sought the favor of Shiva since the eighth century. When an over-eager British resident ventured that Fateh Singh might set up a finance department to keep better track of things, the prince replied, "I am Rajput. Soldier and sportsman. Not moneylender." Scorn for bankers was nearly universal among the princes: when the moneylenders' demands for repayment grew too insistent, the maharaja of Indore liked to drive them in teams of four around and around his racecourse.

But even Fateh Singh could not stop the twentieth century. He angered the British during World War I when—already exempt from having to provide troops—he refused even to allow the mining of

Seated at lower right and portrayed with a halo, Shambhu Singh, maharana from 1861 to 1874, hosts a banquet on the black and white marble courtyard at his tranquil island retreat in Udaipur's Lake Pichola. The maharana converses with guests as his cooks, their mouths covered, prepare kabobs.

mica in his hills for the imperial war effort. Then the poorest of his peasants rose against him in a series of civil disobedience campaigns. They were led by nationalists who had slipped secretly across his borders and who were trained in the nonviolent tactics of Gandhi.

In 1921 the British finally stripped him of his powers—though not his titles—and replaced him with his more malleable son, a genial dwarf. Fateh Singh died in 1930, an anachronism even among the Indian princes.

By then princely India was already doomed. The free, democratic republic envisioned by the nationalists had no room for monarchs, no matter how benevolent their rule or ancient their lineage. The princes had been Britain's staunchest Indian allies, and they would have to take the consequences when freedom came.

The maharajas tried to fight back, forming a Chamber of Princes in 1921. But the chamber could rarely agree on a united course of action: compromise does not come easily to princes. When India was finally granted her freedom in 1947, the British could no longer defend the princes—they were simply abandoned.

The princes then faced a clear but brutal choice: they could declare their independence and try to resist sure invasion by the independent republic that now surrounded them, or they could merge their states peacefully into it, in exchange for certain privileges and a privy purse. One by one the maharajas reluctantly yielded their thrones.

Some of the ablest princes played important roles in Indian life after independence. The last maharaja of the kingdom of Mysore, the grandson of Krishnaraja IV, became the first governor of the new state of Mysore. The maharaja of Jaipur became rajpramukh, or president, of Rajasthan, made up of the old Rajput kingdoms.

But the days of royal splendor were over. The gleaming lake palace at Udaipur became a luxury hotel, catering to charter tours. And some years ago agents of the Indian internal revenue service climbed the long hill above Amber and smashed their way into the treasure tower to claim its contents as part of a judgment of tax delinquency against the descendants of the great Jai Singh.

TRAPPINGS
FOR A GOD

Made of solid gold, this three-inch-long figure of Nandi—a sacred bull that is Shiva's companion—crouches before an image of the god (overleaf) in the temple at Eklingji.

Fourteen miles north of Udaipur, in a valley protected by dry, jagged hills, lies the temple complex of Eklingji. Its site was selected in the eighth century by Bappa Rawal, an early ruler of Mewar, who believed that he received his kingdom through the grace of Shiva and so built a temple to the god in gratitude. Shiva has remained the patron deity of the maharanas of Mewar over the succeeding centuries: each ruler worshiped at Eklingji at his enthronement and paid frequent visits throughout his life.

The original temple of Bappa Rawal did not survive. But, in the fifteenth century, the maharana Raimal raised the present central temple, an imposing structure with roofs of varying levels that bristle with cones and figures of lions and elephants. The same maharana also installed the temple's most sacred treasure, opposite: a stone statue known as a linga, the image by which Shiva is primarily worshiped. The linga recalls a principal myth of Shiva relating how the god tore off his phallus and dropped it to earth, where it turned into a colossal pillar of flames. The fiery column signaled Shiva's presence to the other gods; on earth men copied the pillar in the form of the linga.

As objects of devotion, lingas present a visual paradox, combining the pillarlike shape of Shiva's phallus with one or more faces of the god. Such an image is both erotic and ascetic, because it evokes at the same time sexual desire and the mastery of mind over desire. The juxtaposition of face and phallus also reflects the Hindu belief that Shiva is a god of contradictory aspects, at once creator and destroyer, man and woman, hunter and healer, tyrant and lover.

The most time-honored form of Shiva worship is a ceremony led by priests who anoint and adorn a linga, in the belief that such a ritual invests the linga with Shiva's presence.

The rulers of Mewar endowed the temple at Eklingji with especially lavish offerings for use in this ceremony. The most important adornments appear in this portfolio. Those on pages 154–161 are ritual objects kept near the linga's sanctum; the gold ornaments (pages 162–169) that actually adorn the linga are stored in a separate treasury, which only a priest may enter. By virtue of these holy riches, the Mewar dynasty proved its devotion to Shiva and at the same time made Eklingji one of the greatest pilgrimage centers in all Rajputana.

A benign face on this linga—the symbol of Shiva— gazes out from an inner sanctum. Carved from black stone, the linga is five faced: two other faces are in profile, the fourth is in back, while the rounded top of the linga represents the fifth. The faces embody the five elements (space, air, earth, fire, water), the five senses, and the five mantras—or incantations— associated with Shiva. A priest has placed three leaves from the wood apple tree on the linga's crown at the start of a ceremony to honor the deity.

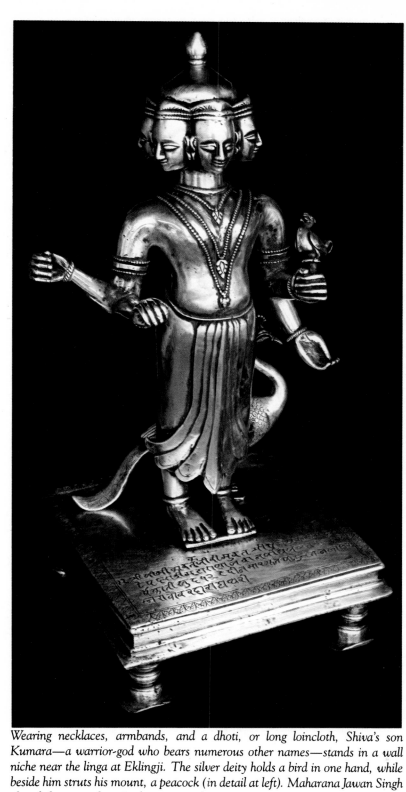

Wearing necklaces, armbands, and a dhoti, or long loincloth, Shiva's son Kumara—a warrior-god who bears numerous other names—stands in a wall niche near the linga at Eklingji. The silver deity holds a bird in one hand, while beside him struts his mount, a peacock (in detail at left). Maharana Jawan Singh placed the statue here in the nineteenth century.

OVERLEAF: Four of the six heads of Kumara gleam on this detail from the statue above. Another of the god's names is Shanmukha, "the six-faced": he is said to have been born with six heads, then nursed by six of the stars of the constellation Pleiades.

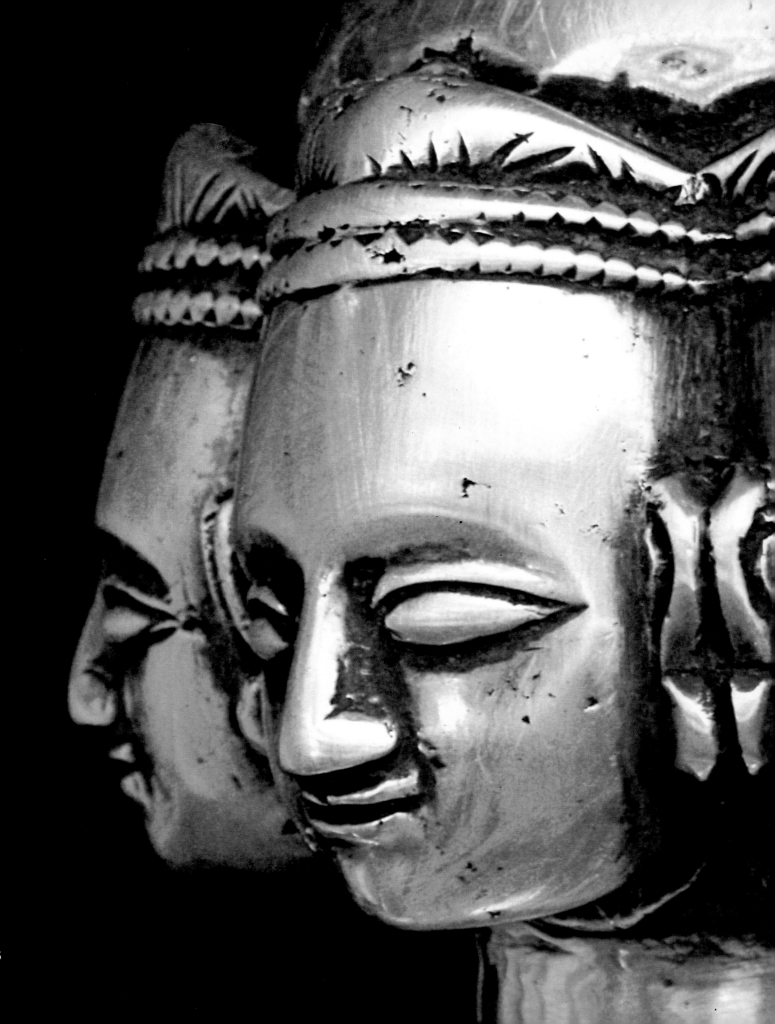

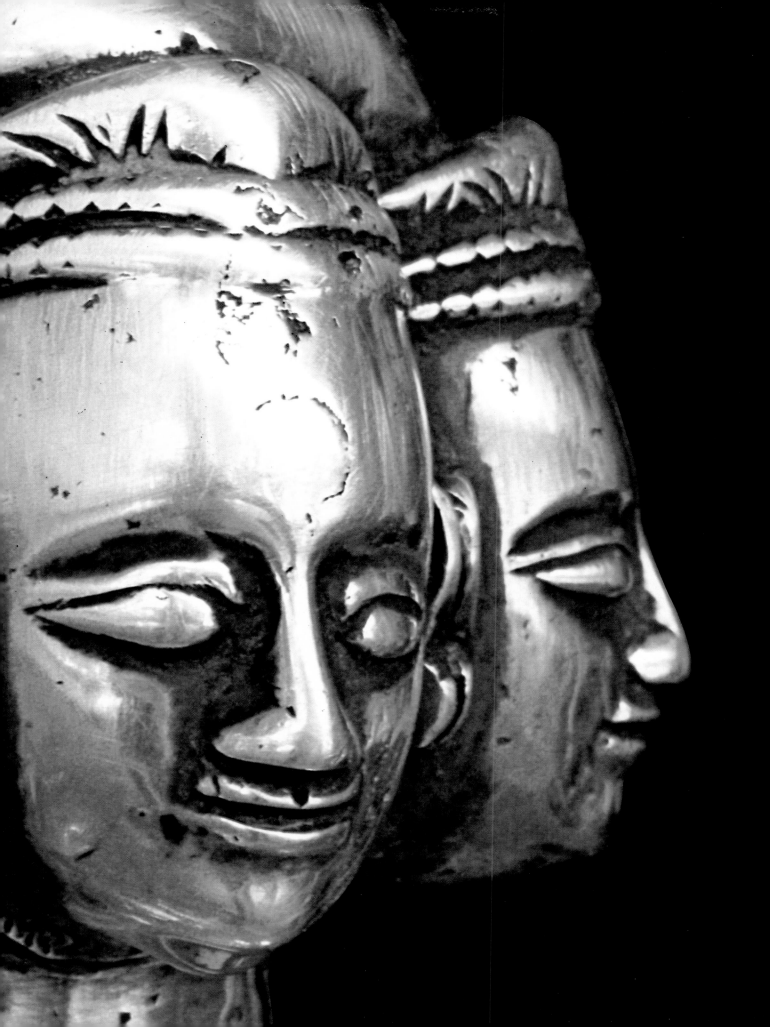

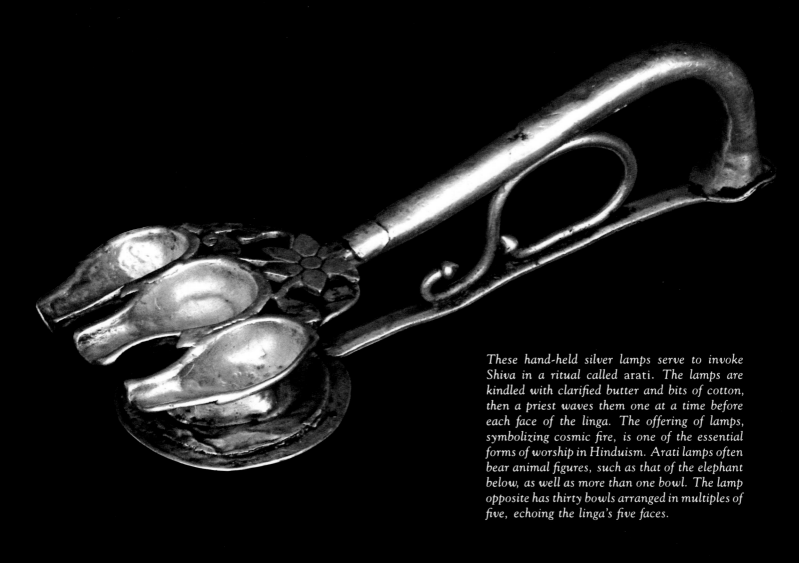

These hand-held silver lamps serve to invoke Shiva in a ritual called arati. The lamps are kindled with clarified butter and bits of cotton, then a priest waves them one at a time before each face of the linga. The offering of lamps, symbolizing cosmic fire, is one of the essential forms of worship in Hinduism. Arati lamps often bear animal figures, such as that of the elephant below, as well as more than one bowl. The lamp opposite has thirty bowls arranged in multiples of five, echoing the linga's five faces.

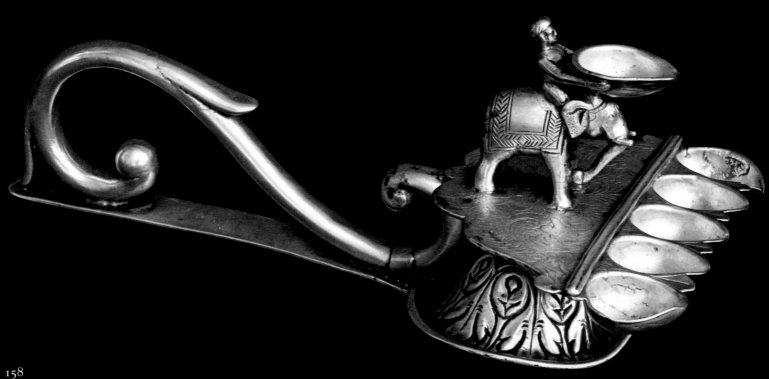

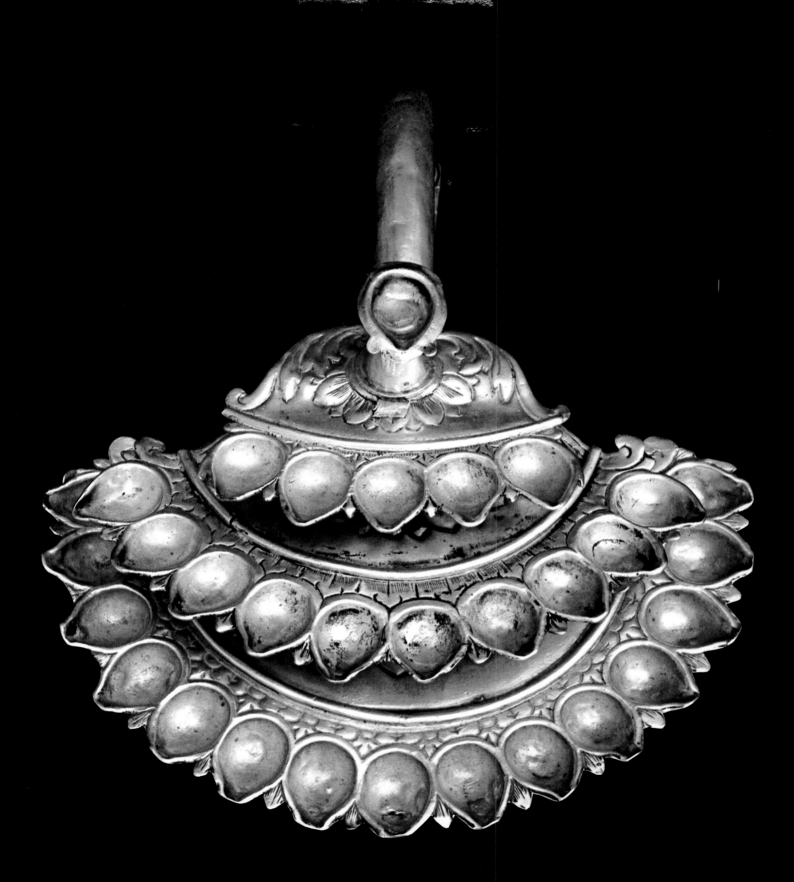

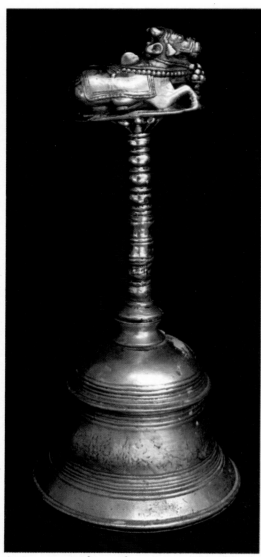

As he waves each arati lamp (pages 158–159), the temple priest rings the foot-high silver bell above, its handle topped by a gilt image of Nandi, the bull that symbolizes Shiva's strength and righteousness. The beast's compact, powerful form, in detail at right, bears a string of bells, harness trappings, and a saddlecloth. Between his forelegs he clutches a bowl with offerings of delicacies for the god.

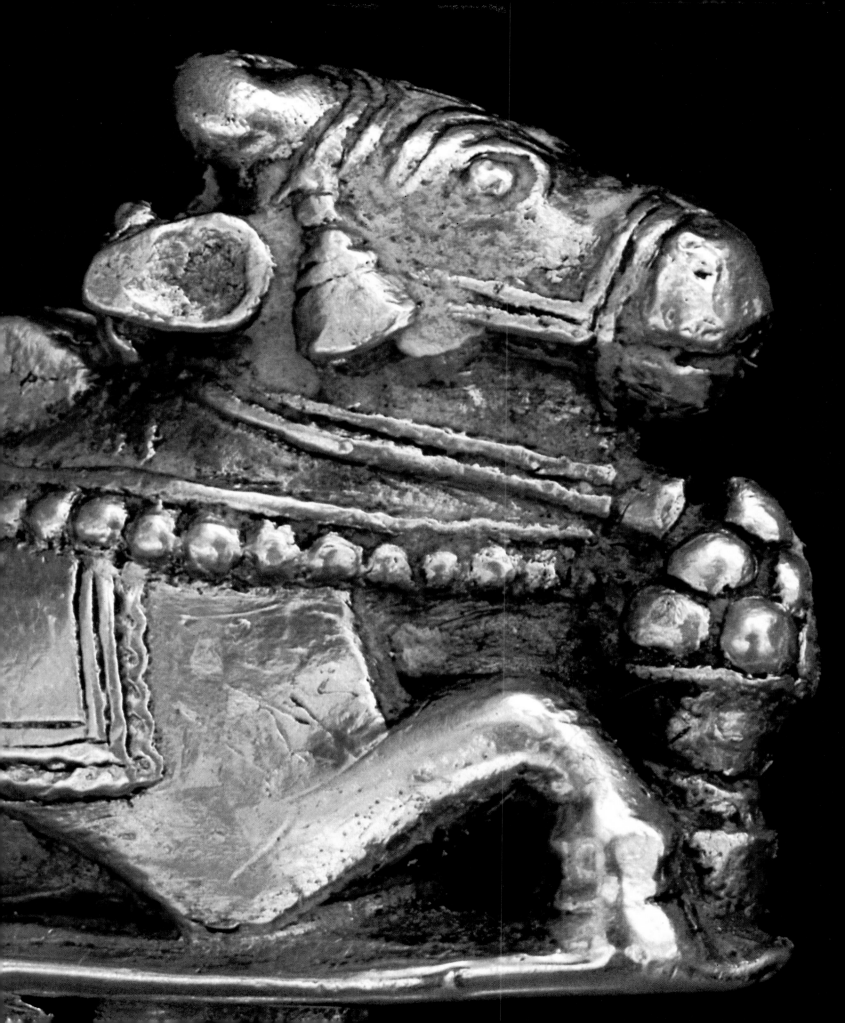

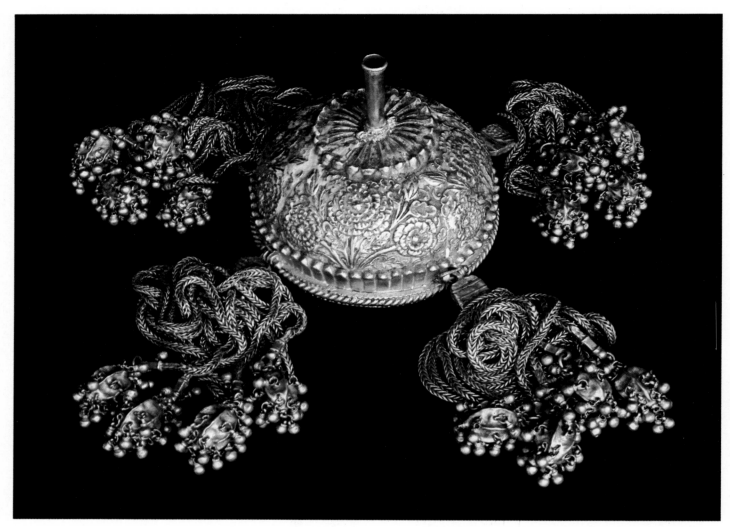

Embossed with floral patterns, this gold skull cap—which priests lay within the coils of the cobra opposite—has four clusters of four long gold chains that frame each face of the linga. At the end of each chain is a gold bead in the form of a seedpod, akin to pods from a tree that is sacred to Shiva.

The nine-headed, gold cobra opposite, measuring ten inches at its coiled base, is the headdress for the Eklingji linga. Able to shed its skin and able to kill, the snake symbolizes both renewal and death.

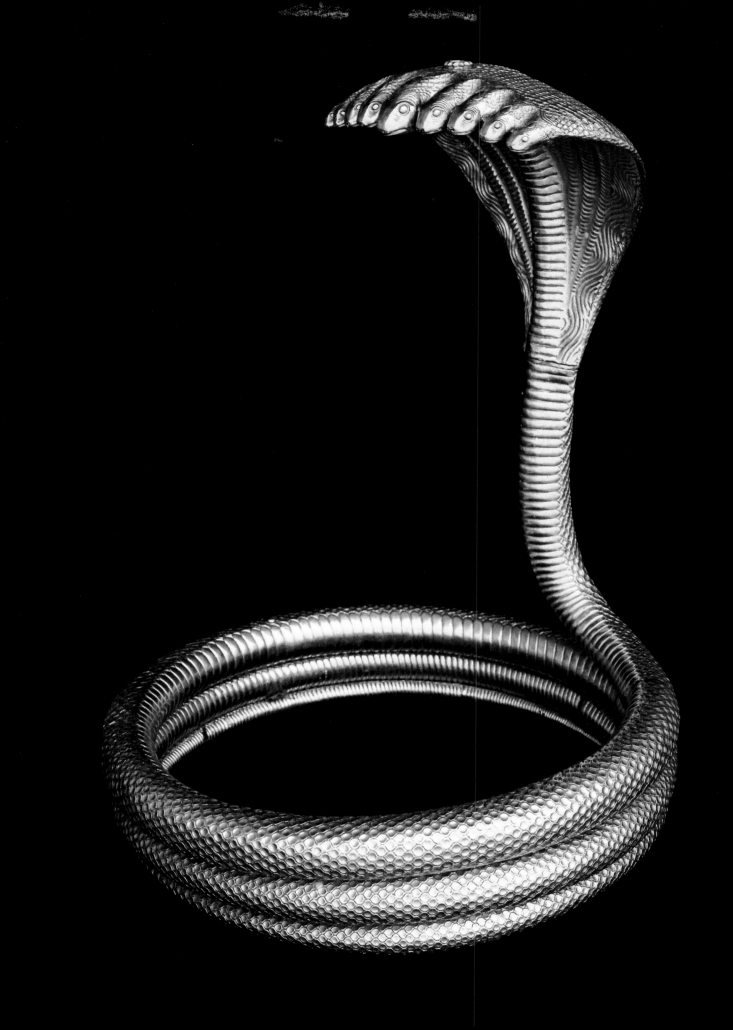

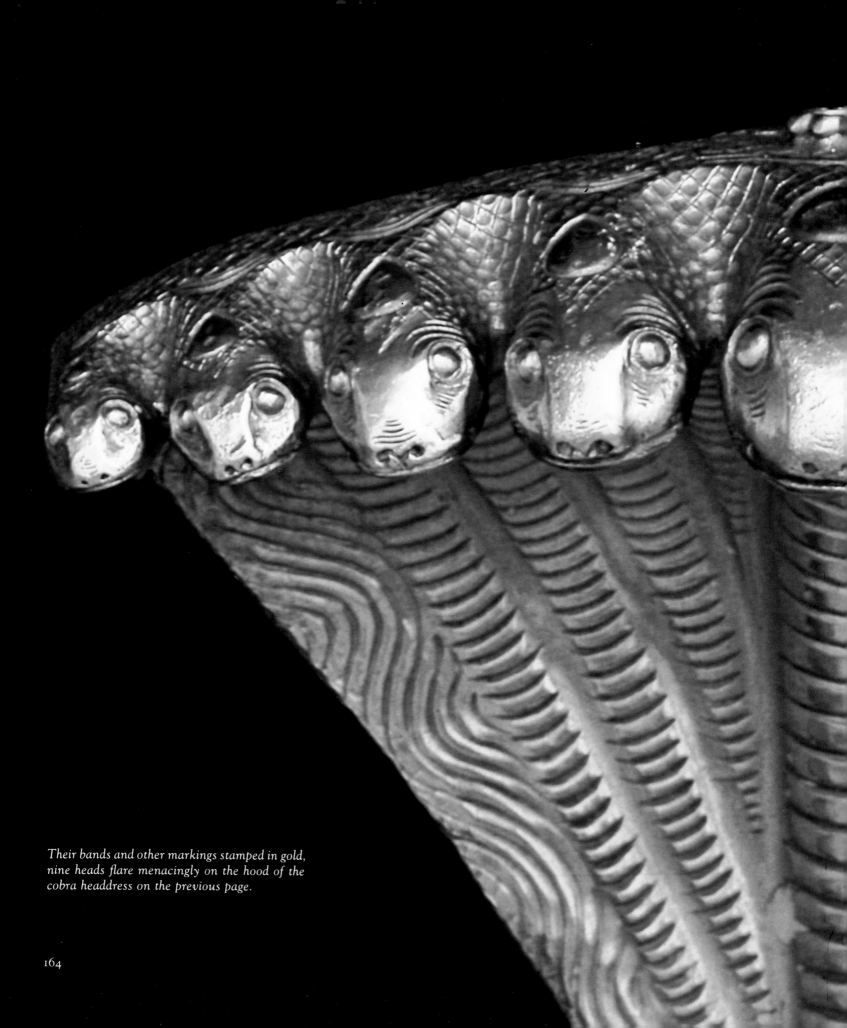

*Their bands and other markings stamped in gold,
nine heads flare menacingly on the hood of the
cobra headdress on the previous page.*

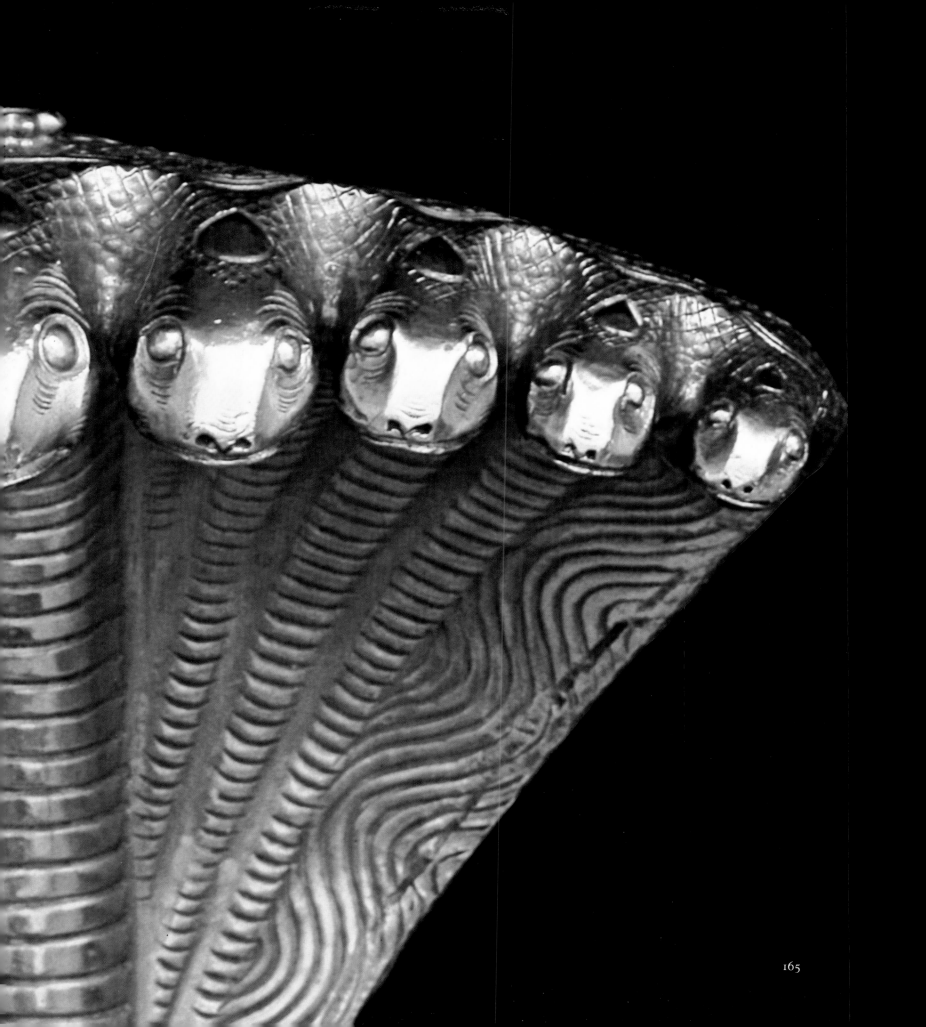

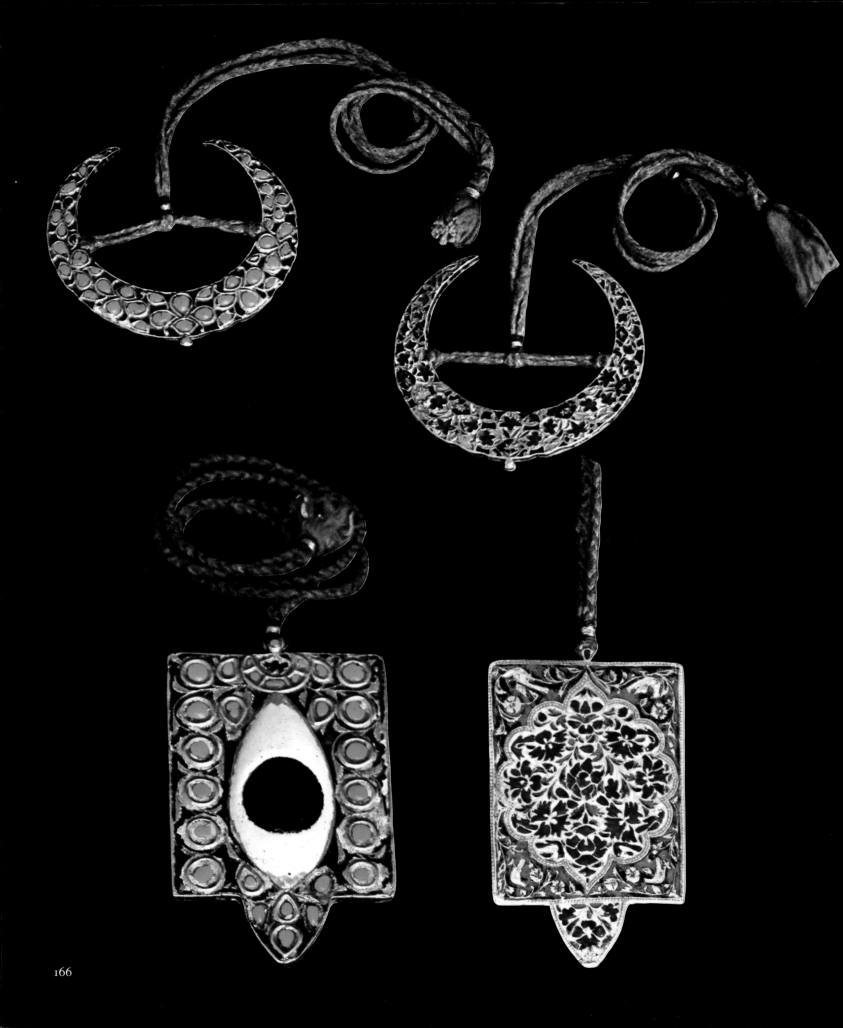

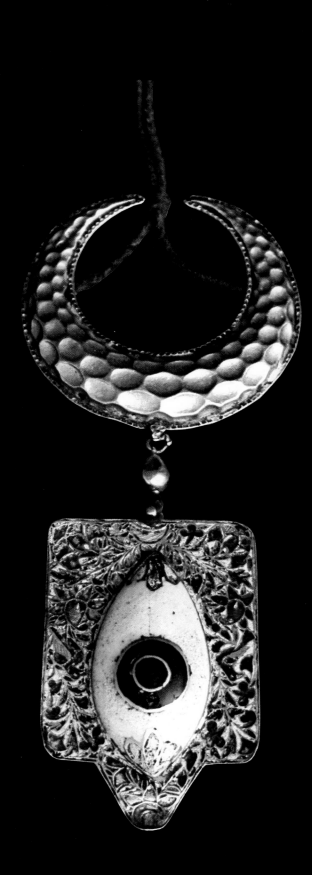

Adornments of gold set with semiprecious stones convey various attributes of Shiva. On the opposite page a crescent moon (top left) is a symbol of life and immortality, while the emblem below it—a rendering of the god's mystical third eye— represents a fiery, destructive force. These sides of the ornaments are inlaid with turquoise, while their backs (also on the opposite page) display exquisite enamel work. Joined together, a crescent and third eye evoke the essence of Shiva: creation vying with destruction. The two pieces joined at left, which are from a different set of ornaments, appear on the statue overleaf, as does the gold-and-pearl nosepiece above—an ornament that, when placed on the linga's left side, emphasizes Shiva's feminine half.

OVERLEAF: Bedecked with garlands of flowers and a full complement of jewelry, the linga is transformed for worship—an earthly image manifesting Shiva's divine presence and power.

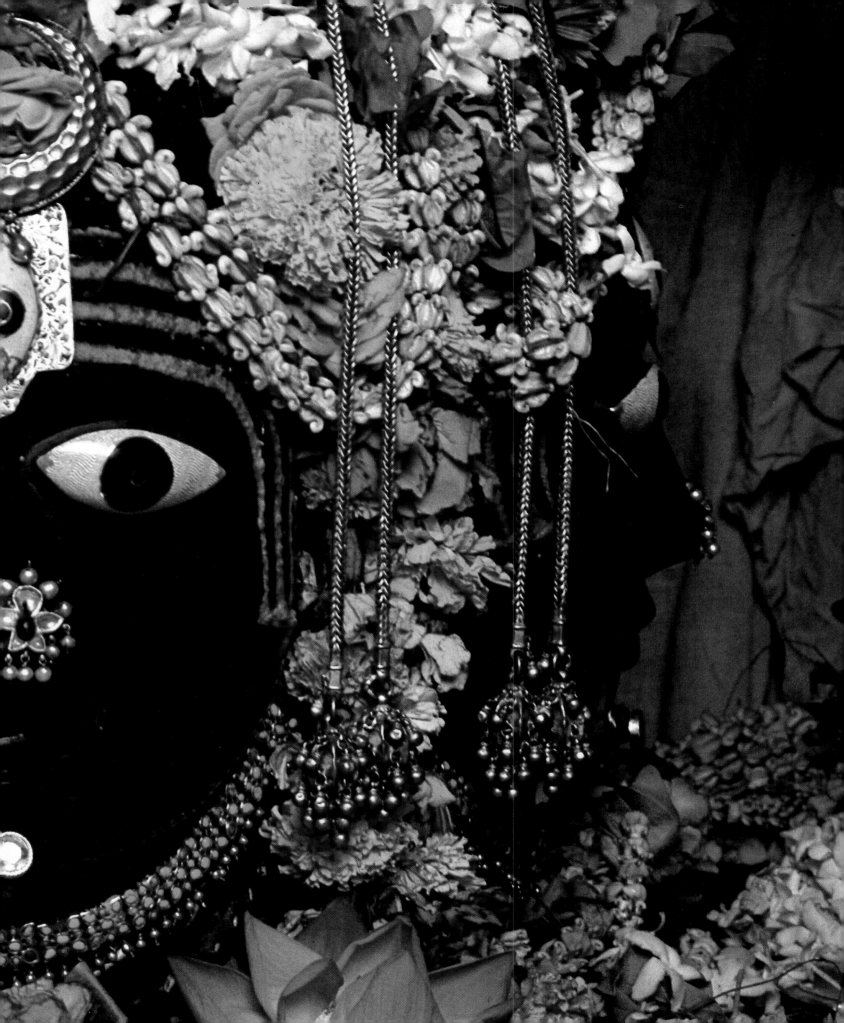

INDIA: A CHRONOLOGY

JAIPUR		BENARES	
c. 1500 B.C.	Aryans move onto the Indian plains, bringing sacred lore that merged with indigenous cults and divinities, forming the basis of Hinduism	1738	Mansa Ram founds ruling family of Benares
		r. 1740–1770	Maharaja Balawant Singh
c. 1000 B.C.	Scythians invade northern India and intermarry with local peoples: the origins of the Rajputs	c. 1740	Balawant Singh rebuilds Benares, including the Ramnagar palace
		r. 1770–1781	Maharaja Chait Singh
7th c. A.D.	Arab Muslims invade India	1776	British East India Company forces governor of Oudh to cede the city
c. 1100	Rajputs found Amber		
1526	Baber captures Agra and establishes Mogul empire	r. 1781–1796	Maharaja Mahip Narain Singh
		r. 1796–1835	Maharaja Udit Narain Singh
r. 1556–1605	Akbar, Mogul emperor of northern region of India	1820	Udit Narain commissions illustrated version of the *Ramayana*
1600	British East India Company chartered by Queen Elizabeth I	r. 1836–1889	Maharaja Ishwari Prasad Narain Singh
r. 1605–1627	Jahangir, Mogul emperor	1840	Ishwari Prasad builds Queen's College to house Hindu texts
1609	English traders arrive in India		
r. 1658–1707	Aurangzeb, Mogul emperor		
1699	Jai Singh II comes to power at Amber		
r. 1719–1748	Mohammed Shah, Mogul emperor		
c. 1720	Jai Singh builds new capital at Jaipur		
1743	Jai Singh dies		
r. 1750–1768	Madho Singh I		
r. 1778–1803	Pratap Singh		
1799	Pratap Singh builds Hawa Mahal		
1803	Pratap Singh signs treaty bringing Jaipur under British protection		
r. 1803–1818	Maharaja Jagat Singh		
r. 1851–1880	Maharaja Ram Singh		
1857–1858	Indian Mutiny		
r. 1880–1922	Maharaja Madho Singh II		

MYSORE		BARODA		MEWAR	
1610	First celebration of Wadiyar family's annual Dasehra festival	c. 1650	Shivaji founds Maratha kingdom	r. 734–753 (?)	Bappa Rawal
1759–1782	Haidar Ali controls Mysore, but is constantly at war with the British	r. 1856–1870	Maharaja Khande Rao Gaekwar	8th c.	Bappa Rawal builds Eklingji temple to Shiva
1782	Tipu Sultan and British make uneasy peace	1866	Khande Rao purchases the Brazilian diamond called the Star of India	r. 1473–1509	Maharana Raimal
1799	British seize Mysore and place Mummadi Krishnaraja Wadiyar on throne as maharaja		Louis Rousselet visits Khande Rao's court	15th c.	Raimal builds new temple at Eklingji and installs linga
1831	British Commission takes over ruling of Mysore, while maharaja rules in name only	r. 1870–1873	Maharaja Malha Rao	r. 1537–1572	Maharana Udai Singh
		r. 1875–1939	Maharaja Sayaji Rao III	c. 1537	Udai Singh begins building new capital of Udaipur
1868	Queen Victoria names Mummadi knight commander of the Star of India	1877	Proclamation declares Queen Victoria the queen-empress of India	c. 1540	City Palace built at Udaipur
				1567	Chitor falls to Akbar and Moguls
r. 1895–1940	Maharaja Krishnaraja IV Wadiyar	1887	Queen Victoria receives Sayaji Rao in England	r. 1572–1597	Maharana Pratap Singh
1897–1912	Construction of Amba Vilas		Sayaji Rao founds Baroda Museum	1614	Mewar and Moguls make peace
1936	Krishnaraja travels abroad for the first time	1927	Chimanabai serves as chairman of first All India Women's Conference	1620s	Jagamandir palace built
				r. 1628–1658	Shah Jahan, emperor of Mogul dynasty
		r. 1940–1968	Maharaja Pratap Sinha	1632–1645	Shah Jahan builds Taj Mahal at Agra
				r. 1778–1828	Maharana Bhim Singh
				1818	British take Udaipur under their protection
				r. 1828–1838	Maharana Jawan Singh
				19th c.	Jawan Singh installs statue of Kumara at Eklingji
				r. 1842–1861	Maharana Swaroop Singh
				r. 1861–1874	Maharana Shambhu Singh
				r. 1884–1929	Maharana Fateh Singh
				1911	George V and Queen Mary travel to Delhi
					Imperial durbar at Delhi
				1920	Mahatma Gandhi launches large-scale civil disobedience campaign
				1921	British strip Fateh Singh of his powers
					Maharajas form Chamber of Princes
				1947	India becomes independent republic

ACKNOWLEDGMENTS & CREDITS

The Editors are particularly grateful to the following for their extensive assistance: Air-India; Dr. Mulk Raj Anand, Bombay; the Maharaja of Baroda; the Maharaja of Benares; the Maharaja of Jaipur; the Maharana of Mewar; the Maharaja of Mysore; Dolly Sahiar, Bombay; Margaret Tully, London.

The Editors would also like to thank the following for their cooperation: Dr. Robert J. Bingle, Department of European Manuscripts, India Office Library, London; Barry Bloomfield, Director, India Office Library, London; Rosalie Cass, London; M.N. Chatterjee, Consulate General of India, N.Y.; Basil Gray, Long Whittenham, Oxfordshire, England; Alexis Gregory, Vendome Press, N.Y.; A.N.D. Haksar, Embassy of India, Washington, D.C.; Clare Jameson, Harrogate, England; Shaun Kavanaugh, Graham Parlett, and Dr. Robert W. Skelton, Indian Department, Victoria and Albert Museum, London; Brendon Lynch, Sotheby Parke Bernet and Co., London; K.R. Narayan, Ambassador, Embassy of India, Washington, D.C.; Gordon Roberton, London; Pauline Rohagti and Jill Spanner, Department of Prints and Drawings, India Office Library, London; Pallavi Shah, Air-India, N.Y.; Camilla Steel, Press Office, Victoria and Albert Museum, London; Marion E. Vaugh, New Haven, Indiana; Major H.N. Williams, Powis Castle, Wales; Simon and Cindy Winchester, Iffley, Oxfordshire, England. IN INDIA: Sheldon H. Avenues, U.S. Information Center, New Delhi; A. Barretto, Bombay; Kim Berkson, Bombay; Dr. S.K. Bhowmilk, Baroda Museum and Picture Gallery, Baroda; Narayan Contractor, Bombay; Dr. Asok Kumar Das, Maharaja Sawai Man Singh II Museum, Jaipur; D.S. Desagal, India Government Tourist Office, New Delhi; C.K. Gaekwad, Baroda; Marcia Gauger, Time-Life News Service, New Delhi; B.N. Italia, New Delhi; Reyasat Khan, Benares; Rabindra N. Khanna, New Delhi; K.J. Koth, Bombay; Anand Krishna, Benares; R.D. Parmar, Baroda Museum and Picture Gallery, Baroda; Kate Petigara, Bombay; D.N. Ramaswamy, Sri Chamarajendra Art Gallery, Mysore; Dr. M.S. Nagaraja Rao, Department of Archaeology and Museums, Mysore; T. Sudarshana Rao, Mysore; Yaduendra Sahai, Maharaja Sawai Man Singh II Museum, Jaipur; Koochnur Sahiar, Bombay; Guru Satedekar, Air-India, New Delhi; Shakti and Vena Singh, Udaipur; Madhukar Sood, New Delhi; Mr. Subramanyam, Udaipur; Mr. Tandon, New Delhi; Mr. Tulsinath, City Palace Museum, Udaipur.

Map by H. Shaw Borst
Endsheet design by Cockerell Bindery/TALAS

All photographs are by Seth Joel except where indicated. Cover: Courtesy of the Maharana of Mewar. 2: Maharaja Fatesingh Museum, Baroda. 4-5: Amba Vilas Museum, Mysore. 6: Maharaja Sawai Man Singh II Museum, Jaipur. 10-11: Maliram Puranmal Jewellers, Jaipur; photo by Dolly Sahiar, Bombay. 12-13: Victoria and Albert Museum, London. 14-19: The Archaeological Survey of India, New Delhi. 20-47: Maharaja Sawai Man Singh II Museum, Jaipur. 48-49: Victoria and Albert Museum, London; photo by Gordon Robertson, 50: Courtesy of the Maharaja of Benares. 52-53: The Bridgeman Art Library, London. 54-55: Courtesy of the Maharaja of Benares. 56-59: Maharaja Benares Vidya Mandir Museum, Benares. 60-62: Victoria and Albert Museum, London; photo by Gordon Roberton. 63-77: Saraswati Bhawan, Benares. 78-81: Sri Chamarajendra Art Gallery, Mysore. 82: Victoria and Albert Museum, London; photo by Larry Burrows © Time Inc. 83: Courtesy of Shehbaz Safrani; photo by Steven Mays, N.Y. 84-91: Amba Vilas Museum, Mysore; photo on pages 86-87 by Nagaraja Rao. 92: Sri Chamarajendra Art Gallery, Mysore. 93-115: Courtesy of the Maharaja of Mysore. 116-117: Maharaja Fatesingh Museum, Baroda. 118-119: The Bridgeman Art Library, London. 120-121: Maharaja Fatesingh Museum, Baroda. 122 (top): Courtesy of the Maharaja of Baroda. 122 (bottom)-123: Sri Chamarajendra Art Gallery, Mysore. 124-125: Maharaja Fatesingh Museum, Baroda. 127-141: Baroda Museum and Picture Gallery, Baroda; photos on pages 132-133 by David Cripps, London. 142-145: Courtesy of the Maharana of Mewar. 146-147: City Palace Museum, Udaipur. 148-169: Courtesy of the Maharana of Mewar.

SUGGESTED READINGS

Baroda, Maharaja of, *The Palaces of India.* Vendome Press, 1980.

Barton, Sir William, *The Princes of India.* Nesbit, 1934.

Buck, William, ed., *Ramayana.* The New American Library, Inc., 1978.

Collins, Larry and Dominique Lapierre, *Freedom at Midnight.* Simon and Schuster, Inc., 1975.

Eck, Diana, *Banares City of Light.* Alfred A. Knopf, Inc., 1982.

Kramrisch, Stella, *Manifestations of Shiva.* Philadelphia Museum of Art, 1981.

Lord, John, *The Maharajahs.* Random House, Inc., 1971.

Michell, George, ed., *In the Image of Man.* Hayward's Gallery, Arts Council of Great Britain, 1982.

Morris, James, *Pax Britannica: The Climax of an Empire.* Harcourt Brace Jovanovich, Inc., 1968.

Tod, James, *Annals and Antiquities of Rajast'han,* Vols. I and II. M.N. Publishers, New Delhi, 1978.

Watson, Francis, *A Concise History of India.* Thames and Hudson, 1979.

INDEX

Page numbers in **boldface type** refer to illustrations and captions.

Printed and bound by Brepols S.A. — Turnhout, Belgium